No One Asked for This

No One Asked for This

Cazzie David

Mariner Books
Houghton Mifflin Harcourt
Boston New York
2020

For information about permission to reproduce selections from this book, write to trade.permissions@hmhco.com or to Permissions, Houghton Mifflin Harcourt Publishing Company, 3 Park Avenue, 19th Floor, New York, New York 10016.

hmhbooks.com

Library of Congress Cataloging-in-Publication Data
Names: David, Cazzie, 1994– author.
Title: No one asked for this : essays / Cazzie David.
Description: Boston : Mariner Books,
Houghton Mifflin Harcourt, [2020]
Identifiers: LCCN 2020023877 (print) | LCCN 2020023878 (ebook) |
ISBN 9780358197027 (trade paperback) |
ISBN 9780358181781 (ebook)
Subjects: LCSH: David, Cazzie, 1994– | Television producers and directors — United States — Biography.
Classification: LCC PN1992.4.D2788 A3 2020 (print) |
LCC PN1992.4.D2788 (ebook) | DDC 791.4502/33092 [B] — dc23
LC record available at https://lccn.loc.gov/2020023877
LC ebook record available at https://lccn.loc.gov/2020023878

Book design by Chloe Foster

Printed in the United States of America
DOC 10 9 8 7 6 5 4 3 2 1

Portions of the chapter "Love You to Death" first published, in different form, in the March 2018 issue of *InStyle*.

The author has changed the names of some of the people who appear in this book.

To my mother, my sister, and my father

Also for Blanca and Claudia

Contents

Introduction ix

Mean Sister 1

Do Not Disturb 26

Ex Dysmorphia 42

Almost Pretty 50

Is Everything Gonna Be Fine? 57

Tweets I Would Tweet If I Weren't Morally
Opposed to Twitter: I 76

Why God Is Definitely Real 83

Too Full to Fuck 89

So Embarrassing 94

Love You to Death 106

CONTENTS

Insecurity When You're the New Girlfriend 112

Environ-Mental Mom 120

Tweets I Would Tweet If I Weren't Morally
Opposed to Twitter: II 136

Shit-Talking Etiquette 143

My Parasite 161

Privileged Assistant 172

I Got a Cat for My Anxiety 192

This Essay Doesn't Pass the Bechdel Test 207

Tweets I Would Tweet If I Weren't Morally
Opposed to Twitter: III 233

Moving Out 240

Erase Me 264

Thanksgiving 310

Acknowledgments 329

Introduction

I'M AWARE THAT MOST people who write nonfiction books usually have an interesting life story or at least a list of accomplishments to reflect on. I've been alive for only twenty-six years, which isn't very long, therefore I possess neither of those things. However, if someone was interviewing for a job — let's say to be a dental hygienist — and they told you they had twenty-six years of dental experience, you would think, *Hey, that person is qualified!* Therefore, technically, I've amassed enough life experiences to fill a book. I have experience living with three crazy people (my parents and sister). I have school experience; lots of funny things took place there. I have a ton of experience avoiding danger, something I have been doing assiduously since I was born. And once my screen-time average was nine hours a day for a full month, so I have more experience with social media than all sane people and probably some other insane people as well.

Regardless of whether I was able to trick you into believing I've had enough experience to write a book, I will have no

such luck when it comes to convincing you that I'm a likable protagonist. I think almost everything I say is annoying and I'm certain being around me must be a hell I can't comprehend, because I've never had the displeasure of meeting me. I regret every word I've ever said out loud in public and even the words I've said to people I trust in private.

So why would I write a book of thousands of words that will allow people to formulate opinions about me and therefore cause me to panic indefinitely? Because I'm highly skilled at self-sabotaging my mental health. As skilled as I am at making you, the reader, immediately question why you should read this book when even I am saying that I hate me. Why would I do something like that? I don't know. I don't have the answers to everything. Or anything.

I think I could potentially be likable if I were written as a character in a novel. Even the most deeply flawed protagonists are hard not to intuitively sympathize with because you know their lives are constructed by a narrator. If you do end up completely disliking a character, it could be interpreted as a purposeful stylistic choice by the author. If you hate the main character in a book of personal essays, you know it was not done on purpose.

A third-person narrator is even more credible. Seeing the word *she* instead of *I* makes you immediately trust the perspective more, as it's hard to entirely believe what anyone says about themselves. It's like thinking that a person's Instagram is an accurate reflection of who they are. Plus *I* always sounds so self-important. For example:

"She walked into the room and poured herself a cup of coffee."

I think: *She's mysterious. Complicated, but relatable. I too, would pour myself a cup of coffee.*

And then there's this: "I walked into the room and poured myself a cup of coffee."

I think: *Wow, you think you're sooo fucking cool walking into the room getting coffee, don't you? Get over yourself!!*

I unfortunately can't write about myself in the third person, because that would be psychotic. But I do want to start off on a good note, a note where you aren't inundated with self-absorption in the form of *Is* so your eye rolls can be minimized and your confidence in me established. So I made a compromise and "hired" a narrator for the rest of the introduction. He will introduce the book and me in a way that is reliable and sympathetic. You will trust him because his point of view is assured, and because he is a man.

If you are interested in stories with happy endings, you would be better off reading some other book. In this book, not only is there no happy ending, there is no happy beginning and very few happy things in the middle. This is because ~~not~~ very many happy things happened in the ~~lives~~ *life* of ~~the three Baudelaire youngsters~~ *Cazzie David, but despite being incredibly privileged she finds it impossible to be happy and exist in the world.* ~~Violet, Klaus and Sunny Baudelaire were intelligent children and they were charming and resourceful and had pleasant facial features.~~ *Cazzie isn't very bright. She was*

a product of the ADD generation and therefore never read for fun, or even for school, as she was also lucky enough to grow up with SparkNotes, so hopefully you were not looking to be intellectually stimulated by this book. She's not resourceful, per se, but she does have a knack for inventing phone stands out of anything within arm's length, a skill developed from years of incessant laziness. She has facial features that fall anywhere between pleasant and hideous depending on the angle, but ~~they were~~ *she was* extremely ~~un~~lucky, and *still* most everything that happened to ~~them~~ *her* was rife with misfortune, misery, and despair. I'm sorry to tell you this, but that is how the story goes.

With all due respect,
*Lemony Snicket**

* For legal reasons, I'm required to clarify that the above material is adapted from *A Series of Unfortunate Events.* I am not cool enough to actually hire Lemony Snicket.

No One Asked for This

NEUROPSYCHOLOGICAL EVALUATION

Child's name: Cazzie David
Parents: Laurie and Larry David
Child's date of birth: May 10, 1994
Age at assessment: 12.9
Dates of evaluation: March 23, 30 and April 4, 2007

CONFIDENTIALITY

The following report may contain sensitive information subject to misinterpretation by untrained individuals. Nonconsensual redisclosure is prohibited by section 5327, Welfare and Institutions Code.

LIMITS OF INFORMED CONSENT

This examiner carefully informed the examinee's parents of the purpose of this assessment and the intended use of its results. The examinee's parents consented to the activities of this assessment. Specific consent of the examinee's parent is needed to release this report to any person or agency.

REASON FOR REFERRAL

Cazzie David, a 12-year-old Caucasian right-handed girl, presently comes to clinical attention out of concern for her lack of passion for anything. Cazzie is disorganized. She loses books, does not bring home right materials for homework, and does not take notes in class. Cazzie says she is stupid and that is why she cannot do her schoolwork. Both parents see significant symptoms of depression and anxiety (almost always is negative about things, is easily upset; often is sad, changes moods quickly; complains about being teased, says no one understands her, says she hates herself, says she wants to kill herself, says she wishes she were dead, seems lonely, says no one likes her, often says she is not good at things, worries about what teachers think, worries about things that cannot be changed, is fearful; almost always worries; is afraid of making mistakes, tries too hard to please others). Mr. David rates aggression as a problem and significant atypical behaviors (often repeats an activity over and over; sometimes has strange ideas and seems out of touch with reality; almost always says things that don't make sense).

Additional concerns include Cazzie's number of fears. She is afraid to go downstairs in the house alone and since she was young whenever she goes outside with her parents she requires one to walk on either side of her. It is not known whether this is to shield her from intense sadness and empathy she feels for those less fortunate versus whether she is afraid of being attacked. The present level of crisis and the degree to which it has been bound to get the attention of her school and her family may be a means of trying to bring attention to a situation which desperately needs to be addressed to set Cazzie on a different course for the future.

PSYCHOLOGICAL HISTORY

Mr. and Mrs. David have been together 15 years and describe the relationship as stable. Mrs. David describes herself as a disciplinarian who enforces rules, whereas she describes Mr. David as more of a soft touch who tends not to follow through on consequences. Cazzie occasionally feels persecuted by her mother and will appeal to her father, who can sometimes talk with her and help her feel better. Cazzie has a younger sister, Romy, aged 11, who is described by her mother as upbeat, enthusiastic, in love with life,

Mean Sister

Cazzie has a younger sister, Romy, aged 11, who is described by her mother as upbeat, enthusiastic, in love with life, sweet and perfectionistic. Relationship between siblings is "fine with typical sibling fights," though Cazzie has been disinterested in Romy recently.

— *Excerpt from neuropsychological evaluation of Cazzie David, 2007*

MY SISTER, ROMY, THINKS I'm a "mean sister." I think Romy is an annoying sister. I believe the only reason I'm mean is because she's annoying. She believes she's not annoying. You see the dilemma.

One of the reasons she thinks I'm mean is that I don't show her I care about her "through my actions." I'll often forget to check in and ask how she's doing; sometimes I'll forget to respond to her texts. It's not that I don't care about her — of course I do, she's my sister! I'm just very absent-minded, or terribly self-involved, or both. I'll forget plans no matter who

they're with and appointments no matter how important. Everyone who knows me has at one point said, "WHY DON'T YOU USE A CALENDAR?!" and suddenly, inspired by the obvious genius of a calendar, I'll go on my phone to use it but instead look at *Daily Mail* articles, be overwhelmed by how much I hate everything, and forget to add the appointment. The good news is my dad once told me that absent-mindedness is a sign of creativity. Sure, he told me this while I was sobbing to him on the phone at the airport after I'd missed my flight even though I was sitting at the gate the whole time, but it was still comforting.

The only people I tend to remember to check in with are the ones that I feel sympathy for at that current moment. I text my childhood nanny once every three days and any friend who is going through a bad breakup — though the second she's over it, she'll stop hearing from me. I'm like Mary Poppins for the lonely and depressed in my life — once the children don't need me anymore, I'm gone. I don't check in with people who should be fine, like my sister, who has a good job, a boyfriend who loves her, and a mom who takes her shopping once a year out of some brilliant tradition Romy thought of as a kid. The only tradition I have with my mom is getting publicly humiliated via her Instagram comments.

My mom and Romy are extremely similar. My dad and I are extremely similar. My mom and dad got divorced because of their differences. I, unfortunately, cannot divorce my sister, although it's evident that if we were a married couple that is what we would do.

My sister and I don't have a gene in common. I'm unhappy by virtue of birth; she's unhappy by virtue of circumstance. I only worry about existential stuff; she only worries about daily hurdles. All I talk about is death; she can't talk about death without having a panic attack. I was named after a basketball player; she was named after an elegant French actress. I failed almost every class I've ever taken; she's a straight A student. Everything she does is perfect, or has to be perfect. Her room is pink and pristine with not a thing out of place. She has ten perfume bottles that are perfectly lined up along with everything else on a vanity stand that she actively makes sure never to scratch. All of her photos are framed and hung up. She makes her bed every morning, and her cashmere sweaters are organized by color. In comparison, I am a mess. My room is that of an emo, depressed high-school teenager — piles of clothes and crumpled papers with disconcerting school-shooter-y doodles scribbled all over them. When my mom comes into my room, the first thing she does is open a window to "get some light in." Even if the window is already open and it is already light.

My sister loves to point out how different we are. Take the time I was doing my makeup in front of her and I accidentally dropped my eyeshadow onto the floor. She watched in horror as it broke into a thousand little powder cracks. Without reacting, I dipped my brush onto the now sparkly ground and painted my eyes with the floor shadow.

"Wow, we're soooooo different," she said disparagingly.

"Why is that necessary to say?"

"I just would *never* do that."

"Well, congratulations."

Romy and I fight about things most sisters fight about, like who remembers the childhood memory correctly, but we fight about them in a way where you'd think one of us quite literally stabbed the other in the back. Every argument has the intensity of having fucked the other's boyfriend. I'm afraid to mention anything from our past because of the rage that ensues. I'd rather block it all out than have another maddening fight about who won the swimming race in the summer of 2005 (me) and which one of us named our first dog (also me). At this point, both of our memories should be studied.

"YOU THINK EVERYTHING WAS YOU! YOU HAVE A WEIRD COMPLEX, CAZZIE! GO TO THERAPY!" she'll scream.

"Yeah, I do have a complex. A complex for THE TRUTH!"

Like most sisters, we also fight about clothes. I can't wear something new without her questioning me like she's a mall security cop who just saw me steal it from the store.

"What are those jeans?" she'll ask.

"I don't know, jeans?" I'll respond.

"Where did you get them?"

"They're Levi's."

"How did you pay for them?"

"My money . . ."

"Hmmm."

If I told her the actual truth — that my parents paid for the jeans without knowing it — she would freak out, tell on me,

and then probably insist on them getting her new jeans because she would *never* spend money without asking.

My sister's questioning is insidious, especially if the thing I'm wearing belongs to my mother. I'm not allowed to borrow anything of my mom's for reasons such as I'm irresponsible, I'll lose it, I'll stain it, I'll leave it on the floor, I'll lend it to my friend, it'll come back smelling like weed. However, my mom will lend anything to Romy for reasons such as she's responsible, she doesn't lose anything, she doesn't stain anything, she hangs it up in her closet, and it comes back smelling better than it did before.

"What's that sweater?" Romy will ask as if it's the missing sweater a murder victim was last seen in.

"Oh. It's Mom's."

"She gave it to you?!"

"No, I'm borrowing it."

"Did you ask if you could borrow it?"

"Obviously."

"Well, are you gonna give it back?"

"No, *I'm not going to give it back.* Yes, obviously, I'm going to give it back!"

"You always forget."

"I'm not going to!"

Then she'll swiftly go on her phone and text my mom something along the lines of *Did you let Cazzie borrow your sweater or did she steal it?*

To which my mom will reply, *WHAT?!* because of course I stole it. I had to steal it. She won't let me borrow anything!

Romy won't let me borrow anything either, but that's because she has a very bad case of OCD. Can you get luckier than having a disorder that prohibits you from loaning anything to your sister? I wish I had her OCD instead of my five anxiety disorders. The only things I ever got out of them was therapy, medication, and weird looks from my parents. She really pushes it, though, adding new things to the OCD list constantly. I've slept in my sister's bed countless times over the years, but one day I just touched her blanket and . . .

"Ew, Cazzie! You touched my blanket!!!!! Please don't do that, you know I have OCD."

The reaction was as if a sewer rat had licked her. I walk into her room without socks — "Cazzie, your *feet*, I have OCD." I take a tampon — "Cazzie, don't take any of my tampons, I have OCD."

"What does that have to do with anything?!"

"I need a certain amount to be in the box!"

Romy lives in New York but she comes back to LA for all of the holidays, which in my opinion is far too often. During her December break last year, we went Christmas-gift shopping and stopped for ice cream along the way. As we got back into the car from our final task, she picked up my empty ice cream cup and said, "Ugh, you know I hate trash in my car."

"No one *likes* trash in their car," I said, rolling my eyes. We hadn't had the opportunity to throw it away yet.

"No, but I *really hate* it. Like, you don't mind it."

"I do mind trash, but okay."

"All I'm saying is that you can handle trash in your car and I can't."

If Romy could write Instagram bios for the both of us, they would be: Cazzie David — "Much less clean than my sister, can't do anything, *can* handle trash." Romy David — "I shower twice a day, super nice sister, can't handle trash."

At the end of that particular trip, I dropped her off at the airport to go back to New York. You might think that was a nice thing for me to do, but I only offered after a huge blowout fight involving all her "You don't care about me" nonsense.

"You just don't do anything for me. You won't even lift a finger for me."

"Mom already said she would drive you! Why does it matter who brings you there?" I asked.

"You're just so unhelpful. You never help me!"

"No, in this situation, if I bring you, I'm helpful, but I'm not *un*helpful if I don't help you, as you are already being helped by Mom!"

"You're such a *mean* sister!"

At this point, she knew that was all she had to say to get me to do anything; it's like telling a kid you'll give him a dollar to stop crying. And because I am constantly trying to prove that I'm *not* a mean sister, I dropped her off at the airport.

"Say, 'Have a safe flight!'" she commanded as she was getting out of the car. I stared at her, dumbfounded. "Cazzie, please! I have OCD!" As if she wouldn't be able to get on the flight unless I said it.

I didn't want to indulge it. But I definitely did want her to get on the flight. "Have a safe flight!" I said.

The strongest memory I have of getting guilted via "mean sister" was when Romy came back home that summer a few months later. She, my dad, and I were all having dinner when my dad asked what I was doing later that night.

I rarely, if ever, leave my house. I'm not cut out for the outside world, especially the outside night world, so I primarily hole up in my room. But when I was asked by my long-time childhood crush to join him and his friends at . . . a club (somewhere I'd go only for a guy I'd been obsessed with since I was six years old), I decided it would be the one night I'd go out for the year. And to ensure that I would enjoy myself, I invited my most fun and least embarrassing friends to come with me.

"I'm going out with some friends," I answered.

"Wow! Whoa! Look at you! Going out!" my dad said, surprised. "Romy, what are you doing?"

"Nothing," she said dramatically.

My sister never misses an opportunity to try to elicit pity. However, doing "nothing" on a Saturday night isn't sad. I've done it almost every Saturday night for my twenty-six years of living and will probably do it for the next twenty-six years as well. And at that point I'll be over fifty, so I'll definitely be staying in the twenty-six years after that too.

"Why aren't you hanging out with your friends?" I asked, since it *was* abnormal for her not to have plans with them.

"Because half of them are out of town and I'm in a fight with the rest of them."

"Well, you can come to Julie and Glenn's with me. We're watching a movie," my dad proposed.

When I said I do nothing most Saturday nights, I meant that I usually go to my cousin Julie's with my dad to watch a movie. It's something I happen to enjoy, but it's apparently my sister's last choice after actually doing nothing.

"No, thanks," my sister said in a tone even more melancholy than her "Nothing."

Then they both stared at me expectantly, waiting for me to invite her to join me. But I couldn't. This was the first night I was going out in seven months (yes, seven) and I wanted to have fun! It wasn't personal. Does anyone like clubbing with their younger sisters? Anyone besides weird influencer model sisters who take pictures grinding up on each other?

It wasn't her fault that I wouldn't have fun with her; it was mine. She's just not someone I can have fun around because she knows me too well and knows that I never have fun. Here's how it would go: We'd be in the club (Omg no), and I'd be trying to have a good time with my friends. We'd drink, dance a little, jump around, and I'd accidentally let a smile slip out. Enter my sister:

"Wow, I've never seen you have so much fun before."

This observation would make the contrarian in me immediately recoil. When someone points out that I'm having fun I'm instantly unable to continue having fun and even regret

having had fun in the first place. I wish I were the type of person who could respond with something like, "I know right?! It's so fun! *So happy!*" and continue on with the night. But I'm not.

I've had plenty of fun times with my friends before, so it's not strange for them to witness me enjoying myself. But because I'm innately miserable whenever I'm around any of my family members, none of them have ever seen me have a good time. Plus, if Romy came, I wouldn't be able to flirt with my childhood crush because she'd say, "Wait, why are you flirting with him? That's so weird, Cazzie. We've known him since we were six." *Uh, I don't know, why do you think?*

"I would never not invite you if you had nothing to do!" my sister screamed as she stormed off to her room.

"I would never care about having nothing to do! Nor would I ever make you invite me!" I called out after her. My dad looked at me with deep sad eyes, shaking his head in disappointment.

An hour later he came into my room. "Honey, she's really upset. She's going to be alone in the house all night."

"She can go with you! Or stay home, who cares, why is it a big deal?"

"I know. But she's your sister. She's hurt that you don't want her to come with you."

She's your sister is *You're a mean sister* in adult-speak.

A few minutes later, my sister stomped past my room to leave with my dad for our cousin's movie night.

My friends then arrived one by one and we started trying

on clothes, blasting music — a classic getting-ready montage. We were about to head out when a text came in from my cousin Julie: *What happened? Why won't you take her out with you?*

And then one from my dad: *I wish you would be nicer to your sister.*

I explained the situation to my friends and they released a synchronized "Awww," which was absolutely the wrong reaction to have, because, naturally, I started second-guessing myself. *Is it actually fucked up for me to want to go out with just my friends? Does my dad hate me? Does my cousin think I'm a bitch? Am I really a mean sister?*

All signs pointed to yes, but it still wasn't enough to make me voluntarily sabotage my night. I would be uncomfortable if she came! Didn't I deserve to have a good time?

As I was contemplating this, I got a text from the CC (childhood crush) saying they were now going to a bar (not the club) and to meet them there. This new location was much easier for all of us to get into and wasn't really a fun, flirting location; it was a more-the-merrier kind of environment. So, with this change of venue in mind, I thought I should probably just bring Romy so everyone would stop thinking I was a mean sister.

I told my friends I was going to surprise her and pick her up from my cousin's house to come out with us. They again let out a synchronized "Aww." Still very much the wrong reaction.

I knocked on my cousin's door and was let in by her hus-

band, Glenn, who looked surprised to see me. Great, this was already embarrassing. I walked into the living room to interrupt whatever movie they were watching and found my sister sitting between my dad and my cousin on the couch. There was a chocolate bar unwrapped in front of her, and her face was red from crying. It looked as if she had just been dumped. Ridiculous.

The situation felt straight out of a romantic comedy — I was interrupting a moment to surprise someone and profess regret for my actions. The thought made me cringe and want to abort the mission entirely. Everyone was looking at me, waiting to hear what I was going to say. It was too much attention to bear, even though it was just four of my family members.

"I'm here to invite you out," I proclaimed with no enthusiasm.

"Aw, that's very nice. Isn't that nice?" my dad said to Romy.

"You're a good sister!" my cousin exclaimed. It was pretty clear that Romy had been ruining their night with her whining and they wanted her to leave.

"I don't want to come anymore," Romy announced.

According to rom-coms, when someone makes a big gesture, the other person is obliged to forgive them. Especially if it's something as minor as them wanting to go out with just their friends. Meanwhile, I was outside the house with a metaphorical boom box. "Come on, let's go."

"You only want me to come because you feel bad."

"No, I actually don't feel bad at all. I couldn't feel less bad. I just want you to come."

"Go, sweetie, you'll have fun. You should go!" my dad said.

"But I don't —"

"We're not all going to stand here convincing you. Just come or don't come!" I blurted out.

She came.

We spent the entire car ride home arguing over whether I was a mean sister or not.

"You're *so* mean to me, Cazzie."

"How can you say I'm mean to you when I just drove here to pick you up to come with me?"

"You just are."

"You make me be mean to you by acting like this!"

"Just be a NICE SISTER!" she screeched.

We arrived back home engrossed in a full-blown fight, and I knew I needed to create a buffer between us. In what I thought was a stroke of genius, I invited another friend to come with us because he and Romy got along. He could talk to her so I wouldn't have to, I reasoned. A perfect plan.

The five of us were about to head out the door when a text from the CC came in informing me that they were no longer going to the sister-friendly bar by my house but to the club that we were originally going to go to. If only I had gotten the text thirty minutes sooner, I could have enjoyed myself.

Trying to get five people into a popular club on a Saturday night is almost impossible unless you're famous, which I'm

not, or know someone there who is, which I didn't. But it was too late to bail. I was dressed, which means I had already accomplished 88 percent of going out.

When we arrived, there was a twenty-person line outside composed of much hotter girls in much tighter dresses and much higher heels. I can attest to the fact that there's truly nothing more humiliating than standing behind twenty people to get into a club. And I wish more than anything I couldn't attest to that.

To avoid the humiliation of waiting in line, I texted a person I'd met maybe twice that I'd heard through one of my friends was a promoter at the club. (Actually, this might be the most embarrassing part.) *Hi, it's Cazzie! I don't know if you remember me, I'm sorry I'm texting you, but I'm at —* I'm not going to tell you where I was because if you knew, it would make all of this even more mortifying — *and can't get in. I'm five people total. Can you help us out?* I didn't mention to him that one of the friends I was with was a guy, because trying to get one guy into a club is equivalent to trying to get four girls in. So technically we were eight people. The only reason I was even trying at this point was because the CC knew we were outside and I didn't want him to think that I was a loser who not only would go to this club but would go and not be able to get in.

The promoter (ugh) I texted walked outside a few minutes later, and to this day, I've never seen someone look more like they think they're the shit. I've also never seen myself act like

more of a loser. "Charlie!" I yelled out. My voice went five octaves higher than usual, probably because I subconsciously knew that no one wants to let a monotone, sarcastic girl into a place of vivacity. Clubs are for women with long blond locks and token brunettes with their hair pulled back so tight, it creates the illusion of even more filler. A place where personality consists of having one arm up in the air and wanting to get fucked up.

Charlie gave me one-tenth of a second of his attention by ever so slightly nodding in my direction as he talked to the bouncer, who then lifted the rope to let six girls waddle in, self-satisfied looks smeared across their faces. I could hear their thoughts: *We're special, cool, and hot; we're cool and special and hot.*

Charlie approached me and said, "You're next." *Oh, wow, thanks so much, Charlie Fuckface, like I fucking care?* (But actually thank you.) He proceeded to inform me that "for right now" he could get in only me and two of my friends (the original amount I was supposed to come with), but he could try to get the other two in a bit later.

When my sister heard him say this, she gripped me like *of course* she's going to be in my group going in, she's *my sister.*

"Since Charlie knows both of us, we should split up so both groups will have a better chance of getting in," I suggested to Romy.

"What's wrong with you — you would just leave *your little sister* outside?"

My guy friend said he also had to come in with my sister and me because it would be the most difficult for him to get in, which was valid but upsetting to say the least.

If clubbing were a team sport, I was stuck with a collection of every captain's last picks. To compile a good going-out team, you must pick teammates based on who's the most outgoing and who allows you to be the best version of yourself. When you're surrounded by these types of friends, it helps you feel like you deserve to be there and that it's okay that you're taking up space where another human instead of you could be because your team is a *good-time team*. It makes a huge difference in your overall confidence when you are in a social setting where you do not, by any means, fit in. Entering the club with my little sister and friend I'd invited solely to help distract my little sister was not boosting my confidence.

As we started walking in, I turned back to catch a glimpse of my two friends in line, the only people I'd wanted to go out with in the first place. My CC was waiting by the doorway. We hugged and walked in together while I worried about the good-time people I had left behind and the bad team he would now forever know me by.

We were brought to one of the "tables," which they should really just call stools as they are only large enough to hold one bottle of alcohol. My sister, friend, and I awkwardly stood in front of it, since there were so many awful people squeezed into this place, there wasn't room for even a foot behind it.

The circumstances were so uncomfortable that after one single moment my friend whispered into my ear, "I'm leav-

ing," and ran off before I could respond. It would have been nice if he hadn't come in with us in the first place so I could have brought in my two friends who I actually wanted there and who would have stayed, but it's FINE, I GUESS.

This had suddenly become a desperate situation: I was at the club with just my sister. I felt frozen, unsure of what to do. I texted my friends the name of the person whose table we were at, hoping that might be enough, and then I just stood there, thoughts racing about my next move. I wasn't drunk enough to dance — not like there was any amount of alcohol in the world that would encourage me to dance with my sister. If there was ever a world in which I did, she would be sure to remind me of it every day after: *Remember that time we went clubbing just the two of us and danced?* Sickening.

I got a text from one of my friends outside: *I just used the name you gave me. The bouncer laughed in our faces. We're going home. I spent my entire Saturday night waiting outside of* — still not telling. My friend takes her Saturday nights very seriously; that's how fun she is. Saturday night is basically her Christmas. I knew I had let her down.

So there I was, standing in the club with just my sister, the absolute polar opposite of how the night was supposed to go, when the CC finally came up to me. It was too loud to hold a conversation, but we also couldn't stand there silently. So I resorted to pointing at the woman whose job it was to thrust around in a net hanging from the ceiling.

"How dumb is that?" I screamed so he could hear me.

"Oh, I never noticed that before. Ha."

I racked my brain for anything I could possibly say or do to keep him standing there, but before I could come up with anything, my sister approached and said, "What are you drinking?"

"Tequila soda," I responded curtly.

"What should I get?"

"I don't know. Whatever you want."

"Will you come with me to get it?"

"No, you can do it. The bar is right there," I said.

"Okay, *Jesus*," she said, and she walked over to the bar.

I took a deep breath, thanking God I was left alone with him again.

"You're really mean to your sister," he said.

What? No! What the fuck? She was only there in the first place because I *wasn't* mean to her! "Excuse me? No, I'm not. You don't understand."

"She is who she is. You can't change that by acting like that toward her."

I stood there in a state of shock until he walked away. Fifteen minutes later, I saw him in the corner making out with two blond sisters. I called us an Uber immediately.

The next day, as I was doing my morning ablutions, I decided I was going to reflect on myself to find out why I was, in fact, such a mean sister.

"CAZZIE! I NEED SOMETHING FROM THE BATH-ROOM!" Romy screamed even though she was right next to the door.

"I'm about to pee," I said calmly, like a nice sister would.

"CAZZIE, LET ME GET THE THING I NEED BEFORE YOU GO, I REALLY NEED IT, JUST LET ME IN RIGHT NOW TO GET IT!" It was in verbal caps.

I pulled my pants back up and opened the door. If I were mean, I would have ignored the yelling and taken my sweet time.

She came in and opened the mirror cabinet so slowly it was as if she was in *A Quiet Place* and had to make sure it didn't make the slightest creak. In addition to being insanely neat, and clean, and annoying, my sister is also the slowest person on the planet. Not mentally; she's smarter and quicker than I am. I could have maybe been smarter if I hadn't "accidentally" smoked weed every night for the past eight years or didn't have an addiction to banging my head against the nearest wall anytime I felt a rush of shame, but my body, my choice, I guess. Anyway, things that take me or any normal person one minute take Romy thirty. Everything is treated with a preciousness that I've seen exhibited only by Cinderella when she was making dresses with the cartoon birds. Washing her face, putting on pajamas, rinsing fruit/vegetables for dinner, applying sunscreen, doing laundry, packing — Romy does it all with meticulous leisure. My father and I have both driven off with her only halfway in the car, assuming she must already be sitting and buckled up because it's taken her so long to get in and close the door.

After opening the cabinet, my sister ran her finger in slow motion over every row, looking, looking, looking. Her finger finally reached the deodorant and I could hear her unhurried

thoughts aloud: *Ah, here is the thing I have been looking for. I am going to grab it now. Here we go. My hand is now reaching for the deodorant.*

"That's new. What is it?" she said, pointing at one of my products.

"Moisturizer."

"How did you know about it?"

"This facialist I went to."

"Wow, *fancy*, a facial. With what money?"

"My own."

"That's expensive . . . how'd you afford that?"

"CAN YOU PLEASE GET OUT!?"

So I'm mean. Whatever. Why couldn't she have waited five minutes to put on her deodorant? Because her purpose here on this earth is to annoy me in such trivial ways that no one will ever be able to sympathize with why I am such a mean sister. For anything ever to change, my sister would have to meet me in the middle, at the very least by moving a bit faster.

Exactly a year later, I was sitting on my floor alone on a Saturday night, drinking wine from the bottle and smoking a joint, which I was pretending was something more intense as a fun mental game. I had turned twenty-five a few days before and was in a slight existential depression over it, the kind that always exists inside of getting another year older, coupled with general nonsense. But twenty-five was different. Your brain stops developing at twenty-five. Your face and body never stop developing, but when you're twenty-five, they stop

changing for the better and start heading for the worse, even though it feels like you had only one year to appreciate being a young adult without acne, and of course you didn't. So you're looking in the mirror thinking I guess that is my face . . . *for now*, and I guess these are my thoughts, *forever*, when I could have read all of the classics, or learned Spanish, or at least the rest of English. I know twenty-five is young, and anytime someone who is under thirty-four says they're old, every person over that age telepathically hears it at the same time and dies a little inside. But I had decided to indulge in self-pity. At that point in my life, I was well aware that there were only four things that were capable of pulling me out of depression: a text from a very specific person, fucking someone, a near-death experience, or someone else having a serious illness or dying. And just as I was thinking about who I should go fuck, I got a call that snapped me right out of it. Romy was getting emergency abdominal surgery for a perforated ulcer and she was all alone in New York.

The one thing Romy and I do have in common is that we have always lived with the same neurotic spiral — knowing anxiety can cause sickness but still unable to help having daily anxiety about sickness. This was our worst-case scenario come to life. We panic at the onset of a stomachache. Neither of us had ever even been to the hospital, gotten the flu, or broken a bone. My sister would scream "Ow" when I would just brush by her, but that was probably less about pain and more about her being annoying.

The next morning, I got on a flight to New York. Every time I get on a plane, I experience a confusing juxtaposition of an intense fear of germs and an indifference toward dying in a plane crash. I've always been fine with dying on a flight because I think it's chic, in how tragic of a way it is to go. Like, honestly, I could only be so lucky. The plane death cements you in this legendary essence for eternity. It makes everything you once wore seem stylish even if it wasn't and makes you look beautiful in photos even if you weren't. However, on this particular flight to New York, I really didn't want to die because the Jonas Brothers were on it. Yes, I didn't want us to go down because they, I guess, serve a purpose in society, but also because if we did, I would get literally zero attention. Your death day is the best birthday you can have and I need a special death day because (1) I'm clearly a bit narcissistic, (2) I'm not comfortable with getting attention any moment that I'm alive but I feel like I could definitely appreciate it once I've died, and (3) because I foolishly believe I'll be recognized only after death, like van Gogh but with zero talent. That said, if we *were* to come to the worst-case scenario of this plane going down, I decided I would be remiss if I didn't ask Joe and Nick to have a sky-high threesome while literally falling from the sky. What's one more rejection before I go? I'd apologize to Kevin for not being interested but I think he's more tired of apologies than he is of not being thirsted over at this point.

I landed and went straight to the hospital from the airport.

Normally I'd be too anxious to even stand outside of one, but I figured if my sister was brave enough to go through emergency surgery without her parents and have a tube down her throat and drain attached to her stomach for multiple days, I should probably be brave enough to enter a hospital.

A nurse led me to my sister's room; I kept my eyes on the floor, knowing that the sight of someone on a gurney would at best stick with me forever and at worst make me faint. My mother greeted me at the door and walked me inside the hospital room that contained the energy and spirits of five hundred thousand terrifying past scenarios and one terrifying current one. There she was, weak and adorable, attached to tubes and liquids and other things I didn't know the names of because I was too afraid of anything medical to watch *Grey's Anatomy*. I gave her a gentle hug like she was made of glass as I wondered if it was possible for me to go the rest of my life without ever getting a tube put through my nose. She told me the whole story of how she had a back spasm and couldn't move for days. How she called her doctor from home, and she told her to go to the emergency room and get an X-ray. How the emergency room doctor refused to order it for hours because he was sure she was being dramatic and that it was muscle pain and finally agreed to it only so she would go home. The X-ray showed air beneath her diaphragm, so she was transported in an ambulance to the main hospital to get emergency surgery, where they patched up a perforated ulcer that had apparently been bleeding for a week. If she hadn't

forced the doctor to order the X-ray, they would never have found the ulcer and she would have gone home and internally bled out. At this point in the story my mom leaned over and mumbled to me, "You would have felt so guilty the rest of your life for being so mean to your sister."

Yeah.

All my sister could talk about was her gratitude. How lucky she was to have a doctor she could call in the middle of the night who knew what to do and how so many people went through something like this or worse, something completely unpreventable, and were left in debt for the rest of their lives. *Remember two nights ago when you were depressed to be twenty-five?* I thought to myself. *You fucking piece of shit.*

After Romy spent six days in the hospital and then another week recovering in a New York hotel, she, my mom, and I flew home. We got out of there just in the nick of time — my mother and I were ready to break down from a mixture of sadness, exhaustion, and being trapped in a small room together for the past two weeks. Seeing my mom on the brink of complete sorrow was what made me almost lose it. There's nothing more unsettling than seeing one of your parents afraid. The fear in their eyes is unrecognizable. They've been pretending for years to have it together and the moment you realize they don't, it's like being let in on a dark secret. Like how the government won't reveal to the public that they know aliens exist because there would be chaos. If everyone knew parents were constantly afraid, it would be mayhem. If even one parent is scared, no one is safe.

Romy's recovery included going on very slow walks, slowly eating, slowly getting up, slowly sitting down, and drinking water . . . slowly. She was slower than ever.

As I'm writing this, we're a little over a month into her recovery and our relationship has never been better. I check in with her every day because I'm now more worried about her than I am about anyone else in my life — definitely more than any friend going through a breakup. I do everything I can for her, not only because she physically can't, but because if I do it, I don't have to watch her do it so slowly. I think we'll probably continue with these habits even once she's fine. Perhaps all we ever needed was an emergency surgery. Although I do look forward to the day where I'm genuinely annoyed with her again. That will be the moment when I know she's okay.

"CAZZIE! You're so mean!" It will be music to my ears.

Do Not Disturb

You know the first ten minutes of *Spider-Man* — or any superhero movie, for that matter — where there's that scene right before the hero gets his powers and all of his senses become heightened? Everything he does hurts, his skin feels like it's getting ripped off, everything he hears is loud, even if it's coming from miles away? He falls to his knees, grabs his head in his hands, and screams up at the sky, "WHAT'S HAPPENING TO ME!?" Well, that's how I feel all the time — perpetually facing that moment of accumulating powers without ever getting them.

A dream superpower would be the ability to touch someone and make them feel the exact pain I'm in. I would do it to doctors all the time. "Am I okay?! Do you feel this?! What is this pain?!" I'd plead as I touched the doctor's arm.

"Yes, I feel it. You're fine. Your jeans are just too tight."

A nightmare would be feeling the pain everyone *else* is in, which is what I do have. I'm aware that this is something

many people say, probably most. Maybe not that their empathy manifests in the form of feeling like they'll soon be able to throw lava out of their hands, but I don't think there is anyone who would admit to *not* being empathetic. Who would confess that the suffering of others doesn't break their heart? But I'm not your average person claiming to be an empath — a concept justifiably reacted to with eye rolls. And I'm definitely not saying my freakish level of hypersensitivity makes me some kind of superhero. In fact, what's the exact opposite of a superhero? An incompetent, cowardly loser? Yeah. That's me. That's exactly me.

It's strange when everything in the world emotionally affects you and none of it literally affects you, at all. But alas, my body thinks I am a method actor and I must experience every feeling I read about or see, from burning alive to getting a brain freeze. Even human suffering in PG-rated movies can incite mental disturbance and nausea for hours, sometimes days. I'll feel like I'm going to pass out from seeing a woman get a corset laced up in a period piece. As a kid, I had to stop reading *Little Women* the second Beth got scarlet fever. When my mom asked why I couldn't finish it, I told her the girl being sick freaked me out too much.

"Oh, it freaked you out *reading* about scarlet fever? Imagine *having* it, Cazzie!"

"I am imagining it! That's the problem!"

By this point, my friends and family have all gotten used to my hypersensitivity. They'll continue on with their conversa-

tion as if nothing is happening, already moving on to a new subject as I pace, inhale for five, exhale for five, get into a fetal position on the floor, moan, and hold my numbing feet all from hearing the word *tingle*. I'm still mad at my ex-boyfriend for thinking I could handle the Amanda Knox documentary, even with my face buried in his armpit and a pillow over my ears. He was equally mad at me for the lasting impact it had. Sorry I'm not a robot! I can't just *have sex with you* two weeks after fake-experiencing Italian jail. I often wonder what it would be like to be the type of person who can talk about anything, hear anything, without embodying it. But for me, the world is *Thirteen Reasons Why* and I am a triggered, unhappy teen.

Given this hypersensitivity, I'm better off staying at home; I know that if I go out into the world, I'll see things that will disturb me forever. Yet I'll go on the internet from the comfort of my own bed and willingly expose myself to my worst nightmares on a regular basis, sights that are thousands of times more haunting than anything I could find outside or in a movie. On your phone, there is no safe place . . . and I can't stop looking at my phone.

The internet is just one constant onslaught of unpredictable misery. You never know what will pop up right in front of your eyes: "AT LEAST 17 DEAD"; "THESE PARENTS KEPT THEIR 12 KIDS IN CAPTIVITY FOR YEARS"; "PERSON DIES FROM EATING A SANDWICH"; "HOLDING A BOOK IS THE NEW BAG ACCORDING TO THESE MODELS"; "THIS BABY DOLPHIN DIED WHILE BE-

ING PASSED AROUND FOR SELFIES BY TOURISTS";
"_____ FLAUNTS TAUT TUMMY"; "THE US GOVERN-
MENT LOST TRACK OF NEARLY 1,500 IMMIGRANT
CHILDREN"; "20 TIMES JUSTIN AND HAILEY BIEBER
WERE GOALS." The mind-numbing headlines and terms
float around in my brain like a never-ending carousel. "AND
YOU'LL NEVER BELIEVE WHAT HAPPENED NEXT."
"THEY SAID I COULDN'T BE AN ACTRESS TURNED
DIRECTOR . . . THEY WERE WRONG." "CLAPS BACK
AT INSTA TROLLS AND WE ARE SO HERE FOR IT."
"A WHOLE FUCKING VIBE." "GETS CANDID." If only
I could force myself to throw up all of the words, usernames,
videos, tweets, and photos I just ingested, I could feel normal.
Bulimia for phone use.

It feels like the internet was built to desensitize us. Like
it's part of a bigger scheme to make even the most sensitive
among us tolerant of mass destruction and televised death so
we're more naturally able to cope with the world being de-
stroyed in front of our eyes. Humans can grow accustomed to
deteriorating situations as long as the principle of pleasure re-
mains. We're all Pavlovian dogs for little red hearts, no matter
how nightmarish the landscape in which those hearts appear.
Our mouths start watering at the sheer anticipation of digital
attention. Therefore, we have no choice but to desensitize
ourselves to its horrors in the name of the great dopamine
rush. And honestly, if the world is being destroyed in front of
my eyes regardless of how I feel about it, I'd rather be brain-
washed by my phone so I can handle it.

Going on your phone is easily the most effective way to dissociate and forget you're a person, which I am on a quest to do at all times, considering what I feel when I am in my own body. When I'm on it, I forget everything I'm doing, like how I accidentally drank the entire French press I made even though I'm also acutely sensitive to coffee and will now spend the rest of the day shaking. I've spent so much time on my phone and killed so many brain cells that if and when the end of the world hits, my only knowledge will be what I've extracted from social media. I imagine enduring the apocalypse with a few others on an island, each one of us bringing something to the table in order to survive, like in *Lost*. Or at least, I think like *Lost*; I didn't watch because I don't want to secondhand fend for survival on a remote island. Anyways, one of my fellow survivors will ask me to help make a fire or something, and I'll be like, *Yeah, no, I can't help with that, but do you want to know tips on boosting your self-esteem from nine famous models?*

We're all so addicted that if real life were a dystopian film, and the bad guys decided they were going to use iPhones to brainwash people and turn them into an army to destroy mankind, that army would consist of almost everyone. The scary thing is, life right now *is* that dystopian film. Our reality was taken over, only no one had to use force to control us — we turned ourselves over willingly to a pocket-size slot machine. Even when we're told that our phones come with incessant government surveillance and unknown psychological and

physiological damage, we're still like, *Nah, it's cool, as long as I get to look at memes.*

In totalitarian regimes, you're forced to look at a reality someone imposes on you. Our phones have recalibrated our behavior in a similar way; the internet tells us whom to hate, whom to like, what to be offended by, what to post, and what to say. Is it possible to keep track of your own opinions when someone writes something and then someone writes something about what that person just wrote and then people write things based on that thing and it ends with everyone collectively agreeing on Twitter what is right and wrong? No, because the internet is a shithole and nothing makes sense. What makes less sense is why I continue to subject myself to something that makes no sense when I thought I valued sense above all things. *Of course* my head is going to spin when I see an article about why Camila Cabello doesn't talk about her relationship with Shawn Mendes and then an interview with Shawn Mendes about why he's keeping his relationship with Camila Cabello private and then another article with quotes from both of them about why they don't talk about each other and then an article two weeks later titled "Camila Cabello Is Finally Ready to Talk About Shawn Mendes." Every time I go on my phone, I feel like I need to get a brain scan. *Why do you go on it, then, Cazzie?* you ask. Because I don't have a choice!!!

It's cliché to compare the addiction to drugs or nicotine, but the strength it sometimes takes to tear myself away from

my phone feels comparable. You can at least enjoy the self-destructive experience of drugs or ripping a cigarette. The phone is an addiction you get zero pleasure from. I hate my phone like it's a person made up of the same qualities: vapid, attention-seeking, narcissistic, codependent. I get so disappointed in myself for picking up my phone, it's as if I just threw away years of sobriety. *You stupid fucking cunt! I hate your guts! I can't believe you! AN HOUR?!* When I'm trying my absolute best to exit out of whatever app is sucking me in, I picture a version of myself on the phone finally freeing herself from its grip and tackling the version of myself that's forcing me to keep checking every app on loop. Fortunately, the only people who know how much time you spend on your phone are you and the person whose Instagram stories you accidentally check after they've been up for only two seconds. But if they saw your name that fast, then they're on it just as much, so you both have the same embarrassing little secret.

Our collective addiction seemingly comes from us turning to our phones to escape reality and our universal depression. It's like the chicken and the egg. Which came first, modern depression or social media? I pick up my phone subconsciously hoping for something that will make me feel good, but that thing doesn't exist. So I become depressed about whatever it is I saw on it, put it down, start feeling better, check it again, feel worse, want to die, do it again, try to go to sleep, am too affected to go to sleep, finally go to sleep, wake up, check it, rinse, repeat . . . repeat. The need for distraction from think-

ing about life or death is as old as time. People used to just *go outside!* And *play with sticks!* When you think about it, not much has changed since then, as I'm sure there's an app where you can play with sticks. We've just evolved with how distracted we can possibly make ourselves, which is weird, considering the biggest distraction we've ever made is what we most need to be distracted from.

I'm fairly certain that in the future, they'll talk about this era as an insane time where people had these things called phones. *They would hold them constantly and look at them every second they weren't doing anything else. They would sleep with them next to their heads at night. People would get in car accidents because they couldn't stop looking at them and no one could form sentences and then they all went blind from staring into the evil screens all day and died off from radiation poisoning before society even fully collapsed. The end.*

In the midst of writing about this, I need a distraction. I go on my phone and end up checking Bella Hadid's Instagram story — she's in Europe and she's wearing new glittery heels. I take solace in the fact that she was also obviously on her phone for a while in order to post multiple videos of her shoes. I refresh all of my apps one more time to see if anything new arose since I picked it up. Nothing there; didn't miss anything. Except for another seven minutes of my life. The thought encourages me to put my phone down, but I secretly hope someone will text me so I have an excuse to pick it back up and not be alone

with myself. My friend suddenly calls, and I grab for it. I put her on speaker so I can scroll while she talks, barely listening, like you do in class when you're picking up only enough to be able repeat the last word the teacher said in case she calls on you to ask if you've been paying attention.

They say youth is wasted on the young. But how wasted is it now that we've spent the entirety of it on our phones? We'll need a new adjective to describe it, it's so far beyond wasted.

When I die, I imagine God playing my life back for me.

Now, let's take a look at your life and the way you spent it . . .

Deceased me then gets comfortable on the couch, waiting to impress God with my good deeds. But those altruistic clips go by really fast, and then God's projector shows a montage of twenty-five thousand days of me scrolling through my phone. It doesn't even show the things I was looking at, it's just embarrassing footage of me on my phone: in bed, brushing my teeth hunched over the sink, in lines, during class, at my mother's future funeral.

The only thing scarier than spending my whole life checking my phone is not checking my phone. I have an irrational fear that I will miss something important, like an exposé written about me or my family that I need to see first so I can handle the situation. I have never felt the comfort of "If you have nothing to hide, you have nothing to fear." I live every day thinking the racist tweets I never wrote will surface and that my nonexistent sex tape is about to drop.

Checking my phone is something I have to do but don't

want to do, like driving. Similarly, I get overly angry at people's social media presences in a way that mirrors road rage. On a single drive, there are tons of people to be annoyed by on the road, and in your own hurry to get where you're going, you're oblivious to their problems and shortcomings and why they suck at driving on this particular day. Well, there are even more people to be annoyed by online, and they impede your vision and mental state more than any obnoxious Range Rover cutting in front of you ever could. You are SURROUNDED by people online, people none of us were ever meant to know about or see, and now you see them all the fucking time, achieving their dreams, as you live out your nightmare. Yes, some I seek out, but most are just *there, waiting for me to hate them:* the lifestyle bloggers talking about what was in the smoothie they made for breakfast, the "screenwriter" who posts stories of his final draft script open on his laptop, the European model who's all bones and long dresses eating one bite of spaghetti (the bite is documented), the Botoxed mom who thinks she knows how Instagram humor works, the people who talk about their every emotion, the bikini influencers, the guy who looks like a Chainsmoker (the musical duo, not Jessica Lange playing an angry Southern mom), the performative activist, the notes application poet, the girl whisper-singing one sentence in her bedroom pretending it's a full song, the famous person with a social media manager running their account, the famous person you wish had a social media manager running their account, the Facetuners who blur their faces until they look like im-

pressionist paintings, the person who is "so lucky," the actress who posts a photo of herself on set with the caption *Meet Sky* or *Your New Best Friends,* the nightclubber holding a massive bottle of Grey Goose. It's like the Myers-Briggs personality types; there are only sixteen Instagram personalities. I don't know any of their real-life struggles, and they've never done anything to me, but I will still metaphorically roll down my window and flip them off as I pass them by, usually in the form of an impassioned speech to my friends about why this person who I do not know is inauthentic. I can even become upset by some of my friends' posts, because everyone on social media is a fraud trying to get someone to see a particular quality in them. Everyone must find a way to display every single one of their physical characteristics, and all aspects of their complex but appealing personalities. It's all thirst traps next to ironic street signs to show hot and funny simultaneously, and childhood pics that scream *I have always been good-looking.* Selfies to prove she has the face of a little tiny baby on the body of a porn star. Our intentions are so obvious we might as well make them the captions — come to think of it, I've actually seen that done and it just comes off as *wanting to be seen as quirky.* And under no circumstances can you sync up a sensitive real-life personality with an authentic sensitive online persona without sounding like a whiny bitch: "My heart/watery eyes emoji." The only things the internet accepts are beauty, sensationalism, and irony.

It's impossible for a hypersensitive person, let alone a nor-

mal person, not to be affected by the people we're subjected to online. Particularly those who are rewarded for their exhibitionism, consumerism, and stupidity with the accumulation of capital and, thus, power. They're called influencers for a reason. Their existence hinges on their ability to infect others with their logic of superficiality. Unsurprisingly, these people also tend to be the most insensitive among us: narcissists, basics, and bullies.

Narcissists and basics succeed online because they are willing to subjugate their personalities to this technological social hegemony via groupthink and trend following. The internet is an enormous pressure cooker for conformity. Everyone uses the same memes, trendy filters, captions, and aesthetics; everyone makes the same TikToks and wears the same clothes. Innovation is basically dead these days. And if it's not, you don't know where a good idea came from. A thought-provoking concept that would normally take time, nurturing, and years of effort is copy-and-pasted into one post, zooming past the entire artistic process. Chances are what you are looking at is not the original but one of the many thousand copies that float the internet, and no one cares that they're looking at an imitation of an imitation. We're okay with that reality, accept it as such. Social media was able to normalize something as abnormal as changing the appearance of your face in less than two years. All it took was one hot girl posting one hot selfie where her lips looked huge, and *boom*, we woke up one day and everyone had lip injections. That girl was an

innovator herself! So sad. We don't even know who she was. (It's Kylie Jenner.)

Bullies are particularly well positioned to succeed in this era, as they are in all periods of human history, because they prioritize their own success and survival above any moral imperatives, and now they can use the herd-like nature of social media to their advantage, ganging up on their victims by the thousands, if not *millions*. The bullies of the internet strike quickly and with massive swords, bringing "receipts" to their loyal army of minions and leading them to destroy their enemies with unfollows or complete cancellations.

Everyone has one story, if not many, of being bullied when they were younger, even the insensies. You never forget the name of the person, or their face, or the awful thing they said to you. Getting insulted is for life, like a tattoo. Middle school was a hell for every one of us, and luckily the internet has made it so we can feel exactly how we did then every day, forever.

When I was in seventh grade and people in tech were still figuring out the most effective way for everyone to cyberbully each other, we had this app on Facebook called Honesty Box. On it, you could anonymously write anything to anyone you wanted. It was a psychotic feature that our susceptible generation was somehow allowed to have. Someone once wrote to me that I looked like Olive Oyl from *Popeye*. I looked Olive Oyl up, and it stunned me how accurate this was. It has stuck with me ever since, to the point where it's

still the first thing I make sure I don't look like before posting a photo.

A few years later, Honesty Box was replaced with Formspring, a website where, if you decided to take part, people could post anonymous questions to you. Instead of it being private among you, the anonymous cyberbully, and your memory, like Honesty Box was, Formspring questions and answers were placed on a public wall, cataloged so everyone could see all of the horrible things people wanted to ask or tell you. Someone was kind enough to write on my wall that my boyfriend at the time cheated on me. If you're reading this, I guess thanks for telling me?

Today, we consistently hear offensive and unwanted personal judgments from strangers, but they are no longer anonymous. People don't need anonymity because no one gives a shit about anything anymore. And they don't need to. Making heinous comments on the internet is all in the line of duty for the dopamine rush. It's like cheating on your girlfriend or quitting a bad job. You know there's a risk, but the reward could be worth it. And as long as your comments fall within the realm of popular opinion, the risk is minimized, and the reward is maximized.

The people who chose to have Formspring were, in essence, asking for criticism, just by virtue of having it. But even the most sensitive among us can't opt out of social media (without sacrificing socialization). There's no other way to prove you exist. Truthfully, though, *everyone* hates social

media. Everyone complains about it, everyone thinks they get bullied on it, and everyone participates in it. The internet makes us all feel like pieces of garbage floating in a virtual garbage world. It is a place that confirms our collective lack of integrity, sedates our critical mind, and weakens our ability to make good art because making something meaningful requires time and standing against mass culture.

When it first arose, social media seemed like a path to a better world; freedom of speech could spread to all parts of the globe, we could create movements that will change the world (this was true), and no one will use it to sway an election, we naively thought. But as it turns out, it was just the nail in the coffin of decency, democracy, and innovation. The powers that be have always wanted human beings to think like sheep, to be unfazed by or blind to destruction and evil so others can continue to accumulate even more power and money while destroying the planet and entrenching people in poverty. The internet exacerbates the worst instincts of the dominant people in society and makes mindless drones out of the submissives, with the convenient result that we may all be too red-eyed and hunchbacked to face up to the great injustices that are happening all around us.

The only alternative is to be a real radical, which entails understanding the game, being unwilling to play the game, and condemning the game. It takes an extremely strong-willed person to do that, which I clearly am not. No one wants to be alone. We all want a community, which is how our virtual one

got so big in the first place. Social media won't have a true challenger until a counterculture emerges, one where productive and fruitful people can join and belong. The movement will of course need a leader. A new dictatorship of sorts, led by a benevolent ruler, a self-care tyrant who takes social media away and leaves us alone with ourselves.

Any volunteers? Because I'm too busy checking my phone.

Ex Dysmorphia (Insecurity When You're the Ex-Girlfriend)

Cazzie's self-esteem is extremely low, and she is confused and uncertain about her identity. She is unusually introspective and tends to focus on her negative qualities, which may precipitate guilty rumination and contribute to depression.

— *Excerpt from neuropsychological evaluation of Cazzie David, 2007*

THE INSECURITY YOU EXPERIENCE when an ex-boyfriend or long-term fling is with someone new feels kind of like taking acid. Everything you once felt about yourself has shifted. Your arms suddenly look different, your eyes, your hair, your nose, your jokes, your body, your voice, your day-to-day life, your family, your skin. Every detail you find out about this new girl changes everything you once knew about yourself.

The things you liked about yourself you now question, and the things you thought you hated in other people you're no longer sure you do. You acquire a newfound nonchemical imbalance where you no longer know who you are or what is what.

When a guy I had been seeing on and off for years — one of those situations where you think the timing hasn't been right because it's a "long game" that will maybe end in marriage — got a new girlfriend, I began to tell myself the same tale I always do when I become obsessively insecure. The story goes like this: "This person prefers every quality this girl has over the ones you have, or he would be with you and not her." And why wouldn't I think that? He is with her and not me! People will say, "Cazzie, you can't compare yourself to other people!!!" To which I say: "Watch me." And then watch how fucking insane I am when I do it. I will compare every follicle on our heads until we both become unrecognizable beings defined only by our extreme polarities. She is put on a pedestal, exactly where I imagine she is in his mind, except the pedestal in *my* mind is much higher than it is in his. And where am I now, the girl he used to be with? Well, I'm nowhere in his mind, which is still a better place to be than where I am now in my own mind: morphed into a scary, decaying Disney witch, a caricature with bulging eyes, a giant nose, and huge ears like a Nazi propaganda image. Until something or someone pulls me out of it, I possess the face of Dobby and the personality of Squidward. Or the face of Squidward and the personality of Dobby.

The girl my pseudo ex is now with is blond; obviously, I reasoned, this was something he must have always preferred. He was just trying out dark hair, seeing if he could grow to appreciate it. I generally liked my hair, at least when it was done — until I saw hers. This girl's hair is like a Pantene commercial. When she throws her hair up in an effortless bun, it looks like wedding-hair inspiration on Pinterest. I asked myself, *Would you rather be in a pitch-black room or on a sunny island?* As that is the stark difference between our hair and, most likely, our personalities.

This girl emanates brightness and joy. On her birthday, her friends write things like *You are a ray of sunshine. Every time you enter a room it gets brighter.* When I enter a room, people feel like a negative spirit is lingering, but then they see it's me and they're like, "Oh, thank God, it's just Cazzie." I'm pretty sure people sage their homes after I leave.

Another aspect of her sunshine-y energy is her perfect smile. Her smile makes others smile — except for me; it definitely does not make me smile. You can tell from her smile that she's silly and cute and that he once said to her, "You know what my favorite thing about you is?"

"What?" she said, smiling.

"Your smile." And she of course smiled again, and he kissed her real hard and then twice more on each crease of her mouth for blessing him with that perfect smile.

When I'm smiling, you can tell it's unnatural and that I've done it only a few times. I'm an inexperienced smiler for two reasons: one, I don't have a good smile, and two, there are

rarely ever things to smile about. I do have good teeth, I can admit that, but having good teeth and having a good smile are completely different. A good smile can trick just about anyone into believing that your beauty is coming from within, even if you're an awful brat. It is a beaming light that gives off the illusion that your goodness is glowing straight from your soul and out through your face. Good teeth, however, you can buy. They're always scary-looking, but you can.

The new girl's Instagram is kind of shitty, and it makes me feel like mine is trying too hard. It's cooler to be bad at Instagram; it means she's better in person because she doesn't take time out of her life to think about her aesthetic. That's probably why he likes her so much — because she isn't a shallow moron. It's clear she doesn't edit her photos, which means every photo she posts is exactly how she looks in real life. She doesn't even need to edit. I need high-level editing skills. I need my friend who is amazing at editing to edit for me. I noticed she opts for short and succinct captions like a row of sun emojis, which makes it hard to gauge her intelligence. Although, after some light stalking, I found one remotely clever tweet and it convinced me she's funnier than I am, but a funny you want to be around, not a funny like me, where you realize you're only laughing at my misery.

I discovered that she has an eclectic mix of skills, all of which will surely be very appreciated in her new relationship. I know he will appreciate her various talents because I know him and I know me, and now I know her. While, sure, I can surf (I can't) and do yoga (no), I obviously don't do it well or

I'd also be showing it off on the internet. You can tell what people are good at based on their feed, which I guess is why mine is filled with photos of me in bed smoking weed. Her skills may have to do with her being gentile, which means she probably has little to no anxiety. That must be really nice for her and refreshing for him. She's able to be present and notice everything around her, to say things like "Look at those trees, they're so beautiful." Whereas I'd say, "What if one of these trees falls on top of me and kills me?"

There is no question about it — this girl is definitely *fun*. There are videos of her dancing and being cute, which she can do because she has perfect hair and that contagious smile. Great hair + smile = you can do embarrassing shit and get away with it. All you have to do is flip your hair or smile and it's fine. You know those videos hot people post of themselves where they move their body and face around in different angles with no point or explanation? Where they're just admiring their own selves in some creepy 360-degree hotness confirmation? The videos that seem to lack any self-awareness and are cringeworthy, but then all of a sudden, right at the end of it, the hot person breaks out into a laugh and you think, *Never mind, I guess that wasn't completely obscene like I thought it was?* His new girlfriend gets away with *that*.

She's a dream wedding date. She'll dance with you, dance with kids she doesn't know, laugh, smile, take shots but not get out of control. I'm the anti–wedding date. I refuse to dance to most music but wedding-DJ music is at the top of the list, and nothing would make me laugh because everyone would be ei-

ther annoying me or making me feel stupid (it's always one or the other). You would introduce me to people and be amazed by how I can make the simple act of introducing myself into such an uncomfortable situation.

But she would be an even more fun concert date. I once went on a concert date and refused to stand up. That's right — I was the only person seated in the stadium. My poor date was standing ALONE. I think I'm choosing the less embarrassing option in the moment, but whatever I end up doing always ends up being more embarrassing in retrospect. Sitting was obviously more noticeable. No one would have noticed me if I'd stood and swayed. *Just leave your body and sway! Forget who you are!* I tried to tell myself. Anyways, that guy and I don't talk anymore. He'll forever remember me, though, as the girl who wouldn't stand. But THIS girl at a concert!?! Don't even get me started. She's so confident, she's *professionally* swaying. He would even be able to take a video of her swaying because she'd be doing it for so long and look so natural doing it. And you know once she realized he was filming her she'd come up to the camera and stick her tongue out and it would be actually cute. Being cute in a guy's video means so much more because you know for a fact she didn't ask for a redo like she could have if it were a friend.

I know she looks a lot better coming out of the water than me because I just looked at photos of her coming out of water. She's one of those people who, when her hair is sopping wet and slicked back, it doesn't change her face. Honestly, five days ago I thought I was a pretty solid ocean girl. But after

seeing her post-ocean, I now know that was a lie I told myself. She is so ocean, you could push her in the water and instead of freaking out, she'd laugh and pull you in with her, and then right as you popped your head back up, she'd dunk you back in again. Dolphins would swim by in an otherwise dolphin-less body of water, a rare sighting that still wouldn't take away from the vision that is the ocean girl herself.

A few months later, I found out that they'd broken up, and so the perfect blonde was taken off the pedestal. I never thought about her again and regretted every moment I'd spent obsessing over someone who clearly wasn't the girl of his dreams. But the next girl definitely was. A brunette with beautiful curls — Spanish curls, not Jewish curls. Thick, straight, blond locks would be forever meaningless to me now, since they were obviously meaningless to him. It was clear that this new girl was *actually* his dream wedding and concert date, not because she looked hot dancing but because she didn't at all and yet she didn't care. It was cuter that she wasn't coordinated. What kind of unlovable freak was I to be able to hit a softball perfectly? Everyone loves a clumsy girl! They're adorable! She was the epitome of the you're-not-like-most-girls girl. (Even though there are so many of those girls that they *are* like most girls.) But she also didn't end up lasting for long, which was unfortunate, again taking into account the amount of time I spent obsessing over her. You know what they say about the definition of insanity.

Then we saw each other, and I didn't have to think about

anyone. Until the next girl, and then the one after that, and so my ex dysmorphia continued to morph. I'd thought him being with someone who was artsy would make me feel worse than him being with a sorority girl until he was with both and they consumed me equally for different reasons. The city slicker who used her oven as shoe storage was just as wifey material as the farm girl who made sourdough. Even the girl I found mindless was just as threatening as the one I considered smart.

I eventually came to two conclusions. The first was that it always hurts when someone you felt deeply for likes someone new or chooses someone else over you. It hurts worse than it should because you know he doesn't deserve your hurt and yet he still has it. It never mattered what these other girls looked like or seemed to be like. It's just that they weren't me.

The second: My eyebrows were better than all of theirs. No question.

Almost Pretty

I REALIZED I WASN'T pretty when I was in second grade. My ears were so big, it was the first thing people noticed about me, even before noticing I was a girl. My grandma used to tape them back every time she visited, which would make my mother cry, but was fair considering they were almost as big as my head. So basically I had three heads. Nicknames were obvious: Dumbo and Elf Ears. There were no nicknames for the pretty girls. What would they be? "Pretty Girl"? In seventh grade, I was actually stoked when I found out I was number 42 on the boys' hot list because I thought for sure I would be farther down. In addition to the big ears, I was also much too skinny; collectively, the bones, ears, sad eyes, and the fact that my personality rarely allowed me to muster a smile made me resemble a child from the Depression era.

If there were just a couple of things about my face that were a tad different, I could be pretty, but I'm not. Instead, I'm almost pretty. I'm not complaining. I'm incredibly grateful and

lucky to be almost pretty. Not as grateful and lucky as I would be if I were full pretty, but more grateful and lucky than if I were not pretty at all. Let me explain. There are many differences between being pretty and almost pretty, and if you're not sure which one you are, then you're probably pretty. But in case you don't know, here is how you can tell.

PRETTY

• You look the same from every side and angle. You never look like a different person. You have one face.

• When strangers walk by you on the street they think to themselves, *Oh, wow, that girl is really pretty.*

ALMOST PRETTY

• You look like a different person from every angle. There is only one specific angle where you can trick people into thinking you're pretty, but if you move even an inch to the left, right, up, or down, the truth will be uncovered. You have multiple faces. You show only one of these faces on Instagram.

• When strangers walk by you on the street they think nothing, because it's a normal occurrence for them to walk by people who aren't exceptionally pretty.

PRETTY

- Regardless of what your personality is, it makes no dent in your prettiness.

- You look Facetuned IRL and possibly have had work done. If you had to get surgery to be pretty, it seemingly does not take away from your prettiness. Similar to when people convert to Judaism — they are thereafter considered Jewish.

- If you mention to your friends that you want to get filler or some work done on your face, you will be met with outrage.

ALMOST PRETTY

- If you have an amazing, magnetic personality it can bump you up to being regular ol' pretty. But if your personality is bad it can knock you down to not pretty at all.

- No one will wonder whether you've had work done or not because it's obvious you haven't. The best way to describe your looks is a "natural disaster." You fit in better with celebs' "before" pictures.

- If you mention to your friends that you want to get some work done on your face, you will be met with support or even suggestions like "I bet you could get a noninvasive nose job?" when you've never mentioned a problem with your nose to them ever.

PRETTY

- You look like a porcelain doll.

- You can't really make jokes. In fact, you may have never made a joke in your life. You especially can't make jokes about your appearance. If you were somehow able to come up with one, no one would laugh; instead, they'd say, "You can't make jokes like that because you're actually pretty."

- You have a variety of cool outfits and multiple pairs of sunglasses.

ALMOST PRETTY

- You look like a porcelain doll that something went a little bit wrong with in the factory process. Therefore you don't look like the other porcelain dolls and they'll have to toss you out.

- You have a great sense of humor. You've been joking as long as you can remember and can make as many jokes as you'd like about your appearance and people will always laugh.

- You have a variety of pajamas with bloodstains on them and a retainer.

PRETTY

• When you get your makeup and hair done for a special occasion, no one is surprised by your appearance — yes, you look fantastic, but you look the same as you normally do.

• You can put your hair up in a bun at any time or place. Your buns are effortless. No one can decide which they prefer you with, a bun or no bun.

• You are a pretty girl no matter where you are.

ALMOST PRETTY

• When you get your makeup and hair done for a special occasion, people are shocked by how different you look. In a good way. Because you look so good for you. If that's a good thing.

• When you put your hair up there is nothing to distract from your face. A bun on you tends to make it look like you've had a really long, tough day and are maybe a mother of three. You look like you were dealing with three toddlers all day.

• You are a pretty girl at law school or with camp goggles. But the prettiest girls at camp were still the ones with the effortless buns.

PRETTY

• When you start dating
a new guy, you can wake
up in the morning and
not stress about what you
look like.

• When you look in the
mirror after making out
with someone for an hour,
your hair is probably a little
tousled.

• You can get a good
Instagram of yourself any
given day of the week.

• You look pretty no matter
who you're surrounded by.

ALMOST PRETTY

• When you start dating
a new guy, you must set
an internal alarm clock to
wake up before him so your
ugly face can adjust back
to normal as your body
continues resting.

• When you look in the
mirror after making out with
someone for an hour, you
look like Harley Quinn in a
DUI mugshot.

• You can get a good
Instagram of yourself at most
once a month. You can get
more than that only if you
make a huge effort and the
entire thing is planned.

• If you're around multiple
pretty girls, you will look
pretty. If you're around
multiple unattractive people
you will morph into being
unattractive.

PRETTY

- You're Instagram-hot.

- You can pick up a FaceTime call any hour of the day. You don't look amazing — no one looks amazing — but fine in the front-facing camera.

- When you're on FaceTime with your friend and her mean little brother walks by he says nothing.

- If you make one of your photos black-and-white, it will look cool and indie.

- Sometimes if you're full pretty, you're not beautiful.

ALMOST PRETTY

- You'd look hot in a drawing or painting. But if someone were to make a caricature of you it would be hideous.

- Whether or not you answer a FaceTime call depends on the lighting of the room you are in, and even if it's flattering, you still show only half your face to the camera.

- When you're on FaceTime with your friend and her mean little brother walks by he says, "Whoa, I thought you were the girl from *The Ring*."

- If you make one of your photos black-and-white, it will look like it's a photograph of a pre–World War II immigrant on Ellis Island.

- Almost pretty people are almost always beautiful.

Is Everything Gonna Be Fine?

Her fits of pique may be an effort to capture the attention of her parents, who she feels are too involved with their own needs and own lives. Ironically, in doing so, Cazzie becomes another member of the family who is invested in her own experience at the expense of others. There is an aggressive component to this manner of interaction, for which Cazzie pays with anxiety, as imbuing the environment with aggression leads her to anticipate potential retribution for these actions. The darkened house, the dangerous outside world, and other aspects of her environment consequently become persecutory.

— Excerpt from neuropsychological evaluation of
Cazzie David, 2007

I KNOW FOR A fact the saying "God doesn't give you anything you can't handle" isn't true because if it were, then God would not have made me a person. Every day I cannot for

the life of me believe that I'm a human. It must have been a grave mistake; I figure I was simply a contented soul or spirit floating in the beautiful, tranquil place where souls or spirits reside and then I accidentally fell down some kind of wormhole and got trapped inside a body. I imagine it happened in a similar fashion to how Nemo of *Finding Nemo* was captured by deep-sea divers and ended up in a dentist's fish tank. The panic that Nemo felt when he realized he was trapped in a fish tank forever is the way I feel when I wake up every morning and remember that I'm stuck inside a human body.

I wish that as a fetus, you were given the choice. You'd be shown an introductory video to life on earth, like a commercial for a medication that lists all the side effects. It'd go: "The things that can happen to you in life are nausea, rape, murder, cancer, UTIs, watching your family and dogs die, natural disasters, witnessing criminal injustice, disease, texting the same selfie you sent to your crush eight months ago for a second time."

Then a God-like figure would appear and ask the fetus: "Would you like to live?" Personally, I would be like, *Yeah, you know what . . . that doesn't sound like it's for me. I appreciate the opportunity of life, but give it to the next person.* Although I'm sure if a mentally stable fetus was offered my life, it would take it in a heartbeat.

I don't think it's a coincidence that I'm just as afraid of living as I am lucky to lead the life that I do. It's a privilege to think about the human condition so much, to be able to be scared because you have nothing real to pay attention to

other than your own guilt for thinking about all of the things you know are happening to other people every day. My mom will yell at me, "Just be grateful, Cazzie!" And I'll yell back, "Of course I'm grateful! If anything, I'm so grateful it makes me miserable!"

The first time I realized the terrifying truth about being a person in this world was when I was four and I choked on kale. To answer the immediate follow-up question: Did people even know about kale in the 1990s? Yes, my mother seemed to have, because I nearly died from choking on it. Fortunately, the irony of the world's healthiest leaf almost killing me continues to sum up my life.

The incident occurred at one of my mom's infamous family dinners, this one a tradition called "Taco Tuesday" even though it regularly took place on other nights of the week (and was thus renamed Taco Monday, Taco Wednesday, or Taco Thursday). Suddenly, my face was purple and my panicked mother was giving me the Heimlich maneuver, but it wasn't working. I was then passed around like a hot potato for other people to also try the Heimlich, but not in a fun way where everyone just wants to see if they can be the ones to do it but in the way where if someone couldn't do it, there would be a dead child. In a final attempt, complemented by a background score of screams, my friend's nanny reached her fingers down my throat and pulled out the leaf that was trying to end my life. Apparently you're not supposed to do that when someone's choking or it can push the item down even farther, but I'm glad she did, even if it did interrupt what was

likely God's messy attempt to return me back to being only a soul. So I was "saved," I guess, but it was also the moment where the first of my many debilitating fears took root. Eating: something I must do to survive but that can also kill me. What to do?

Not eat, my young self reasoned. I was like Gandhi on a hunger strike, but instead of protesting colonialism, I was protesting the cruelty of a world where choking was possible. My mom tried just about everything to get me to eat. Every day, the principal of my preschool would come into my classroom at nap time and gesture for me to join her in her office. There, she would offer me peanut butter and doughnuts. At the time, I was a bit unclear as to why she was doing this. Why was I getting such special treatment? Why was I the only one allowed to eat doughnuts instead of taking a nap? Was I a princess? Was she a creep? As it turned out, since I had been refusing to eat — because if you eat you might die — my mother had asked the principal to try to persuade me to eat. According to my mom, I caused her to age a decade during this time. "Can you imagine your child refusing to eat food?" she asked. "Could you think of anything worse?" Genocide. Your child not eating because you can't afford food. Thin smoothies. But I agree it wasn't an ideal situation.

From that point on, everything I learned about (in order: vomiting, whooping cough, ghosts, amputations, the fact that I have a skull) terrified me. And when you're five years old, you have the whole world to learn about or, in my case, fear. The same year I learned that you can die from eating, I

heard about a sickness going around called the chicken pox. Chicken!? Pox!? What in God's name was a pox?! And what in the fuck did it have to do with chickens? After hysterically interrogating everyone I knew about this pox, I learned that they are ITCHY SPOTS that take over YOUR WHOLE BODY and you're not allowed to scratch them NO MATTER WHAT or they stay FOREVER.

After that, I refused to leave my room, fearful I'd contract the vicious pox right outside my door. My parents, trying to reassure me, said, "If you get the shot, you can't get the pox!"

And that's when I learned what shots were. Given that I was scared of everything, the idea of a needle painfully piercing through layers of my skin and injecting something into my bloodstream was going on the list. I cried and begged my parents to promise me (1) I would never get chicken pox, and (2) I would never have to get a shot. I couldn't determine which was scarier, the sickness or the shot. No amount of comfort (or logic) could console me. Without the shot, pox. To stay free from pox, a shot. I went around and around in my five-year-old head, making myself sick. And I was only getting started.

Due to my growing anxieties, my parents couldn't experience any of the exciting things that come along with having a child. Their kid's first Halloween! What a fun time! Nope, terrified. First haircut? Cried hysterically. First time in a pool? Learned about drowning. The beach? Fish phobia. First time at the movies? My dad took me to see *Shrek*; what could possibly go wrong? It ruined all of our lives for months. Every sundown, I was petrified I would turn into an ogre. Even as days

passed and I remained a human, I was convinced becoming an ogre was my fate. I'd sob and beg my parents to promise I wasn't going to turn into an ogre, which, in theory, was a much easier promise for them to make than the others, but still, I didn't believe their reassurances. Turning into an ogre didn't feel that far out of the realm of possibility, considering everything else I was finding out about.

I can't help but resent my parents a little for not thinking more seriously about what a mixture of their DNA could create in a child. They must have known I'd be their Frankenstein, a toxic combination of every anxiety one might inherit. Before having kids, they should have had to go in front of a board and be interviewed for hours. By the end of the assessment, the committee would surely have said, *I'm sorry, but you two are not a couple whose genetics we can allow to blend. Your DNA together is combustible. If both of you were to find different spouses and come back, I'm sure we can allow you to have children, but certainly not together.*

My father concentrates his neuroses around health and sickness. He's gotten himself injected with stem cells and vitamins so he can have a superior immune system. He's experimented with every heath innovation there is and has bought every medical invention available. His basement looks like a hospital lab. My mother, however, looks outward; she focuses on every kind of danger and global catastrophe that might befall people and the planet. She believes my lifetime of unease can be attributed to her being eight months pregnant with me during the 1994 California earthquake, but just having

lunch with my mom can give an enlightened person an anxiety disorder. My mother is like a robot who can do nothing but speak of what terrible things might happen, will happen, or are already happening. She will see me breathe and inform me that "ninety-five percent of the air we inhale is polluted." I'm always tempted to scream, *Mom, what am I supposed to do with that information!?!* But I don't, because she'll respond with something just as useless like "Get every young person to vote!"

My mother is the definition of a doomsayer, yet she believes she has had no impact on my obsessive negative thoughts whatsoever. In fact, she believes she is a comforting source of information. Which, if you don't actually listen to the words she's saying, she perhaps could be. Her tone is often nice and soothing, but the content is always unsettling. Kind of like a backhanded compliment.

"Did you hear about the *E. coli* outbreak?" my sister asked one day.

"No, what? Is it contagious? What is it? What happened? What?" I responded.

"It's everywhere. People have gotten it from Starbucks, even."

"Change the subject, girls! Positive thoughts! You have a higher chance of being raped at a party than getting *E. coli!*"

See what I mean? She's like an alien monster in an action movie who sucks up other people's energy for more power, except that instead of energy, she sucks up information and then uses it solely to make me more fearful. She keeps a baseball

bat next to her bed "just in case." (Intruders, burglars, thieves — one never knows.) And after Bush won the presidential election in 2000, she stayed in bed for weeks crying, "It's over! The world is ending!" as my dad paced in circles around her, wondering aloud which diet would help you live the longest, vegan, paleo, or antifungal.

Alas, my parents didn't ask to be alive either, which is probably why they had children — the usual desperate attempt to find meaning and happiness. According to the many adults I've asked, one of the only good things in life is being a parent. I assume it's because you get to create a person (like Build-A-Bear, but it's a person!). A cutting-edge anxiety pet that's obliged to keep you company the rest of the way, to be there for you once *your* parents die and you're sad and old and everything is going to shit. The ultimate insurance policy against loneliness and a sad death.

I never understood people advising others by saying "it's okay not to feel good all the time!" Who ever said that wasn't okay? Who is so okay to the point where they need to be reminded that it's okay when they don't feel okay?! When people "reveal" they "get really bad anxiety," I'm dumbfounded, because I've never not been anxious long enough to "get" anxiety. It doesn't leave. Not ever. You know when you're wondering where your friend is and then you check your Find My Friends and see they're at home so you think to yourself, *Oh, they're at home, so they're just chilling?* I am never chilling. Not when I'm at home. Not when I'm tucked in bed. Not

when I'm in an aromatherapy bath surrounded by candles. I've never gotten excited that a weekend is approaching, because it's just one more week closer to whatever inevitable cancer is waiting for me. My permanent state of being is that time your boyfriend hid behind a door when you didn't know he was home and jumped out and scared you. Panicked to the point where your bones are rattling in your body so fast you can't feel them vibrate.

There's no other way to be when the world is a twenty-four-hour-a-day minefield of possible dangers and pitfalls, and at any point you might mysteriously suffer from something crazy and die. People say you can never be too careful, but that's not true because I am. I don't sit for too long, so I don't have a high risk of dying from cardiovascular disease. I never eat sugary cereal anymore even though it was probably the only thing that ever brought me joy. I sometimes wear a magnet in my pocket to deflect rays from technology. Anytime I enter any room or building, the first thing I do is clock the exits and figure out an escape plan for multiple scenarios. My first thought when I hear a plane overhead is that it's about to fall on top of me. When I hear a faint whistle, I assume it's a code between two people to move ahead with their plan to kidnap me. Every time I walk down a flight of stairs I picture myself at the bottom of them with my head cracked open, which encourages me to walk in slow motion down each one. When I go to take a shower, I have a twenty-minute debate in my mind: Do I lock the bathroom door and risk keeping someone from saving me if I fall and hit my head? Or do I leave it open

and risk an intruder coming in to rape and murder me? Or what if it's locked and I can't tell there's a fire and I burn to death? I live every day like I'm dying, but not in the fun way where you live life to the fullest; in the miserable way where you live it to the emptiest.

For years, I believed my unruly catastrophic imagination was protecting me, which is why I never fully addressed my generalized, social, panic, phobia, and panphobic (fearing everything) anxiety disorders beyond therapy and one try at Zoloft. What could possibly be done to change the inevitabilities associated with being alive, choking, privilege, and my DNA? I planned to continue living like this until death, even after my friends held an intervention where they informed me they were no longer going to be able to indulge my Is Everything Gonna Be Fine? days.

"What's an Is Everything Gonna Be Fine? day?" I asked.

They explained they are full days where I relentlessly ask them, "Is everything gonna be fine?" without really listening to their promises that everything was going to be fine. I didn't realize that I did that, let alone that my Is Everything Gonna Be Fine? days had become, well, every day. But I could go on without my friends' reassurance, I decided. I'd reassure myself if no one else would, all I'd have to do is repeat a 24/7 mantra of *I am alive and it is fine. I am alive and it is fine. Yes, you have fingers, and that's fine; you don't need to freak out at the idea of having fingers. You are a human with thoughts and it doesn't matter that there is no explanation of how we can think things and hear them and that absolutely nothing about being*

a person makes sense. You are fine to just walk around not understanding anything. You will get sick someday and you will die. Yes, all of that is fine.

The only thing that ended up convincing me to seek more serious help was my mother telling me my negative thoughts would cause ulcers and cancer, and so my biggest fear became my own personality. When you're as scared as I am, it's a dark day when you realize your own mind can kill you. I added phobophobic (fear of having phobias) to the list and signed up for an intensive psychological treatment program.

My mother was thrilled. Maybe too thrilled. She was the reason I'd been in therapy since I was five years old; she strongly believed that I should be on medication and that if I wasn't, my brain would implode. My father, however, had always believed therapy was a complete waste of time and that medication would destroy my brain. Anytime I tried to talk to him about my mental instability, he said the same thing:

"You're lucky you're unstable! Embrace your instability! You don't want to change one thing about yourself! That's your mind!"

Then again, my dad thought all you needed to do to cure depression was take a shower.

"What if I've already taken a shower?" I'd ask.

"Then take another."

"What about a bath?"

"No, baths are too contemplative."

I managed to get his blessing when it occurred to him that

going could make for promising "material," and I entered the program the summer of 2014.

The first thing I noticed about Joanne, the main psychologist I would see for three hours each day, was that she carried a Céline bag, which made me feel stupid and guilty for how much my parents were probably wasting on this pricey stint in anxiety camp. The next thing I picked up on was Joanne's therapy dog. He was impossible not to notice because he was a French bulldog, and they are constantly struggling to breathe. Why they were created, let alone why someone would buy one and keep the bulldog industry alive, is beyond me. Bulldogs aren't happy. They can barely move around and have severe respiratory issues. Also "They're so ugly they're cute!" is not really a concept I understand. If I had been given the choice as a fetus, I would have volunteered myself for the disaster that is life if it meant sparing the existence of bulldogs everywhere.

After I gave Joanne my simple explanation for why I entered the program ("I can't believe I'm a person. I don't want to be a person. Why am I a person? What is a person? How do I accept that I am walking skin, blood, cells, and bones? I don't know how to be a person knowing I will get cancer one day or have to get surgery. I don't know how to be a person knowing everyone else has cancer or has to get surgery. I can't be a person knowing I will grow old and die. Or not grow old and just die. I wish I had never been born so I wouldn't have to die or grow old"), Joanne decided the solution was to give me a series of exercises designed to help rewire my brain so I would stop living in the future and be in the present.

"There is no way to be happy if you dwell on things you have no control over," she said.

"Happiness is really not a priority for me. It's, like, last on my list. Who cares about being happy? I find that insane."

"What is a priority for you?"

"Not aging. Not ever going to a hospital. Not being a person. Stuff like that."

I could see she was already on the brink of exhaustion.

One full hour a day was spent brain-spotting. This involved me staring at a blank wall and thinking about one of my worst fears while Joanne alternated between playing classical/calming music and what I can only assume was the soundtrack from *The Shining*. In those moments, I thought about my phobias in what looked like a bat mitzvah montage, but instead of embarrassing pictures lovingly curated by my mother of my friends and me with braces, they were nightmarish flash images that could only have been put together by Lucifer. Seizures, fevers, time passing, anesthesia, blood clots, blindness, cancer, cancer, cancer, cancer, cancer, MS, Alzheimer's, that dead mouse I accidentally stepped on barefoot when I was seven, my body, toxic shock syndrome, vomiting, my body, heart attacks, knowing what happened to Otto Warmbier, knowing what happened to anyone, animals suffering, children dying, me dying, anyone dying, everyone dying.

After a few minutes, Joanne turned off the music and asked, "How did the calming music make you feel when thinking about your fears?" with the kind of fake expectant look on her face that you see on every therapist in every television show.

"Obviously, more calm," I said.

She nodded, jotted a note on her clipboard. "And how did the intense music make you feel?"

"Obviously, less calm."

"Interesting."

I did not think this was interesting. Therapy can be truly worthless if you have a low threshold for bullshit. I couldn't help but express my frustration with the blatant obviousness of her experiment. So Joanne tried to explain it to me in a way that would override my skepticism but every time she got to "the neurotransmi —" I stopped paying attention. It's hard enough to listen to scientific explanations generally, even more so when there is a dog gasping for air in the room.

After wasting time with Joanne every morning, I'd go to neurofeedback, where I'd sit in a chair in front of a TV that played a prerecorded video game with sensors attached to different parts of my scalp. This, I didn't even care to understand. After neurofeedback, there was "inner-child therapy," which I desperately tried to get out of based on the name alone, but it was mandatory, I guess. Fortunately, the instructor, Mandy, looked like a chubbier Monica Lewinsky, so I was able to tolerate her because I love Monica Lewinsky — her TED Talk is a must-see. In this course, you'd "go on a journey through your mind" and talk to the child version of yourself. In my case, I was instructed to tell my young self not to be afraid, which sounds easy but was actually the most difficult thing I'd ever had to do because it was the stupidest thing I'd

ever had to do. Mandy ignored my groaning and eye rolling and eased me into my childhood bedroom, where I found myself (pre–choking incident) lying on my bed, disagreeable Jew-fro awry and gaunt limbs aloft, reading Betty and Veronica comic books to escape the sad, frightening world. As a kid, I needed so much self-soothing via comic books that I eventually had tall stacks of fifty, each one balancing on the other, like Jenga towers all around my room. I sat down next to me on my green floral bedspread and told her not to be afraid. With a deadpan expression, she looked up at me and said, "What the fuck are you doing? You're embarrassing us." And I was like, *Yo, Mandy, this shit works! That was for sure a young me.*

The final stage of my intensive program involved "supervised walks" with Christina, a frail woman with hair almost as curly as mine. This slightly more sensible activity took place during the sixth hour of the day. Christina (who I guess specialized in walking?) strolled beside me and "guided" me to think only about the things I saw or felt in the moment. For example: *There's a crack in the sidewalk. That leaf is green. That breeze feels nice. My feet are touching the ground.* It felt like a lesson on how to think like a dumb person. Or perhaps how to think like a dude, but the kind who would meet up with a girl on Tinder while on a family vacation.

The only part of the program that seemed to have any real logic behind it was the yoga classes. Finally, a proven method. I was given the schedule for the closest studio, which listed all

the types of yoga available: bikram, yin, vinyasa, restorative. I'm not really a yoga-goer (I'm too embarrassed to use the word *yogi*, even though it seems I just did), so I had to borrow one of the sticky rental mats that you can pick up staph infections from, something my college roommate told me about before she learned that she can't tell me anything. Thankfully, I spotted some disinfecting wipes on the front desk and grabbed a handful. Probability of staph decreased.

"Oh, each wipe is one dollar," said the very smug woman behind the desk.

"Each wipe. Is one dollar," I repeated, just to be sure I'd heard her correctly.

"Yes."

I stared at her blankly, which made her next response entirely predictable.

"Sorry . . . I don't make the rules?"

I dropped a crumpled ten-dollar bill in front of her and grabbed ten wipes, feeling guilty for the other ways that ten dollars could have been spent. When I got into the studio, I positioned my mat on the floor in the back of the room in a spot that would guarantee the most space around me. I ferociously scrubbed the mat, leaving the pile of wipes beside me so everyone would know I was a germaphobe and that they should set their mats elsewhere. I laid on my back and closed my eyes, trying not to think of the hundreds of sweaty people who had lain there before me.

A few seconds later the teacher burst in and shouted,

"Hello, mommies!" I opened my eyes and saw that I was surrounded by twenty pregnant women in various stages of "about to pop." It was in this moment I learned what prenatal yoga was. I don't know why I knew what whooping cough was at four years old but not what *prenatal* meant at nineteen.

Leaving abruptly felt like the wrong thing to do. I didn't want to draw more attention to myself; class had already started, and I had already paid for it, and for the wipes. So I pushed out my stomach and did baby-safe yoga — without carrying a baby, surrounded by baby-bearing women — for an hour that was filled with more shame and anxiety than I had ever experienced pre–brain rehab.

I quit the program after three weeks, and Joanne probably got herself a new pair of Dior sunglasses. The whole thing had become so self-indulgent, it was making me sick. Every time I sat on that couch, my insides wanted to crawl out of my body and leave it there to suffer alone, fearing even the memory of doing something so self-involved. Ironically, this might have been the reason that I did start to feel better. Not because any of it changed my perspective, but because I may have subconsciously solved some of my issues so I wouldn't have to keep going. I guess slowly annoying your patients so much that they are forced to improve themselves is a program that could work in and of itself.

In reality, I knew there would always only be one solution: IgNoRaNcE i$ bLiS$. Ignore that you are a body or even a

soul. Ignore everything that's unfathomable, like the fact that you have eyeballs you can see out of. Ignore that you live on this planet and that there is such a thing as a planet. Ignore what can happen, what will happen, and what has happened. The less you know, the better, since anything you know can instill fear, sadness, or confusion, but mostly paralyzing fear. What you already know? Pretend you don't know it. Willfully *unknow* it. Live your life like an asshole. Assholes figured out the way to live a long time ago. Too dumb to think about the state of humanity and life and death. "There's nothing I can do about it anyway, so why should it affect my happiness?" is a great quote from every asshole.

Except sometimes you'll be sitting there trying to distract yourself from mortality and the fact that you're currently decaying and that nothing will ever matter. No impact no matter how great will ever make a difference — even Jesus Christ will eventually be forgotten. You'll put on a breathing meditation, and take a deep breath but then think about how you're breathing, and then suddenly breathing no longer feels like breathing; it feels like drowning. So you stop breathing. All you have to do to die is not breathe, and all you have to do to not breathe is think about how you're breathing. You'll try to take your mind off the anxiety the meditation brought you by thinking of anything else; absolutely anything will do. Except how any day now the Big One will hit Los Angeles and you and everything you call home will be lost in a gaping hole in the earth. You'll go sit outside, thinking that could help ease your mind, and ten minutes in you realize you're giving your-

self three different cancers at the same time: skin (sun), brain (hot phone in the sun), liver (beer).

Shhhhh, you tell yourself. *That leaf is green. That breeze feels nice. My feet are touching the ground. And I have feet. Because I am trapped in a fucking human body. Fuck!!!!!!!!!*

Tweets I Would Tweet If I Weren't Morally Opposed to Twitter: I

Guys, I hate Twitter soooo much

If I had one wish besides world peace it would be to delete twitter but that's kind of the same thing

Everyone can be a journalist now!!!!!!!!!! yay!!!!!!!!!!!

Twitter's like: Alright u guys, write the most disgusting thing you can think of in 140 characters. Everyone in the human population ready? Ok 1 2 3 GO

The only thing worse for my mental health than Twitter or Instagram is *Deadline Hollywood*

Anyone who texts *We need to talk* in this day and age is an actual terrorist.

u cannot text a person w/ 5 anxiety disorders "Can I
ask you a question?"

The only time I experience joy is when I see a big dog
next to a little kid

If I hate myself when I'm young how will I like myself
when I'm old

Remember when you were three years old
and the worst thing you knew was getting
sunscreen put on? None of your parents' friends
had died yet and everyone was in love and
happy?

There are as many Jewish supermodels as there are
pretty comedians

I can't be a bad person because I will hold in my
pee if I'm in a group of people who are having
fun as to not leave and affect the good energy
they're feeling

Serenity and the opposite of serenity is truly believing
nothing matters

Why do we as humans hate taking care of the
toothpaste cap so much?

Being high is turning a flashlight on in the middle of the day.

I was so depressed last night that I read my horoscope

I was so bored last night I watched every single Instagram story on my feed.

All of my crushes are dead

What if I'm about to die and don't know it's about to happen and I'm looking at an article about Scott Disick

Sometimes I think about the girl who got canceled for tweeting that she thought the kid from *Stranger Things* was hot. I hope she's recovered from that traumatizing experience

I spend the same amount of time talking myself into walking into traffic as I do talking myself out of it

It's hard for me to choose what's worse, life or death. Is it worse being alive and watching people die or being dead and having to watch people be alive

I can always tell if someone hasn't gotten a text back from a guy they're hooking up with by the content they're posting on their story.

Sometimes you gotta do something nasty to make things clean

Favorite pastimes: texting boys and collecting their T-shirts.

You will never see a more immediate reaction out of somebody than if you say "I don't feel good" in the back of a cab.

I wish there were a third gender for just non-idiots. It's my only identity

The meanest comment you can get on a photo of yourself is "You inspire me to be the most confident version of myself."

My least favorite comment I get is "who hurt u?" bc I don't know!!! and they're right I sound rly bitter !! Idk what happened!

The only effective way to get off your phone is for someone to take a picture of you looking down at

your phone. It's the ugliest version of yourself you will ever see

It's weird we haven't found a better system than water fountains. I feel like a circus animal every time I drink out of one. How do we have iPhones but still water fountains?

Whoever marries Shawn Mendes is going to hate those performances of "Señorita." It's kind of like . . . think about your future wife, u know? U can be loyal to your gf while being disloyal to your future wife and the google search that will haunt her for eternity

What doesn't kill me makes me more fucked up.

It sucks that all your exes are just out there doing whatever they want, stuck only with the memories of the embarrassing things u did and said w them

Imagine the anxiety of being on *Love Island* and getting diarrhea

Every time a gang of motorcyclists pass by I have to stop myself from screaming at them, "LITERALLY EVERYONE HATES YOU!!"

One of the biggest lies one tells besides "It's in the mail" is "Can we please celebrate once I'm back?"

Ways I like to pass the time: think of all the ways I can kill myself without leaving the room I'm currently in.

in order to cook octopus they have to beat them to death because if you try and kill one instantly the octopus's muscles tense up and the texture is too hard to eat. Sorry, I just didn't want to be the only one who knew that.

If you respond to a troll on the internet you are not stable no matter how stable your response sounds

I have never taken a nap in my life. Naps and "passing out on the couch" are not possible if u have obsessive thoughts.

falling asleep can maybe be done if u play a game called ONLY LISTEN TO THINGS THAT AREN'T IN YOUR HEAD for at least a couple hours

every night I want to scream at my bed "seriously what do you want from me?! I took off my socks, I put them back on, I tried both sides, going on my back, I put a pillow between my legs!!! WHAT DO YOU WANT!"

What would really happen to you if you could lean the seat back on an airplane one more inch during takeoff and landing?

I am 90 percent hate and 10 percent water

Do you think there's anyone who is still jerking off to magazines by choice? Like indie masturbation, the cassette tapes of porn

It's so rude that you can't stop time no matter what.

Every time I sit in a beach chair I feel like a fat Southern man holding a beer even if I'm not holding one.

Do u guys feel that? It almost feels like a huge weight on your shoulders?

I pretend I'm a spy every time I plug in or pull out a charger

Life is just waiting for someone to contact you with something interesting

Why God Is Definitely Real

I'M COMPOSED OF CONTRADICTIONS, and so I am constantly at war with myself. I hate everyone and everything, but I also feel bad for everyone and everything. I think I'm too loud but also too quiet. I don't trust anyone, yet I trust *everyone*, arguably to the point of self-sabotage. I believe nothing matters and everything matters, that life is meaningless and also precious. I believe in nothing, but I also believe in the universe. I believe in sense, but I also believe in God. God makes no sense, yet God is somehow the only thing that makes sense. I'm not superstitious, but I believe in God so much that I actively try not to figure out the meaning of life, because I think if and when you do, God kills you.

It feels like a betrayal of my personality to believe in anything that isn't backed up by a great deal of proof, but I believe in God because there is confirmation of Their (God tweeted that He has switched His pronoun to They) existence everywhere we go, and I'll prove it to you — you know, beyond having you watch anything narrated by David Attenborough.

1. Puppies and Kittens

If there weren't puppies and kittens, I might not believe in God, but since there are, I have no choice but to believe. Imagine if you were God, and you were in charge of creating everything on this earth. After you created people, would you not 100 percent think to create a pet for said people? I think you would. There is no way God isn't real, because puppies and kittens are the exact creatures a God would make for a person. They're simply too cute to have been created by anything else. Of course, they shit and piss and fuck up your furniture, but nothing God makes comes without a lesson. God's favorite hobby is teaching lessons. God knew exactly what They were doing, so They created the cutest animals possible to distract us from the banality and horror of being alive.

2. Because Everything Gets Old

We know everything has to die eventually. But what God did, which was so brilliant and a sure reason why They definitely exist, is make it so that everything is supposed to get old before it dies. God intended for everything to get old before death so it would be easier for *us!* When our parents and grandparents get old, we almost start to *want* them to die because they can barely talk or hear and that's no fun at all! Why is it so much sadder when someone young dies than when someone old dies? Because no one wants old people to keep living, since

they are such a drag! God makes people age so we don't care as much when they die. It's simple, and it's genius. The type of genius that could only have been thought of by God. Plus, we all get so hideous by the time death rolls around that we're into dying. Way to go, God.

3. Fruit

I'm sorry, but how could fruit be real if there wasn't a God? God was just like, *A'ight, I'm gonna create a few super-cute, delicious but also hydrating things for people to eat that they can find on trees, bushes, or in the ground!* Um, good idea much? If there was no God, do you think an apple or strawberry could exist? Think about the *color* of a watermelon . . . you think that's nature? Well, guess what — God *created* nature! If you were God and you had to create what a specific fruit tastes like, you would without a doubt make one that tastes like a fuckin' tropical island (mango, papaya, pineapple). If you had the ability to create what fruit *looks* like, you would be overwhelmed with power, unable to restrain yourself from ordering hot pink! Lime green! Orange and red! God is so fucking real. And don't even get me started on coconuts. The hard shell so it stays perfect, and when you crack it open, you get this miraculous, sweet, sometimes pink water? And every fruit has different vitamins! Feeling sick? Oh, it's chill, God made oranges to fight it. Get your shit together. God's real, and it's because fruit is real.

4. Alcohol/Weed

So let's say God is real and They've created everything: People are there, fruit's there, the dogs and cats are on the way, but God knows one thing is missing . . . everyone on earth is bored and miserable, despite the fruit. What does he do? *Bam.* Weed. Alcohol. God gave us alcohol and weed because God knew most people wouldn't survive on this planet without inebriation. God really went the extra mile, creating something that could single-handedly induce good times and alleviate the bad. People can drink and smoke or they can choose either or none, but God knew both needed to exist. Of course, they both come with lessons because, again, God can't get enough of those. But still, it's too perfect for it not to be the work of God — did I mention weed is also a miracle drug that can cure almost any ailment? EXPLAIN THAT. That's right. God.

5. Mint

No accident could have made mint. It's a flavor that helps everyone on a daily basis, elevating their quality of life in morning and night. There is not one person who thinks mint smells or tastes bad. It is universally agreed upon as the thing you want to smell and taste like. Coincidence? I think not. It's the only flavor that will never make you nauseated no matter what state you're in. In its natural form, it can even *alleviate nausea.* It makes humans' mouths smell good, and it's without

a doubt the best ice cream flavor. You know what they say: If mint is real, God is real.

6. Sun and Snow

Although weather conditions can sometimes be so terrible it makes me not believe in God, good weather can feel so good that it makes me believe again. Sun feels *so fucking good*. Like, sex is cool, but have you ever soaked in afternoon sunlight? When you haven't been in the sun in a little while, and you see a crack of sunlight in the sidewalk and step into it, it feels like God Themself is giving you light, strength, and warmth. It's a healing station that's free and open eight hours a day. Also it can make you tan, a.k.a. look hot, which is absurd.

Snow, on the other hand, is so beautiful that if you're just around it, it can trick people into thinking you too have ineffable beauty. Not only is snow the most extraordinary thing to watch fall from the sky, but you can also ski and make stuff out of it? Just another added plus by God. Classic. I left out snowflakes on purpose because if I really think about them, I'll lose my mind.

7. Coffee

Coffee gives people a reason to wake up. After mint, it's the most ideal thing to taste first thing in the morning, and nothing else could ever compare. It is never too early to have coffee, whereas it can be too early for literally anything else.

Coffee is the sober person's alcohol, the hungover person's medicine, and the average person's reliable ol' pal joe. Without it, it would be difficult for most of us to even get through the day. It can be social or solo and is just as enjoyable in both settings. Its smell is unparalleled. God, You've done it again.

8. Flowers

Flowers are the puppies and kittens of nature. I mean, how freaking cute are they?! Do we live in Super Mario Sunshine? The answer is yes but even cuter. All different colors and sizes and smells and shapes and kinds. God put them there to brighten up your home and day. It was Their idea of a natural cure for depression. Well, that and to feed insects, birds, and other animals, because they're insanely multifunctional like all things God makes. Without flowers, the world would be a less beautiful place. With them, the world is magical, and magic can only be explained by God.

So there you have it. It's pretty clear why anyone with eyes should believe in God. Oh. Shit. If you don't have eyes or you're blind, I completely understand why you wouldn't believe in God. That's beyond fucked up, and I wouldn't believe in God either, knowing They could let that happen. I can't believe I almost forgot about the blind. All right, so, besides the blind, all evidence points to God.

Too Full to Fuck

FOR STRAIGHT COUPLES, THERE is one key difference be-
tween sex for the male and for the female: a woman gets a
penis inserted into her while a man gets to insert his penis into
someone else. That's all nice and good. Sex is pleasurable for
both genders. But from what I've discovered, only one gender
has to *save room* in her body if a penis is to go into it — mean-
ing that sometimes, if you've eaten a hearty meal, there isn't
enough room for a penis.

Sure, women can eat and then have sex. But they really
can't eat *a lot*. You know the saying "You can always make
room for dessert"? Well, you can't always make room for a
dick. Especially if you've eaten dessert.

Sometimes I'm just too full to have sex. I don't know for
sure if this is something other girls experience or just me,
because I've never heard any of them discuss it. Maybe it's
supposed to be kept secret among us girls, information so
sensitive that we cannot risk releasing it in conversation. Or
maybe I'm actually the only one who gets too full to be able

to have sex, and if that's the case, then pretend this never happened.

I love to eat (ever since I got over my fear of eating). I tend to eat until I feel sick. Similar to how people test their alcohol consumption to see how much they can drink without puking, I've tested how much food I can eat and still fuck. On nights I know I'm going to be having sex, of course I eat less, which is annoying but in the end it's worth it, because you get to have sex and feel good and not bloated while having it. This — and the fact that you shaved for no reason — is why being flaked on sucks, especially for girls, because in anticipation of hanging out, we ate just one piece of pizza instead of the regular four, and now it's late and we're hungry and we didn't even get laid. Although not eating and then getting flaked on is still preferable to the times where we eat a shitload and then randomly get asked to hang out. This is most distressing because there is almost nothing in the world we wouldn't drop to spend time with our crush. The only reason we will say no to a spontaneous hang is because it's after dinner and we don't feel hot. It will pain us to say no for this reason, but trust me, we will.

I suspect there are women everywhere who don't want to have sex with their significant others for the sole reason of being full. However, no one is comfortable with using the excuse of being full. We're all perfectly fine using our periods as excuses, but when it comes to being full, we find other justifications, perhaps because our instinct when it comes to rejecting men is to blame something we have no control over

whatsoever, like sexual orientation or religion. It'd be cool if there was some involuntary signal like our eyes turn light blue when we're uninterested. Anything to avoid hurting a person, and the scene that invariably follows.

I'm also someone who came of age during the height of the blue-balls myth. In high school we were taught (I don't know by who, but that person should be arrested) that it was morally wrong to not finish off a boy that you were hooking up with. The person who taught us (again, WHO AND WHERE ARE YOU?!) made it very clear that it doesn't matter how you get there, just make sure they don't leave having not shot their load. If you couldn't commit from kissing to finishing, you really shouldn't kiss at all, and if you couldn't kiss at all, you would have to think of an excuse that wouldn't hurt their feelings, like "I have a boyfriend" or our most sacred "I'm on my period," which sadly doesn't go the extra mile to protect against blowjobs. From my personal research, every other generation seems not to have been as burdened by the "Don't tease a guy or they will be writhing in pain" sentiment. Even in old movies, the woman is constantly leading the guy on. They share one small kiss, and it's not even until the last scene. Fortunately, before we subjected ourselves to even more horror, we were informed by some hero (I don't know who this was either but thank you) that it was all, in fact, a myth, and guys are, in fact, pieces of shit. Still, the excuses and fear of disappointing someone had lasting psychological impacts. Like the inability to admit to others that we are too full to fuck.

When an ex-boyfriend and I would go out for dinner, we'd order the same amount that four people would. I know that because one time after we finished our meal I overheard the waiter recommend our exact order as a feast for the double date next to us. After eating an entire meal sized for two pregnant women, my then-boyfriend asked if we could go get ice cream. Obviously this is something I love to do, but it would have been nice to be told in advance so I could have rationed my courses to accommodate how much my stomach would be able to load. I had begun to find myself in this situation a lot in this relationship, as we were constantly eating and fucking. I was sick of the secrets and lies, so after many dinners and many ice creams, I told him about being too full to fuck. I didn't have much of a choice, as being touched by your boyfriend when you're full is one of the most irritating sensations there is. When you're full, even him putting a hand on your side can be upsetting. I had to come clean after my boyfriend rolled on top of me in bed to kiss me after a big dinner and I accidentally screamed, "GET THE FUCK OFF ME! PLEASE DON'T TOUCH ME!"

It was nice to have everything out in the open.

"If I eat ice cream, I won't be able to have sex later," I declared after our meal. There's no debate that it's a super-weird and unsexy thing to admit. It's also a super-weird and unsexy thing for me to have to decide which I would rather do, eat ice cream or have sex. They're pretty on par. They definitely both fill you up, emotionally and physically. It was too hard for me to pick, so I asked him to. "Would you rather eat ice

cream with me or have sex with me?" For him not to choose having sex with me would be mildly insulting. But he would never want to deprive me of ice cream, and depriving me of ice cream for sex feels kind of problematic.

Like most people would, he wondered, "Why can't we do both?"

Well, both cannot occur because I do not have room in my stomach for a full dinner, two handfuls of cream, and a penis.

I chose sex so no one would be displeased. That psychological impact, man. We sat right outside the ice cream shop, close enough that I could smell the fresh waffle cones being pressed in the iron. I stared at him as he took every lick, jealous that straight men can do both sex and ice cream, since they ultimately have everything.

I watched as a drip of mint chip slowly melted down the cone and onto his hand.

"You dropped some," I said somberly.

"Just get ice cream, and we won't have sex tonight," he said.

"No, no, it's fine. I don't want it."

He licked the melted mint chip off his hand and chomped off a bite of the cone. "No, do it. I want you to do it," he said. And of course, despite him saying this out of kindness, I thought he didn't want to have sex with me, because he was telling me to get ice cream. And he thought I didn't want to have sex with him because I was salivating at the ice cream. And at that point, no matter which one I chose, neither would be as good as it was supposed to be, because something great had to be sacrificed in the process.

So Embarrassing

Cazzie has conceptual difficulty understanding the prover-
bial "big picture," which relies upon understanding how
things in her environment are related to one another. "Big
picture" limitations have significant emotional implica-
tions as they make it difficult for Cazzie to develop insight
about the nature of her difficulties, which would be the
first step to develop strategies to resolve them.

— *Excerpt from neuropsychological evaluation of*
Cazzie David, 2007

You know the things you do when you're alone, the
things you're too embarrassed to do in front of others but
can do in front of yourself? I can't do those things. I've never
looked in the mirror too long, sang in the shower, or danced
alone in my room to loud music. I've never even listened to
music alone in my room, because for some reason I also find
that embarrassing. Before I get two verses in, I'll dissociate,
look down at myself, and think, *What are you doing, you loser?*

You're not a cool, sad teen in an indie movie! The
when I'm alone is as if I'm being filmed for a movi
show. Or like I think super-hot boy ghosts are watching me.

Embarrassment has undoubtedly been my default emo-
tion since exiting the womb. I experience it when I am alone
doing nothing, around people doing anything, and at dinner
with my family. Taking a shower embarrasses me, thinking
about how stupid and primal I must look standing there na-
ked. Buying groceries is embarrassing — people can see the
things I want and need, and by people, I mean me. I can't
drive with the windows down; I'm much too exposed, it's so
vulnerable. I don't need people to be able to look into my
car, let alone at me *driving.* I'm too embarrassed to wear sun-
glasses even when I am being blinded by the sun. When I see
other people wearing sunglasses, I hardly even notice. It's as
routine as wearing a shirt or having a nose. But when *I* wear
sunglasses, I'm convinced everyone who looks at me thinks
I'm trying too hard to look cool, and all I can think about are
the sunglasses on my face and how they're being perceived. I
feel like I have to tell everyone who passes by, *I promise I'm
not trying to be cool, it's just sunny outside. You get it, you're
also outside. Isn't it sunny?*

Even the simplest, most benign tasks make me want to
crawl under the floorboards and hide for the rest of eternity.
To comfort myself, I try to play that game where you wonder
if anyone on earth is doing the exact same thing you are in
that moment. But I doubt anyone else at this very moment
is also brushing their teeth and getting so embarrassed about

their own existence that they want to take the toothbrush out of their mouth and repeatedly stab themselves in the eye with it because they are such a disgrace to themselves and all of humanity and the only thing stopping them from doing it is the embarrassment it would cause thereafter.

Most people do not think twice, or sometimes even once, about things I find deeply humiliating, things like writing their profession in their Instagram bio or wearing a jumpsuit. People's actions are unhinged and they still get reactions like *OMG I LOVE YOUUUUUU! OUR QUEEN.* Yet I'm embarrassed every time I walk into a room because I know people will look over at me, and then I'm embarrassed to leave that room because I might exit in an embarrassing fashion — like, I'll hold my neck at a strange angle and I'll look like a turtle. Maybe God slipped up when distributing shame and I accidentally got all of my generation's allotment — which could explain why vloggers exist.

Oh, the things I could do with just half a percent less shame. I could sleep, for one. While other people's night routines may end with chamomile tea or some chewable millennial-marketed melatonin, that's where mine begins. In order for me to even attempt the miracle of sleep, I must run through my last interaction with every person who has ever laid eyes on me, hoping none of these encounters were humiliating enough to cause me to relive it over and over again for perpetuity. But the truth remains: As long as people know you exist and have witnessed anything you have said or done, there is reason to be humiliated. If I had the ability to Eter-

nal Sunshine myself from the memory of everyone who had ever met me, I would. The technician performing the erasure would ask, *Are you sure you want to erase this one? All you're doing is waving from across the street.* And I would yell, *YES, PLEASE, TAKE IT! LOOK AT ME! TAKE THEM ALL!*

Without my embarrassment issues, I'd be able to masturbate, which would be nice. The shame I have around masturbation is obviously not a religious thing, it's just my classic "I hate myself and can't do anything in front of myself" thing. I don't think it's embarrassing that other people do it. Just me. Only *I'm* embarrassing. Even though I sincerely believe it's worlds more embarrassing to *not* masturbate out of embarrassment than to masturbate. There's not much I can do about that, though. For me, the pleasure of self-stimulation does not outweigh the strenuous brainwashing it takes to convince myself I'm not myself.

When I inform other girls that I don't masturbate, they're stunned: "How can you not masturbate?!" "I would die without it." "I fucking love masturbating. It's so freeing." Because doing anything that someone could describe as "freeing" is too embarrassing for me to ever do. Fortunately, there aren't that many "freeing" activities. The only other one I can think of is throwing your phone into a fountain. I'd maybe be capable of doing a less freeing version of that, like stomping on my phone and then throwing it in the trash. I'd have to be careful how I tossed it in the trash, though. It would have to be a very uncinematic toss to keep the shame away. And I could under no circumstances smile as I walked away from it.

Up until college, I was too embarrassed to eat anything that wasn't plain in front of a guy I liked. I didn't want to be associated in their mind with anything that could be considered off-putting. I guess I thought boys would think I was undesirable and unkissable if they saw me eat or order anything that wasn't simple and universally liked by all. So I compiled a list of foods in my head that wouldn't be gross if you made out after eating them, and then those became the only foods I'd allow myself to eat in front of boys — you know, so they could still picture making out with me. WTF?

Cute foods I could eat that wouldn't gross out a boy or embarrass me: waffles, toast, all desserts, French fries, cereal, berries, cucumbers (the only vegetable that isn't gross/embarrassing to say out loud), pasta, grilled cheese, croissants, anything a picky toddler would eat.

Gross foods boys will forever associate me with if I am seen eating them: eggs, vegetables, salads, soup, fish, sandwiches (excluding grilled cheese), anything a normal person would eat.

One week in high school, one of the hottest guys in the grade ate lunch with my friends and me a few days in a row. I think all of his friends were sick or had detention that week. So every single one of those days, I ate a large chocolate chip cookie for lunch, thinking he would think that was cute and not gross. My friends, however, were confused as to why I was now eating only cookies at lunchtime . . . every day. So they did what anyone would do and asked me what was up with this — in front of him.

"What are you talking about? I always have a cookie for lunch! HAHAHAHA."

I was so embarrassed. Not only because I was caught but because he now knew I ate things that weren't cute foods like cookies. He would never want to kiss me.

I've made progress since then. I can order like a semi-normal person on a date. But I still cannot under any circumstances travel with a guy. The humiliation of putting your arms up in the X-ray machine at the airport is too much to bear in front of myself, let alone with someone watching who is supposed to want to continue having sex with me.

I will marry any boy who doesn't think I'm embarrassing, but I will never ever have a wedding. If my future husband wants to have a ceremony, he will have to hire a double to play me, as I would be too embarrassed to attend. If he's against the double idea, there's a small chance I might participate, but under no circumstances would I walk down an aisle. I can't think of anything more mortifying than walking in general, let alone in a choreographed motion in front of people who know me and, even worse, are overjoyed for me. I'd rather walk in front of them to my execution.

I got a glimpse of the horrors and humiliation of walking in front of people while they look at you during my college graduation. When my mother asked about the date so she could start booking flights, I told her I wouldn't be attending because I don't do ceremonies. She was adamant it would be a day I'd never forget and if I didn't go, I'd "always regret it." She was definitely right about it being something I would never forget;

I don't forget anything embarrassing. But I would never have regretted it; missing an event has never been the type of thing I regret. The things I regret are everything else in life, like letting myself speak and be seen.

My mother switched arguments when she realized I would never care about going and instead declared it was important to her and my dad to see me "walk." So I asked my dad if he cared about seeing me walk like my mother had said,

"*Walk?* How stupid. Why would I care? I don't care," he said.

I relayed his answer back to my mother, who now decided she didn't care if we didn't care, we were going.

Walking is only one of the many reasons why a graduation ceremony is degrading. The amount of effort it takes to go in the first place is another major contributor. My family would have to book hotel rooms, fly from Los Angeles to Boston, wake up at six in the morning for the graduation, and then fly back later that day. My attendance alone would give the impression that *walking* was worth this huge effort from my family and me, which completely contradicts the "I don't give a shit about anything" persona that has made me feel safest from shame, even though it's clearly largely ineffective. Telling my mother all the ways in which going would be a nuisance for her was also largely ineffective.

It wasn't until it was too late that I remembered the most embarrassing aspect of graduation of all: the costume. Costumes are inherently embarrassing, but there's something about a cap and gown that's worse. Maybe because the cap and gown

disguise any true emotion you might actually feel and projects to the world that you feel only one emotion: excitement. Or because it represents accomplishment, so wearing it implies that you're proud of yourself. But it's probably most embarrassing because it's emphatically heinous. The cap takes up your entire forehead, replacing it with the widow's peak from hell. And the gown is basically anti-feminist, it's so bad for a woman's body, accentuating her breasts by clinging to them and then just protruding out from there in an attempt to erase the existence of the rest of her. Not even Billie Eilish would be caught in one.

At seven in the morning, I walked from my hotel to the ceremony in the big, black, boxy sheet that drew so much attention, it was as if my outfit were one big pair of sunglasses. Most people I passed on the street stared and whispered about me. Some, unfortunately, didn't whisper, like the mother who pointed at me and said to her child, "Aw, look, honey! She's graduating today!" Some even went as far as to talk *to* me. "What college are you graduating from?" "Congratulations! Big day!" "Ah, to be back in college . . ."

When I arrived at the gymnasium, hundreds of students were gathered and bursting with pride for the accomplishment of graduating from a liberal arts college. I didn't feel accomplished about this. For one of my final projects, I'd turned in a video of my cat walking around my apartment with a depressed voiceover narration. I got an A. My discomfort grew as students hugged and took selfies together. I even heard one girl yell to her friends, "We did it!" and I audibly gasped. It was

such a universal cliché that I never thought someone would actually say it at a graduation, the same way we've all collectively agreed to no longer take photos of avocado toast or kiss in the rain.

We got put into lines and I tried to talk to some of the students around me to cope. "Guys, how embarrassing is this?"

"How embarrassing is what?"

"*Graduating* . . ." I said, thinking it was obvious. They furrowed their eyebrows in confusion, proving themselves to be self-assured humans.

When my line walked into the auditorium, I was blinded by smiles. I wanted to cry, or hide, or throw up. The humiliation was excruciating. Families of students jumped up and waved enthusiastically to their graduates. I was so happy for all of them and so embarrassed for me. I put my hands over my face like I was a celebrity in a mob of fans. I didn't want my family to see me and I did not want to see them or *this*. Covering my face backfired since it made it that much easier for my family to spot me, because who else would do something like that? I peeked through my fingers to see my mom waving both her hands in the air, my sister laughing at me, my boyfriend (who'd forced me to let him to attend) taking pictures of me to humiliate me even more later, and my dad (not looking at me) fake-conducting "Pomp and Circumstance." It also didn't help that both my dad and my boyfriend were famous; their presence garnered more attention for me than the kid who decorated their cap with a three-dimensional abstract art piece.

As students got their diplomas and walked across the stage, some actually did POSES for the jumbotron. One kid dabbed, one girl blew a kiss, someone did a peace sign. I wanted to give a middle finger, but I was afraid people would think I was trying to do a cool, badass pose instead of a serious *Fuck everything about this*. Friends and families clapped and shouted things like "Go, Hannah!" and I thought about how I would be too embarrassed ever to cheer and then wondered how it was possible that some people's personalities allowed them to scream out of joy. I got sad for a moment, because I knew no one would ever yell like that for me. First, because I had no college friends, and second, because if I did, they would know how much their shouting "Go, Cazzie!" would humiliate me. Somehow, the second reason felt sadder.

Truth be told, I'd been terrified to graduate, and not just because of how embarrassing the ceremony would be. I was scared of how embarrassing my life would be following it. I'm too embarrassed to follow my dreams but not as embarrassed as I am to have written the phrase *follow my dreams*. I secretly want to be a stand-up comedian, but I can't do it. And it's obvious that I can't because it took me closing my eyes to be able to type that sentence. My true dream is for someone to come up to me on the street, put a gun to my head, and say, *Cazzie, that's it! I'm forcing you to do comedy*, leaving me with no choice. Because without life-or-death motivation, I can't do it — mentally, physically, and emotionally cannot. You know how they say that all comedians hate themselves or they wouldn't be able to be comedians? Well, it's a lie. Well,

maybe it's not a lie, but they're certainly not as self-conscious and humiliated as they say they are, because if they were, they wouldn't be able to get onstage and talk about how self-conscious and humiliated they are. So, in conclusion, I am more self-conscious than every self-conscious comedian because I refuse to do it, even though I figure I would be amazing at it, considering all it seems to entail these days is discussing how mentally ill you are.

Stand-up is one of the most embarrassing professions that exist. You're essentially begging the audience to think you're as funny as you clearly think you are or you wouldn't be doing it. Comedians might as well go up on stage with a cardboard sign that says NEED LAUGHS AND ATTENTION (comedy rimshot sound effect). That terrible joke is why, instead of doing stand-up, I write. That way I won't ever have to know in real time how unfunny you think I am. I'm not one who is capable of continuing on with life after a moment where no one laughed when I wanted them to.

Writing is still embarrassing, though. When people ask me what I do, I can barely get the words out, like I'm a guy with commitment issues saying "I love you" for the first time.

"And what do you do?"

"I'm a . . . I'm . . . I'm a . . . wr — a wriiii . . . ter. Ter. I'm *trying* to be a wri . . . you know what, let's just not talk about it."

Writing is grossly self-involved and narcissistic, and I hate people who are self-involved and narcissistic. Nevertheless, I was told from a very young age that writing is one of the

most helpful tools for processing emotions, which in my case would be how embarrassed I am about everything in life. It's not like I can talk to my therapist about it; I've avoided her for two years and now I'm too embarrassed about it to reach out. Plus, there's too much to talk about — two years of embarrassing moments for me is two lifetimes for others. It is rather unfortunate, though, that instead of writing helping to alleviate my perpetual shame, it's just added to the list of things I'm embarrassed by — like having written this essay in the first place. And how truly embarrassing it is to think anyone would want to read twelve pages about how embarrassed I am.

Love You to Death

I MOVED BACK INTO my dad's house right after graduating college, like a lot of people do. Although most kids move back home for different reasons — not having a place to live yet or not having the money to get their own place. That wasn't my thinking. I was moving in with my dad because I wanted to spend as much time with him as possible before he died.

Yep. He's dying. No, he is not sick, nor has he been diagnosed with anything. Not yet, anyway. But someday he will die, because everyone dies. So every moment with my father must be cherished. He's in great health at the moment and will hopefully be one hundred and twenty when he passes, but it doesn't matter. He will go someday. And now that I have reached adulthood, it is officially sooner rather than later.

Since the age of five, I have been obsessed with death — not enamored of it or seduced by it, the way a love interest in a Wes Anderson film might be, but immobilized by it. When I learned what death was, it was my death. The second I was informed of it, I was no longer alive but instead "going to die."

And if *I* was going to die, my dad was *really* going to die. The present is a myth. There's only the future and the past. If time could stand still maybe there would be a present moment, but every second that goes by becomes the past and every second that hasn't happened is the future and the future is my dad is either dead or almost dead.

By the time I was twelve, my dad had me read every Edgar Cayce and Elisabeth Kübler-Ross book on death, promising me with each one that I could stop agonizing, that there is proof of life after death, and if either one of us died, the first thing the other would do was go to a medium and wait for the deceased one to say the code word we'd agreed upon. (We have to change it once a year because we always forget what it is, but it'll be fine.)

Well-intentioned people say, "You don't need to worry about that until it happens!" As if that's comforting, or even makes sense. I won't be able to worry about my dad's death once it happens because he'll be dead — *duh*. If I don't worry about it until it happens, I'll just be left feeling like an idiot, wondering why I wasn't worried that entire time. Therefore, I like to mentally prepare myself for the worst and the definite. Every day, preparing. How can you not when you know it's coming? People prepare for interviews and pregnancies and marathons and battle; why not death?

If everyone truly internalized the fact that the people they love are going to pass, I feel they'd behave more like I do: spending every possible moment they can with that person and panicking about their upcoming passage to the other side.

My dad spends almost every night sitting on the couch watching a movie from the forties. I find old movies to be boring in that they require the same kind of tedious attention it takes to read an esoteric novel, but I'll sit with him despite my lack of interest. He has so little time left; I must take note of everything. Even the way his hand holds the remote, how his long fingers wrap around it and his concave pinkie veers freakishly to the left, like a runaway train. When I noticed that, I *had* to ask what happened to his hand. After all, one day I won't be able to. He told me it was from a basketball incident. The ball hit his pinkie. Fascinating. Thank God I found out before it was too late.

As often as people tell you not to worry, they tell you to cherish the people around you because you never know when they'll be gone. Is this what they had in mind? Forever acting like my dad has a terminal illness and is going to die in one year? How do you even cherish someone to the fullest extent? Just by thinking about how much you love them while they're alive? All that does is make me unable to look at him without thinking about him dying. I don't know anymore if there's much of a difference between me picturing him dead every moment he's alive and him actually being dead.

"Why don't you go hang out with your friends? Go do something," he said one weekend a year after I had moved in.

I told him I could do that whenever, but how many more times would I be able to sit next to my dad as he watches Cary Grant and yells, "*This* is dialogue! Now, *this* is what dialogue is!"

"What are you talking about? We do this every night," he said.

And I thought: *Yeah, every night . . . until you die!*

Every time he gives me advice or says something funny or smart, I jot it down, like I'm writing the biography of a man who's on his deathbed. Literally, though, exactly like that.

A few examples:

When we were outside sitting in the shade in Martha's Vineyard: "The way plants are drawn to light, I am drawn to shade."

After someone bragged to him about their child: "The way people talk about their kids is sickening. Sickening! I would never talk about you unless I'm asked. I hope you don't mind."

When I was crying about something stupid: "Nothing is more disgusting than self-pity."

After I showed him a video of someone I hated trying to be funny: "You can't *try* and be funny! If you can't be funny, don't try. Either be funny or don't try!"

When he caught me smoking weed: "The fact that you can smoke weed is the only thing that proves to me that you're not crazier than I am — otherwise, you have me beat. So nice try ever pretending you're crazier than me again!"

And: "Everything you eat is either giving you a disease or helping your body fight disease." (He didn't come up with this one himself, but he says it all the time.)

Loving my dad so much is debilitating. Sometimes I wish he were a less great dad and person. It would just be easier if he weren't so wholly good; at least I'd feel less sad when I

looked at him. I don't know how it's possible for a person to be so kind and compassionate while still being so overtly aware of the stupidity of humanity. I don't know how he can have no ego at all when he has one of the greatest comedic minds of all time IMO, IMHO! He says, "One cannot be funny and also arrogant, it is mathematically impossible. If you're arrogant, then there's no way you're funny."

"How'd I get so lucky to have you as a dad?" I wondered out loud to him one day.

"I think the same thing about you."

"No, Dad, I suck. No one likes me."

"Well, their loss!" he yelled back, smiling.

SEE WHAT I MEAN? It's so unfair. Just call me a disappointment, I'm begging you!

Every time I walk into my dad's closet, I can't help but picture the day I walk in there after he dies. Running my hand through the hanging line of identical sports coats and sweaters, burying my face in his shirts that all smell of sunscreen, dragging my feet around in his Simple sneakers.

I think about the day of his funeral: Who will be there, what it will look like, whether I'll be in a fight with my sister and why — perhaps because he left her all of his money and me only his notebooks of illegible unfinished show premises. I imagine sitting there, vacantly staring, wishing to be more dead than I already was.

It's a completely different experience imagining future scenarios that you know are going to happen (rather than ones that just *might* happen) because you know that one day, you'll

be living that nightmare. That funeral will come and it will be how I pictured it. The day I see a medium will come, and I'll break down no matter what word she says. I will one day feel exactly how I imagine feeling: inconsolable and incapable of believing that I will ever be able to get up off the floor.

All I knew when I moved back home was that I would never again leave that fucking house. Well, if he died, I would leave. I would leave only in the circumstance of his death. But not until then. I didn't care if I was a nuisance whenever he wanted to bring a date home or do anything that would actually bring him joy. I didn't care that I would live forty minutes away from all of my friends and probably never keep a boyfriend because my best friend and roommate was my dad. He definitely *would* care that all of the water glasses would wind up in my room and that I'd wake him up with the smell of toast in the middle of the night. But it didn't matter if we were both miserable until he died as long as I could be in his presence as much as possible for his final twenty, twenty-five, thirty (if we're lucky), or ten (if we're not) years.

Insecurity When You're the New Girlfriend

> Cazzie's distress and dysphoria are considerable and at a level that would justify medication consultation with a child psychiatrist.
>
> — *Excerpt from neuropsychological evaluation of Cazzie David, 2007*

THERE'S NOTHING LIKE THE high of a new relationship. You're in love but, more important, *your partner* is in love. Let me rephrase: There is nothing like the high of someone being in love with you. It's like someone taking a fire extinguisher to every negative thought you've ever had about yourself. Someone thinks you and your mind are beautiful and you think that person is beautiful; could it be? *Could this person actually really love . . . me?* you marvel to yourself. They must! Or they wouldn't want you to be their girlfriend.

Falling in love is amazingly stupid. All of a sudden, you feel like you have a purpose in society, like you're a part of

something bigger, even though in actuality you have less of a purpose than ever before because all your thoughts have turned into a stream of *Me, me, me, you, you, you, me, you, you, me.* You now find it totally acceptable to go to the beach in the late afternoon just so the two of you can kiss and stroke each other's hair while you watch the sunset. You don't cringe when you hear yourselves talk to each other in a way that could be mistaken for dialogue from a terrible YA romance novel. You've lost all self-awareness; you feel no shame at the fact that you speak the same language as lustful vampires. You're touching and staring at each other all day, every hour, adding new mannerisms to the collection of things you're in love with. You miss the other when they go to the bathroom and during the hours you're asleep even though your faces are still touching. Your screen-time average plummets. At first that's because you don't want them to know you're on your phone an unattractive amount, but then it becomes natural. You don't need to go on your phone anymore, you're getting all the attention you need.

Then the dreaded day comes where their declarations of love aren't as YA-novel-sounding as you need them to be. Doubt settles in; old memories of past relationships haunt you. Being told they love you is not enough, or maybe it's just less in their eyes. The first thing you want to say to them in the morning is no longer "I love you" but "Do you still love me?" But you can't say that, so instead you look at them with wide, desperate eyes and whine, "PROMISE?!" And they're like, "Promise what?"

You don't even know what. Well, it's something along the lines of *Promise you still love me just as much and always will and will never leave me no matter what?!*

The dialogue now is him saying normal things and you getting offended because you're analyzing everything he says for evidence that he doesn't really love you. He'll say something as gentle as "Love is an incredible thing." And instead of just agreeing that love is an incredible thing, you think, *Oh, so you think love is super-common? That anyone could fall in love? That you could fall in love with anyone and have fallen in love many times?*

In my experience, the honeymoon period in a relationship doesn't end because you and your partner have gotten too comfortable with each other; it ends because you start to feel insecure. The moment you enter that dark side is when the reality that the two of you each had a life before meeting each other hits. And while having life experience can be good for both people in a couple for many reasons (e.g., sexual experience, maturity, knowledge about the female/male brain and anatomy), it can also become the cause of all of your insecurities in that relationship.

Dating someone in high school was easy. The odds were that you were this person's first relationship ever, or at least their first serious one, leaving them with no one from their previous experiences to compare you to. Let me rephrase again: leaving *you* with no one from their previous experiences to compare *yourself* to. If you dated someone during

your college years, your boyfriend (or girlfriend) most likely provided you with at least one serious ex (usually from high school) to stalk and be insecure about. College relationship exes are particularly bad, because your college boyfriend is probably homesick and his ex is the personification of home.

The moment you stalk your new boyfriend's ex for the first time is pivotal, as it is the moment your relationship will be altered forever. It's also the moment you take a match to all the good thoughts your relationship had given you about yourself, extinguishing all the joy that the metaphorical fire extinguisher brought you just weeks before. Darwin once said jealousy is a survival tactic, but if that's the case, why does it make me feel like I'm dying?

Don't forget all of the wonderful things he has said about you! Remember that day he said you were enchanted? But he's probably said just as wonderful things about the people who came before you. What were the wonderful things he said to them? They just get to have memories of nice things he said to them? While I'm with him?

My college boyfriend once asked me why I didn't wear dresses more often or dress up for him. The comment clearly came from a building frustration with the fact that I only wore pajamas day in and day out. If I'm home, I'm not going to *not* be wearing pajamas. That would be insane. I'm not a Kardashian. The second I get home I switch from jeans to sweatpants so fast, I resemble a cartoon tornado. The thing is, I'm almost always home, therefore I'm almost always in

pajamas. But it's not like he had never seen me at my best. I tried to explain it to him in a way his young-boy brain could understand.

"Well, you know what I look like when I'm not in sweat-pants, so what's the difference, really?"

He retaliated with "Well, you know what I'm like when I'm nice, so why do I have to be nice all the time?"

Instead of thinking about how ridiculous that argument was, I thought about how his ex-girlfriend probably always wore dresses, which led me to believe that his dress-preferring sentiment was unquestionably spawned by the fact that he was not over his ex-girlfriend. Meanwhile, I hate dresses so much that I look forward to winter so I can witness everyone's collective disappointment about having to wear pants. *Ha*, I'll think, *now we're ALL in pants. Including your stupid ex-girlfriend.* I unfortunately don't have the choice not to wear pants, as wearing anything else makes me feel like a fake. When I wear a dress, I feel like I'm lying. A dress represents Femininity, Joy, Positivity! All the antonyms of my character. I'm Negativity with Butch undertones.

Being the person that I am, I was nervous about going out into a world of dating where boys everywhere had more life experience under their belt. The guys I would date could have anywhere from one to five ex-girlfriends. This, I think we can all agree, is just too many ex-girlfriends for one new insecure girlfriend to handle. Older and wiser adults will tell you that the more relationships you're in, the easier it gets,

that you'll have more confidence and know how to deal with certain situations. This is wrong. The older you get, the more ex-girlfriends and ex-hookups your partners will have racked up, leading you to be more insecure than ever before. "There's a reason those other ones didn't work out!" they'll say. But why did they break up? Did she initiate it, and now he just has to live on without her, settling for someone else? Or did *he* break up with her? Even if he was the one who wanted to break up, there's always the possibility he regrets it. Is that worse than him being dumped? Is regret more lasting than rejection?

Any reason your new boyfriend and his ex-girlfriend broke up other than "I suddenly became disgusted with her" is unacceptable. There's just no way to know how much your new boyfriend enjoyed the times with all of the others that didn't work out. And when you hate yourself, it's hard to believe that your new boyfriend's experience of being with you is better than others he's had. You're just supposed to assume you're the best? How does one do that if she's pretty much positive she is not the best? Believing you're better than one person is somewhat doable, but the amount of convincing it takes to get you to believe he likes you more than three girls? Four? In any or all departments? Impossible. (*You're all special in your own ways!* says a feminist voice in my head that I buried under rocks to write this essay.)

The only type of person you can ever feel secure in a relationship with is a person who has never had a life before you.

Unfortunately, there's only one type of person that fits the category of never having lived before seeing your face, and that is a newborn baby.

Newborn babies have no ex-girlfriends, no DMs, no past hookup experiences. They don't know what they like or what they dislike. They don't even know what a girl is, let alone what a *hot, confident* girl is. A newborn doesn't have memories they can pull up at any time from that night with the sexy girl in the Jacuzzi who gave the most amazing blowjob he's ever had. Or the smart model who played a perfect game of pool and wanted to show him one of her scars from dirt-biking in the bar bathroom. (Those are my personal worst-case-scenario-new-boyfriend-greatest-hits memories, in case that wasn't clear.)

Obviously, you can't date a newborn baby. Sorry to even clarify that. So the next best route to go would be dating the most inexperienced but age-appropriate person you can find, the only pitfall being that it's up to you to teach them how to be good at sex. If the sex education is too much work for you, you can seek out someone with serious commitment issues who's had only a string of meaningless, yet informative, sexual encounters. There's just that constant mental hurdle of wondering if you are interesting enough to keep him from inexplicably leaving you to move to Paris or go to grad school. You could also go after someone with just one official ex-girlfriend, but that ex-girlfriend needs to seem so awful that you aren't jealous of her at all. Except if she is evidently that bad, it can only mean she has some other redeeming quality that

he couldn't help but be in love with. She was probably really sweet or the life of the party. She helped him through a really rough patch, had great taste in books and music and movies, and all of his friends and family loved her. She probably dressed up for him.

Yeah, it's a newborn or therapy.

Environ-Mental Mom

MY MOTHER IS AN environmentalist. An overzealous one. I know what you're thinking: *What a swell gal, How nice of her.* It sure was nice for the rest of the world, but it certainly wasn't nice for me growing up.

For my entire life, my mother's job has been to help inspire change to protect the environment, from big to small. She organized and advocated — lobbying Congress, speaking at schools, fundraising, working on increasing fuel-economy standards, and producing documentaries on the climate crisis. Meanwhile at home, she was an absolute eco-friendly dictator. Everything that wasn't done in an ecologically efficient way was scrutinized. That's generous of me; truthfully, everything was scrutinized — if you're inside reading, she asks why you're not outside. If you're outside, she asks why you're not inside helping with something. If you're sitting eating snacks, she wonders why you're not exercising. If you mention being sore from your workout, she'll say, "You work out too much

— it's not healthy and you need to eat more snacks." But the environmental scrutiny was always the most passionate and thus the most frightening.

The only times I was ever grounded by my mother was when I left a towel on the floor or didn't unplug something after using it. "You're part of the problem!" she'd yell. "If you can't unplug a charger, you can't have children, because they will have to grow up in a world that is MELTED!" I lived in fear of accidentally leaving lights on after I left a room, not because I thought I would single-handedly melt the earth but because I knew if I left the lights on, my morals would be seriously questioned.

When I was in elementary school and kids asked me what my mom did for a living, I told them she was an electric-car salesperson. I said this because I believed that was her job. Why else would someone get out of her car and approach every parent in the carpool lane to tell them they needed to buy an electric car? I thought she was just hustling. I didn't find out until 2005 that she didn't work for the electric-car industry, and that she was instead just crazy.

When I was growing up, no one else I knew seemed to have any idea about the severity of climate change, let alone their carbon footprint. It felt like this niche, bizarre thing that only my family had decided to devote their lives to, like being Scientologists. And the same way Scientologists try to recruit or save people, so did my mom, informing every parent and stranger she came across about how they could do better, with

an additional ten-minute bonus lecture about the precise ways in which the planet was burning up.

In most houses, drugs and alcohol were prohibited. In mine, plastic was. Bringing plastic into my house was as disrespectful to my mother as bringing in a rock of cocaine. It wouldn't matter if I was dying of dehydration and my only option was buying a bottle of water; I think she would rather I drank my own urine. One time when I really wanted to upset her after a fight, I bought a six-pack of plastic water bottles and placed them in different spots around the house. As punishment, she forced me to stare at pictures of landfills, disturbing images of plastic that had settled inside whales' stomachs, soda rings choking turtles, and balloon ribbon suffocating birds. Then she made me keep all of the bottles in my room for eternity as flower vases — "Must reuse everything!" Ten years later, we probably still have them somewhere.

My mother's attitude toward plastic was tolerable compared to some of the other house rules that my family endured on a daily basis. Turning on the air-conditioning or heat was strictly forbidden. If either system was ever turned on out of sheer desperation, she would have us line up in the living room — me, my dad, my sister, and our housekeeper — as if we were at a police station. Pacing back and forth in front of us like a detective, she peppered us with questions and demanded to know the culprit.

At some point, she realized how long my sister's showers were, so she started monitoring everyone's shower time. She bought these special extra-loud alarms for all of us and would

yell, "Soap up and rinse!" right outside the door. We were each allowed two minutes, which she thought was more than generous, considering the environmental repercussions if we were in there any longer. My dad and I held a grudge against my sister for years for ruining showers for us all.

Complaining was the communication style of choice in my house, but it never fazed her. Nothing was going to get in the way of us doing "the minimal amount" to save the planet. *"We just want to be comfortable! Is that so wrong?! We deserve comfort!"* my dad would yell. It seemed reasonable to me. No one in any other household I'd visited seemed to get yelled at for using paper towels to dry their hands or wipe crumbs off the counter.

We cared about the environment because we had to out of fear of reprisal. That's not to say that we didn't believe it was as important as she made it out to be. It's hard to question anything my mom says because she has no doubt in her mind that she's right about everything. I know this because she once told me, "I have no doubt in my mind that I'm right about everything." As a result of never thinking she's wrong, she has also never felt insecure. She is so freakishly confident she can barely fathom how she could have raised someone who is anything but. I do wonder if my mother would be just as confident if she'd grown up with social media, having to be subjected to a million people's faces, bodies, and personalities, but if anyone could, it'd be her.

Because of my mother's inherent confidence, she hosts one hell of a nonprofit benefit and salon. I can barely go to a

dinner without having a panic attack, let alone host my own. Every week when my sister and I were growing up, she'd host a dinner with the most interesting human beings, experts in every field. You would not be at the table if you weren't what she considered interesting. Or if you were a slob, which was why I was no longer allowed to attend after I spit-taked in front of Senator John McCain. Still, no matter who was sitting at the table, my mother's presence was always the most dominant (at least through my eyes as a kid), which often made it hard to know who really was the most important person there.

She would tell people exactly where to sit and then would follow it up with "Sit wherever! There are no bad seats!" There were definitely bad seats, and she knew exactly which ones they were. Hosting seemed like this unique skill she was born with. She always made the guest of honor feel special, kicking off the gathering with the kind of toast that would usually only be heard at a birthday party or a funeral. Conversation was never boring, and there was never a lull, a result of her ensuring there were always funny people at the table and that only "one conversation!" was allowed, something she shamelessly blurted out whenever anyone started to have a side discussion. Of course, the main goal of the dinners was to debate important issues affecting the world and persuade people who were in positions of power to do whatever they could to help, starting as soon as they left the house. This, I had no problem with; she was free to educate anyone who came over voluntarily about environmental de-

struction. As her daughter, I don't know how voluntary my situation was.

My least favorite thing to do with my mom, besides going to the beach where she tells strangers not to put on sunblock before going in the ocean because it's bleaching the corals, is grocery shopping. Shopping is not an activity I recommend doing with an environmentalist. My mom is appalled every time she enters the market, acting as if she hasn't been there a million times before.

"Look at this! Plastic, wrapped in plastic, wrapped in plastic," she'll pontificate as we make our way down each aisle. "WHY DOES A TANGERINE NEED TO BE WRAPPED IN PLASTIC?!?! I'm bringing this up with the store manager."

"Mom, please, do you have to?"

"And look at this — coffee filters. Can you believe people buy these things? Every morning throwing another one out when they could use a percolator and waste NOTHING!"

I'll nod. There's nothing else to do.

"What's even worse is the people who order their coffee filters ONLINE! Creating endless fumes from the delivery truck just to drop off your precious coffee filters, all because of your laziness and greed. Ordering anything is just terrible, not to mention it makes local stores go out of business."

"Totally," I'll agree.

"And how about people going *out* for coffee every morning! Plastic top, plastic cup, plastic straw, now existing in a landfill FOREVER. BECAUSE OF *THEM*. I hope any time you see someone drinking coffee, you tell them that."

"Yes, I try to." (I definitely did not try to.)

Once, on one of these trips together, I threw a pack of tampons onto the conveyor belt when we got to the checkout line.

"Nope. You're not buying those," she said in her usual disturbing tone, pushing them away from the checkout guy, who had just reached his hand out to scan them.

"What? Why not?" Right after the words came out of my mouth, I realized why.

"They're plastic. Find eco-friendly cardboard ones," she said. The checkout guy's face contorted into an expression of pure vicarious embarrassment.

"There weren't any! Sorry, but I need them ... now," I murmured, doing my best not to be heard by the checkout guy. He started to press buttons on his register to escape the awkwardness. I could imagine his internal monologue: *Yep, that button works. So does that button. Great, great, great, all the buttons work.*

"Not only will the plastic from that tampon sit in a landfill for eternity, but it has chemicals in it that will *seep* into your *vagina*. Do you want that?"

No, I did not want that.

Cardboard tampons weren't that bad; they were just a tad less ... smooth going up. What actually was bad was the 100 percent recycled toilet paper we had in all of our bathrooms, which led to a never-ending battle between my mother and our butt cracks. It took years for my butt to adjust to the thin, scratchy eco-paper, mostly because anytime you used any other bathroom *anywhere*, you would experience the softest,

most-horrible-for-the-environment toilet paper your butt has ever felt. Our toilet paper felt like you were using a winter leaf.

My dad had a secret stash of Charmin he kept underneath the sink for "emergencies," which I guess now must have meant diarrhea. When my friends came over, I'd steal one of the Charmin rolls because our toilet paper embarrassed me so much; every time someone came back from the bathroom, they'd ask what was up with my TP. I didn't want to be known at school as "the weird girl with the weird toilet paper." Kids are mean! That stuff happens!

When my friends started driving, I made them pick me up a block away from my house if they had what my mom called "a gas-guzzler." When my friends asked me why they had to park so far from my driveway or why they had to leave their Starbucks cups in the car, I would simply tell them the truth: "Because my mom is crazy."

One day, my friend Julia was picking me up for lunch, and I looked out the window just as she was pulling her mother's SUV into my driveway. Frantically, I said goodbye to my mom and told her I was in a rush because Julia was outside waiting. I ran out of the house desperately hoping my mom wouldn't follow, but she did because she "just wanted to say hi."

GO! Drive! Get out of here! Leave me behind! I wanted to yell to her. It was too late.

"There's three kids in my family. This car fits all of us," Julia whimpered to my mom.

Later, I tried reasoning with my mother by saying that

maybe they couldn't afford an eco-friendly car. Wow, was that a dumb thing to say.

"OH?! But they can afford a hundred dollars' worth of gas every week?! Inexcusable! The *environment* can't afford their carelessness!"

It was clear my mom had officially lost her mind when she started putting fake parking tickets on gas-guzzlers. They read: *This vehicle is in violation of polluting the planet.* (Yes, the notices were printed on recycled paper.) Whenever we went out anywhere, we had to account for an extra ten minutes so she could park her car and hand out tickets. I'd anxiously wait for her, hiding on the floor of the car, occasionally peeking out the window to see people's reactions once they discovered them on their windshields. Some people crumpled them up and tossed them. Some laughed because of how downright insane it was for someone to do this. Others looked genuinely confused, as if it were a real ticket. Word eventually spread that my mother was doing this and they ended up parodying her on *South Park*, which I thought might officially shame her out of shaming strangers. But it didn't.

"Good," she said after we all watched the episode that roasted her. "Maybe someone will be inspired and reconsider driving a gas-guzzler that will contribute to their future grandchildren's asthma. Do you know how many people are going to have asthma and allergies in the future because of air pollution?"

Much to my dismay, my mother's righteousness didn't end with environmental rules. Her documentary topics began to

widen into other areas that you also would never want to be scolded about by a stranger. The time she was researching for her documentary about the sugar and food industry was a particularly bad era. My new boyfriend and I had just parked outside of her house when I noticed he was holding a Mexican Coke bottle. It was his first time meeting my mom, so he had no idea what was about to transpire, but I did.

"Don't bring that soda in."

"What? Why?"

"'Cause my mom is crazy."

"But it's not plastic."

"It doesn't matter. Trust me."

"Come on. It'll get hot if I leave it in the car, and then I won't be able to drink the rest."

He opted to bring it in, and as I expected, it was the first thing my mother noticed. Her eyes were drawn to the bottle before she'd even looked at his face.

"So nice to meet you! I'm —"

"Do you know how much sugar is in a bottle of soda?"

"Uh . . . no?"

"Why don't you take a look at the grams on the back of that bottle."

"Uh . . . okay." He turned the bottle around and looked.

"What does it say?" my mother asked, knowing the answer full well.

"Thirty-nine grams," he said nervously.

"Thirty-nine grams. And do you know how many teaspoons of sugar thirty-nine grams is?"

"No," he muttered.

"Ten teaspoons of sugar. Ten teaspoons of sugar have been dumped into that tiny bottle. Would you eat ten teaspoons of sugar?"

"I don't think so . . ."

"Do you know the diseases this thing causes? Heart disease, cancer, diabetes, obesity . . . this corporation is making millions of people sick and then broke because they have to spend all of their money on medical bills! And you're a part of it! Consuming that much sugar is as bad for your body as smoking cigarettes!" He also smoked cigarettes, but neither of us would be stupid enough to mention that.

The encounter ended with her pouring the rest of his soda down the sink drain as he looked on like a little kid being punished. Let's just say neither of them made a good first impression on the other.

When she told me about her next documentary topic — technology addiction — I knew my days of technological freedom were over. The only thing she could talk about for months was the similarities between iPhones and slot machines. Anytime I picked up my phone, she saw it as a confirmation of my addiction. Even when she was the one calling me, it somehow turned into a conversation about my bad habits.

"You answered quickly. Were you on your phone?"

"Nope."

"It only rang twice before you answered. You must have been looking at it."

"Nope. It just coincidentally happened to be near me at the moment you called."

"I hope you're taking breaks from that thing. You have an addiction, Cazzie." She always called my phone "that thing," which was ironic considering she was definitely addicted to her Apple Watch, the smartphone *thing* for your wrist.

"So, Mother, how was your day?"

She'd continue. "Did you know they make the notifications on your phone red so that you think it's an emergency and check them immediately? If the notifications were green or blue, you wouldn't feel the need to open them as often. Who knows the impact this is going to have on our brains! Everything programmed on your phone is meant to suck you in for as long as it possibly can!"

According to her research, addiction wasn't the only negative side effect of our phones. *Text neck* was a term I heard so often, it began to feel like my name.

"Cazzie, text neck." I'd immediately put my phone up to eye level. "Do you want spinal surgery when you're thirty?"

But text neck was nothing compared to the radiation anxiety. She ordered all of us magnetic gloves to hold our phones to keep the radiation from seeping into our hands. We avoided wearing them whenever possible because we didn't want to look as crazy as my mother made us feel.

The documentary she worked on right after tech addiction was about ivory poaching, debatably the most distressing topic of all time. Truthfully, though, there was a part of me that was relieved by it, regardless of the disturbing information on

the subject I'd come to learn. Ivory wasn't as ubiquitous as phones, sugar, energy, gasoline, or plastic. My mom wouldn't be able to harass someone on the street for killing elephants. Or so I thought. After she found out a jewelry store on Martha's Vineyard sold ivory bracelets, she made me come with her to protest outside of it, telling anyone who dared enter the store the harrowing details of the ivory trade.

Living in her household, I dreamed about the day I could move out and live without restriction and constant information. I could leave towels on the floor and plugs in their sockets. I could ignorantly be sucked into my phone for hours. I'd have toilet paper so soft, I wouldn't dread going to the bathroom. My boyfriends could drink soda and I'd maybe even use plastic tampons to make that insert the tiniest bit more agreeable. My showers could be leisurely affairs if I wanted; I could even take a minute to sit on the shower floor and cry as the hot water came pouring down. Something about that always seemed so appealing. And in case of dire thirst, I'd buy water in a plastic bottle that I'd mindlessly toss after a single use.

But when I finally was on my own for the first time, it wasn't anything like the liberation I had imagined. Every time I wiped with the soft toilet paper, I felt guilty. I wasn't able to bring myself to use plastic tampons, bags, or bottles. Text neck still scared me. Even boys who drank soda scared me. My showers remained military-fast. I'd bring a reusable cup to buy coffee and stare at all the people around me using plastic and throwing it away, thinking about how this was just *one*

coffee shop out of millions in one moment out of billions. I lived as though my mother were standing next to me at all times, questioning my values and the person I was because of my daily choices.

It wasn't long before I became a straight-up mini version of my mother. The first time I realized it was when I was back in Los Angeles for spring break and saw a woman watering the plants in her front yard drop the running hose on the ground to chat with someone in her driveway. As I stared at the sparkly water gushing out onto the already drenched spot on her lawn, an overpowering wave of anger rushed over me. I tried with every fiber of my being to stop myself from saying something, but I couldn't keep it in.

I self-consciously shouted across the street, "Um, hi! Sorry! Your hose is running! It's just so . . . wasteful."

The woman stared at me incredulously. "What the fuck? Mind your own business."

I nodded and backed away as she huffed and turned the hose off.

Afterward, she went back to her conversation and I overheard her say how obnoxious I was. But like my mom, I didn't care. Instead I felt an unfamiliar sense of pride that I was able to save maybe a minute's worth of running water and perhaps make this woman think twice the next time she watered the plants. I guess it took me becoming my mother to finally realize that my mom was a hero for being so fucking crazy. And if everyone was brave enough to act half as socially inappropriately as my mother, the world would be in a better place.

Today the planet is burning before our eyes. Because of that, it's become morally necessary for everyone to at least appear to care about the environment.

The other day I was standing behind two girls in a supermarket checkout line.

"Would you like a bag?" the cashier asked them. The girls raised their eyebrows in unison.

"Um, no . . . hello? The *environment?*" they said in stereotypical Valley girl accents.

I smiled, thinking about the shame I used to have around my mom when she said that and I had to watch her passionate speeches fall on deaf ears. I guess the only good thing that's come out of the world's imminent ecological end is that my mom doesn't sound crazy anymore.

We're now two degrees away from the most vulnerable regions being wiped out, fundamental species extinctions, unendurable heatwaves, and mass amounts of people dying. Many of us have grown up witnessing devastating floods and tornados and droughts and hurricanes and earthquakes. We watched almost five hundred million animals burned alive in the Australia fires. Five hundred thousand is a lot. Five thousand is a lot. Five hundred is a lot. Fifty would be a lot. Five is a lot. But five hundred million? That's five hundred million *Marley & Me* movies. How do you distract yourself from that horror? Talk about boys? Watch television with no bathroom breaks until you die? The point is, we're fucked.

Every new natural disaster I groan on the floor to my mom, "*Moooom, what do we do?!?!!*"

"We get the world to start doing something about global warming. We raise money for NRDC, and we elect Democrats." It's the same thing she said twenty years ago.

"Mom, it's too late!"

"We can still prevent the next one," she'll say matter-of-factly.

Apparently, my mother, the biggest worrier I know, has always moonlit as an optimist. "I don't get it. How can you have any hope right now?"

"You can't be an environmentalist without it," she'll tell me. "It's part of the job."

And really, that's everyone's job. To always have hope, to always keep fighting for justice in the face of new injustices every day.

In other words, to always be crazy.

Tweets I Would Tweet If I Weren't Morally Opposed to Twitter: II

The worst text I can receive is my mom texting me *Call me when you're up.* Like . . . what. So I can talk to *you????* When I WAKE UP?!?

Having a TV in your bedroom is the best thing that can happen to you in life. Period.

I can't imagine being a teenager right now and having the boys I like wear a single long earring and grind in the air on the internet

The one thing every girl has in common is a deep hatred for when their boyfriend gets a haircut.

It takes such manipulation to be able to convince your boyfriend not to get a haircut without him knowing the

reason is because he looks so bad every time he gets one.

I'm the luckiest person in the world but sometimes I think God actually is only laughing at me

My new thing is tricking God into thinking I do not at all want the thing I want the most by constantly thinking about how I don't want it. I'm hoping that will make Him give me what I want the most. We'll see if it works.

People can't hide their excitement when they realize their friend is taking a video of them doing something silly even though they know that excitement will now be apparent in the video

My friend told me she's never had a cigarette in her life and it was the rudest thing anyone has ever said to me.

Eating a lemon is a really good substitute for cutting

I can't look anyone in the eye. I don't know if it's because I don't want them to really see me or I don't want to really see them, but I think it's 'cause I don't want to violate their soul by looking into their eyes. I don't have the right

My daily chores are looking at the Instagram stories
of everyone I hate the most every morning

Seeing my dad cry is like watching a dolphin be
murdered

I've only heard my dad cry once and it replays in my
head whenever I'm doing nothing just to torture me
with its sadness

Living with your dad is cool, you just constantly
overhear him and his friends talk about who has
cancer right now, who's finally cancer-free, and who is
waiting to hear if they have cancer

One of the most frustrating things to ever happen
to me was when I got sick in college and bought all
seven seasons of *Gilmore Girls* on iTunes and a day
later it came out on Netflix.

There are twenty desperate horny straight girls for
every one guy who doesn't care about any of them

Main goal in posting absolutely anything online, no
matter what it is, is to make every person who's ever
gone out with you feel pain and every other person
think you're a mood

The human body is amazing; I can't believe I can
have this level of internal anguish and not have
imploded yet

High thought: Have you ever examined a zipper
before? Like, really examined it? 'Cause whoa.

Two things I heard two of my insane friends say:
(1) I've been super-respectful with her. Yeah, every
time I've fucked someone else, I've used a condom.
(2) I fucked a couple, independently. It goes against
all logic.

The easiest mind trick you can play on someone is
pretending you're confident and sexy. People actually
buy it; it's wild.

It seems you're still reading my book. I'm so sorry.

We don't talk about the trauma of UTIs and yeast
infections enough.

People who aren't foreign who greet people by
kissing them on the cheek cannot be trusted

My biggest fear is people hating me, yet I do nothing
at all to prevent it from happening

The closest I've ever gotten to watching porn is rewatching *The Outsiders* every six months since I was thirteen

My favorite thing is when Dua Lipa is off the market

If you meet a guy who doesn't know who Dua Lipa is, marry him

Don't say your significant other's name for the entirety of the time you date bc by the time you're on your fourth relationship you WILL call them the wrong name. Maybe even multiple wrong names. Names are for spouses only

If you have delusions of what your face and body look like, make someone else make your bitmoji/memoji for you.

I obsess over a new aspect of my face every month and won't stop until I've looked up a hundred pictures of other people's chins, lips, freckles, etc and find one person with the same thing I have who I don't find unattractive so I can believe that maybe I'm not either.

Remember in high school when you thought u were depressed bc u put on Bright Eyes and cut yourself

but didn't want to do any real damage so they were just pathetic meandering red scratches you'd trace over again and again until they made a mark so you could have evidence of your own depression? Just me?

One of the most telling examples of how easy men have it during sex is that women have to focus with all their might on coming, and men just have to focus on not coming.

If ur caption is a paragraph I probably won't read it unless I scroll to the bottom and it says RIP

Where's more embarrassing to say where you met your husband, on Hinge or at Coachella?

A perfect explanation of how my brain works is I had splitting migraines for seven days in a row and my first thought was I have brain cancer and my second was I'm developing superpowers.

The inside of a grapefruit looks like alien flesh

On a scale of sadness from 1 to 100 a waiter working at a restaurant not getting any business is like an 11. But anything on the scale from 1 to 100 can feel like level 100

Even if there was nothing sad in the world except for one old, lonely dog that died fifty years ago life would still be sad just bc of that knowledge

The meanest thing you can say about someone's work is "It's cute."

My mom said my book was cute.

I saw my therapist after she watched the premiere of *Curb* and she said, "I watched *Curb* last night." I said, "Oh yeah?" She said, "Yeah. Cute." I wouldn't tell my dad that but he's read it now in this book.

The way that people force themselves to pay attention to politics so they don't become complacent is what I do with stupidity. Yes, that's right, I take on the enormous burden of hyper-focusing on people's secret awfulness for the benefit of society. I'm a true hero.

Shit-Talking Etiquette

Ms. Muller and Mr. Baron, Cazzie's math and English teachers, rate her with significant externalizing problems (sometimes annoys others on purpose, gets in trouble, defies teachers, disobeys; teases others). Both teachers in addition to Mr. Tsakiris see symptoms of depression (almost always seems lonely, is sad, is negative, is pessimistic, is easily upset, says she doesn't have friends) while Mr. Baron and Mr. Tsakiris also see symptoms of withdrawal (almost always refusing to join group activities).

— *Excerpt from neuropsychological evaluation of Cazzie David, 2007*

DEPRESSION IS THE OPPOSITE of anxiety. It numbs you from your head to your toes and makes you feel like nothing matters. You don't care about anything or anyone, including yourself. Anxiety, on the other hand, makes you feel everything. You care about everything and everyone, *especially* yourself. Depression has always been the only cure for my anxiety. Deep down, there's a relief in it. It takes all of the

terror I feel about everything away, and although the misery is excruciating, and I no longer value myself or my life, that state of mind is almost preferable to the constant panic and fear that will slowly kill me while I panic about being killed.

There is something about depression that makes me feel powerful, like I've developed a weapon that can hurt someone just by having them look into my eyes. No matter how deeply someone were to stare, all they'll see is a wall that screams back, "YEAH, SCARY RIGHT? I DON'T GIVE A FUCK ABOUT ANYTHING!" I'll drive recklessly, smoke cigarettes, get on the back of a motorcycle, be able to stand outside alone at night and not freak out. Meanwhile, when I'm anxious, I'll drive below the speed limit and question the act of driving so much so that I'll forget how to drive and have to pull over until I can stop my brain from overthinking the concept of automobiles. I'll worry about every toxin I've ever put in my body. I wouldn't get on the back of a motorcycle for one million dollars and I am not brave enough to sit in my own living room at night.

If depression is the opposite of anxiety, misanthropy is both of them combined plus rage. It's the only thing I've found more challenging to live with than my depression or anxiety, and I often consider it the catalyst for both of these conditions. The people you have around you can help calm you down or distract you from your anxiety. Sometimes just knowing there are people who are there for you can help with depression. There are no people who can help you with the issue of hating people.

Misanthropy is so all-consuming that it should really be its own disorder. Symptoms include thinking something is deeply wrong with you for thinking how much is wrong with everyone else; having so much energy you don't know what to do with it and yet not enough energy even to make an expression on your face; a soul-sucking, heavy depression you feel in every cell, especially your chest and eyes. Your blood is *always* boiling; you have a constant desire to punch everything but you also want everything to punch you back. You're always on the verge of tears but too angry to cry. You are in an eternal bad mood, because what is at the root of every single bad mood anyone has ever had? People.

It may seem like my policy when it comes to hating people is that they're guilty until proven innocent, but that is not the case. Like a true American, I abide by the rule that someone is innocent until proven guilty. It's just that many people tend to prove themselves guilty the second they open their mouths. Humans are deeply flawed. They can be pathological liars or have ulterior motives, they fall asleep during movies, or, on a milder but just as enraging scale, they simply don't get it (*it* being *agreeing with all of my opinions*). Inauthentic people are all around us, often living under the guise of "nice." "I think she's nice," someone will say. "You'll like her, she's really nice." No, I won't like her because she's nice. *Nice* is a meaningless quality. Sociopaths can be nice. You need to be more than just nice for me to like you.

Of course I don't actually hate *everyone*. There are many people who are painfully good, so brave, strong, kind, and

hardworking that it makes you hate the people you hate more than you already do. People who devote their lives to helping others, people who face injustices, people who actually do get it. Most people either make me cry from the absolute love I have for them or enrage me. Then there's a gray area, which is composed of people who are great except for the fact that they like things or other people I can't stand. I'll meet someone who is seemingly good-natured and think to myself, *Oh, cool, I don't hate them,* but then I'll check their socials and think, *How can I like this person who likes and supports someone that I wouldn't follow on Instagram even if they saved me from a burning building?*

Still, I hate myself more than all of the people whom I hate combined, which is deeply confusing considering the amount I hate them. There's a whole lot you could say about me; I think of something new every time I breathe or move my body. I'm constantly inducing anxiety in others just from my presence alone. My disposition is persistently that of a teenage boy who wants to leave the dinner table so he can go play Nintendo. I'm wildly inarticulate for someone who wants to be a writer. I know close to nothing about anything but come off like I think I'm smart because I'm far too opinionated and much too passionate about those opinions, which are only ever in regard to things no one else cares about. I'm like the Nelson Mandela of petty grievances. There are also hundreds of mean comparisons that can be made about my face and voice, starting with the fact that I look closely related to Nick Kroll and sound like a man with pneumonia.

My worst trait, though, would be that I talk too much shit about people. It's okay. I have come to terms with it, as it is the only thing that has ever eased my misanthropy. I know when I die, people won't be able to say the things you want them to say, like, "She only saw the good in people." "She never said a bad word about anyone." "She didn't have a speck of envy or anger inside her." "She was a true angel." When I die, it will be more of a Steve Jobs situation, where people can't help but recognize and discuss my obvious flaws — except I'm not also a genius.

My shit-talking seems to have environmental roots. When I was growing up, after my mother hosted some dinner party or event and the last guest had sauntered over to their car, my parents, sister, and I would all gather in my parents' bedroom to talk shit. It might be the only thing the four of us have in common — a keen ability to detect the most inconsequential flaws in others' social behaviors. Anytime during the party that I observed something I knew we'd all find ridiculous, I'd store it in my head to bring up later, bursting with excitement to get it out of me and make my family laugh.

Going to school turned out to be a challenge, as it was like one massive dinner party every day. I had a 24/7 urge to talk shit about people. The quality was noxious. Every critical thought made me feel sick. But on the rare occasions when someone agreed with or, better yet, laughed at my shit-talk, I'd feel the opposite. It was only in those moments that I didn't feel alone, because there is nothing more isolating to be in this world than someone who hates everything. No one can

relate. Even the people who claim to hate everything don't, actually, because if they really did feel the agony of hatred they wouldn't post a Wednesday Addams meme and write *LITER-ALLY ME* on it because they too would hate people who did that. They would hate all people who write *Me* on anything because it is an admittance of unoriginality to openly relate to something that is purposely made for people to relate to.

I know this is starting to read like the Joker's notebook. To be honest, I likely have many of the characteristics of a murderer without whatever it is that makes you actually fucking kill people. Imagine how angry murderers would be without the outlet to kill? That's me. Well, me and, like, Eminem. Which is why I need to talk shit. Because I can't rap.

Surprisingly, my misanthropic tendencies never made it hard for me to make friends. It only makes it hard for me to *like* my friends. You start to feel truly evil when one of your closest pals innocently sings along to the radio and for some reason you can't understand, it makes you fantasize about biting your fingers off, one by one, like a werewolf, gratifyingly ripping them right off their stupid knuckles. *Both of us should be in hell!!!* I'll think, them for singing and me for being so affected by the singing.

I met my first best friend, Rachel, in middle school, and we immediately became inseparable. We would sit in her bed taking embarrassing thermal photo-booth pictures on her laptop and talking shit about all of the bizarre things people from school were doing. She was smart and funny (rare), and we found almost all of the same things idiotic. The things I

couldn't express as to why I found them so stupid she could, and vice versa. Like shit-talking fireworks. And what more can you really ask for in a friendship?

Unfortunately, as it turned out for most people I would spend my time with, the more I hung out with Rachel, the more I unintentionally started to think shit about her. It all began when I unexpectedly got my period in her bed one night. A universally embarrassing incident, but at least it was in my best friend's bed, I figured. The next morning when she woke up, I tentatively told her about the stain. She abruptly got out of bed and paced around the room in a panic, making big hand gestures.

"FUCK!" she yelled.

Probably the opposite of the reaction I had predicted. Usually when an *accident* occurs, you at least pretend not to be upset.

"I'm sorry," I said, thrown. "It was obviously an accident."

"I mean, it's fine. I guess. It's just my mom is going to freak the *FUCK* out at me."

It's always intimidating when someone can enunciate a *fuck* really well, which she could. "Why would she freak out at you? It was my fault."

"You don't know her. She just will. I'm telling you, I'm going to be in so much trouble!"

The period situation was my first understanding of "kicking a man when he's down." To simply not kick a person when she's down is the most effortless form of kindness there is, a non-action action that some otherwise normal people are

completely unable to do. My sister also kicks people when they're down. My ex-boyfriend once spilled chlorophyll water onto our rug when my parents were out. He was so nervous, he ran to get a wet rag and ferociously scrubbed at the big blue droplet.

"It's not going to come out. It's chlorophyll," my sister said, standing over him with crossed arms and zero compassion.

"It's fine! Please don't worry about it!" I told him. His anxiety over it made me so anxious, it was as if my sister was actually kicking him.

"I mean, it's not fine. It's a really bad stain," my sister said, bludgeoning him with more guilt.

"Romy. Yes, it is! *Stop!*" I opened my eyes as wide as I could to wordlessly make her understand how insensitive she was being. But my sister never understands nonverbal cues. Anytime I've tried to give her one, she'll just say, "Why do you keep making that face at me?" Or "Ow! Why'd you just kick me under the table?"

"How is it fine? It's probably an expensive rug," she said as he began to scrub even harder. I was mortified. I knew my parents would understand because it's nearly impossible to get angry at someone over an accident. They didn't mean to do it! That's the definition of an accident! I knew Rachel's mom, similar to my parents, wouldn't freak out at my unforeseen blood because I'd found her to be, at the very least, a decent person.

A bit after we awoke, Rachel's mom entered the bedroom, leading Rachel to throw the duvet over the stain in a panic. I

believe she did this not to hide it from her mom but to hide the fact that her mom wouldn't get mad. Because of this, I decided to tell her mom myself, as it was my fault anyway. Predictably, she couldn't have been nicer about it. Is there another way to act toward a humiliated, awkward teen who is very new to periods and the stains that they cause?

Irritations like this started to build up. The more time I spent with Rachel, the more I realized that much of what I originally looked up to her for was artificial, all the way down to her voice. I'd watch in horror as she'd effortfully push out her lips as far as they could go and use an intentional lisp, one that would turn even stronger when she met new people. One day, she actually tried to convince me with a straight face that she was psychic. Absurd. I knew for a fact she wasn't psychic because, first of all, if anyone was psychic, it was me, not Rachel, and my psychic abilities confirmed to me that not only was Rachel not psychic, she actually made stuff up. Obviously we were kids, and kids make stuff up. In reality, it was more normal for her to make stuff up than for me to be so bothered by it.

I could tell she was starting to get annoyed with me too. She had never been a particularly accommodating person, but she soon became exasperated by me needing anything anytime I was over. She'd roll her eyes, annoyed that I was a human who required things that were essential for survival, like water, snacks, or a phone charger.

I reached my breaking point when a fake British accent started to sometimes "slip out." I swear, 85 percent of people

with British accents who live in the United States have fake accents and will openly tell you — in their British accents — they've lived in the US since they were two. Like, at least lie and say you were fifteen. But now that I knew she was one of those people, I needed to talk shit about her. And I'm sure she needed to talk shit about me. I know you're not supposed to talk shit about your friends, but it is quite literally the only thing that helps you cope with the nightmare of having friends. So I confided to one of our mutuals about the fake voice, fake psychic abilities, et cetera. I felt so much better, even though all my friend said back was "Oh, I never really noticed." No surprise there. Most people don't notice anything, even after they're told. Straight guys, especially. Straight guys can barely differentiate between a person who is normal and a person who is blatantly psychotic. A straight guy could be stalked and photographed by a girl and if you brought up how fucked up that is to him, he'd say, "I don't know. She's just doing her thing . . . why do you care so much?"

Not too long after I had gotten the Rachel annoyances off my chest, I started at a new high school, which meant a whole new crop of people for me to hate. This school was a lot different than my previous one. Most of the students had recently been expelled from their last school, like me. Well, not really like me, as they were generally expelled for drugs and not bad grades, which made me wish I had just brought drugs to my old school so I could at least have left with some respect.

In this new environment, I quickly made friends with a

group of girls who appeared to get it the most. I could only attribute their fondness of me to my shit-talking skills, which I resorted to out of fear that they wouldn't want to hang out with me if I was boring. Sadly, the only way I knew how to not be boring was to be funny and the only way I knew how to be funny was to talk shit. They were definitely more experienced a.k.a. cooler than I was, which became clear after I listened to their stories of attending raves (I had never heard of a rave before) and giving blowjobs to nineteen-year-old guys in the alleyways of Venice Beach (disturbing but seemed cool?). They also loooooooved drugs.

Every weekend, they'd buy an eight ball of cocaine and a bagful of two-milligram Xanax bars and crush them up into two separate mountains on the table, like they were old-timey rock stars. No one at my old school had done hard drugs. These girls had been doing them since they were, I don't know, eleven!?! They never peer-pressured me; no one does that anymore. Regardless, I didn't want to be the only one not doing drugs. I had never been a part of a friend group before, and even though my position felt secure, I didn't want to be the loser of this crew. I could tell they all thought they were straight out of the movie *Thirteen,* which they never referenced but had obviously all watched twenty times and thought to themselves, OMG, *this movie is so me, it's my exact life!* So I'd carefully participate, never doing above the minimal amount I had to in order for them not to say, "You won't even be able to feel it!" But on the "special occasions" they

got ecstasy pills — their "absolute favorite drug!" — I faked it. I faked it because the only thing dumber than faking taking E is actually taking E 'cause that shit can fucking kill you.

The hypocrisy did not escape me. I talked shit about Rachel for being fake. The main reason I hate people is because they're fake. But yet here I was, *faking*. And not just faking but faking taking ecstasy — the worst thing I could ever be forced to fake because the feeling you are supposed to have on ecstasy is constant pleasure. This could not be a more unnatural emotion for me. Faking an orgasm, something I don't particularly enjoy doing, is still preferable to faking being on E because you're at least in the act of sex. On ecstasy, nothing is happening, yet you're expected to experience an orgasm from a light arm graze or the sight of stupid flickering lights. You're all starry-eyed and swaying, savoring things that could not be more disgusting, like a stranger coming up to you and touching your face all over. If you weren't on drugs, you'd be fucking horrified, and if you're pretending to be on drugs, you *are* horrified, but you're forced to pretend that you love it. I knew that if someone found out I had faked it, I would be the best subject for shit-talk ever, and I'd deserve it.

I looked forward to Saturdays because I got to spend them with Rachel and didn't have to do drugs or fake doing drugs. Our friendship was better than ever now that we saw each other only once a week. I had only good things to say about her. I did, however, have a whole lot of things to say about my new friends, who I now saw every day of the week. But talking about them wasn't nearly as enjoyable as the shit-talking con-

versations Rachel and I used to have. Shit-talking, like improv or tennis, is most gratifying when you have someone to bounce things off of. Someone who can contribute because they understand the circumstances too. There were also no reasons I could think of as to why we weren't all hanging out, so one Friday after school, I introduced Rachel to my new friends.

It wasn't long before Rachel was invited to every drug-infested kickback Megan held. It was unsaid, but it was clear that Megan was the leader of the group, presumably because she had done the most drugs and given the most blowjobs. Also because her house had no rules. My parents would never have thought it was possible for any of this to be going on in a home that seemingly had "supervision," and I often felt bad for how easy it was to say, "I'm going over to Megan's!" and have them think, *What's the worst that can happen? Her mother is home!* The truth is, any parent should be suspicious of whoever's house their kids are spending the most time at. The only reason they're spending their time there is because it's the house with the most leniency. No one has come over to my house since my eleventh-birthday sleepover, when my mom made my nanny sit on the top of the stairs at "bedtime" and shush us whenever one of us tried to talk to the others.

Rachel and I mutually hated sleeping over at Megan's, but we dealt with it because we couldn't roll into either of our houses at two in the morning. Well, it's possible Rachel's mom might have allowed it, but there was an image of an austere mother that needed to be upheld. Megan's house was always

a mess from all the partying. Cigarette butts overflowed from antique ashtrays and floated in cups of wine from the night or week before, creating a repulsive liquid-ash concoction. Rachel and I would sleep with our sweaters spread out over the pillowcases since drunk friends of friends were always spending the night and it was impossible to know when the last time the sheets were washed because everything smelled the same, whether it was clean or dirty. You know those people with a particular scent that makes everything they own and wear smell exactly like them? Their house, their car, their clothes, even their dog? Megan was one of those people. You could find a shirt of hers in your closet after ten years and it would smell just as potent as if she had worn it that day. I know this because I found a shirt of hers in my closet after ten years and it smelled *so* potent. I don't even understand how it's physiologically possible to have such a strong scent. Is it some kind of genetic survival tactic? So your family will be able to smell their way back to you during the apocalypse?

By far the most fun part of every weekend was driving home with Rachel from Megan's on Saturday or Sunday morning and talking shit about all of the ridiculous things our now-shared friends had done or said the night before. It was out of love! Talking shit about your friends is out of love! Well, sometimes it's out of hate, but a lot of the time it's out of love. And I really did love my friends. With them, I felt like I finally belonged, and whether or not they truly understood my hatred for everything, I felt appreciated for it.

I never thought there would be any downsides to having

such a close group of friends or to introducing my best friend to my new friends and having them become close too. I definitely couldn't have predicted that the one time Rachel went over to Megan's in the middle of summer when I was away but everyone else was there, they would all disclose everything I had ever said about each one of them, like some kind of destructive sharing circle. It was enough for them to decide right then and there that the only thing I actually ever brought to the friend group was, well, shit.

One by one, each of my best friends, including Rachel, texted me a paragraph saying they no longer wanted to be my friend and that I was a bad person. Even two of the girls that I never talked shit about since they rarely did anything annoying ended up siding with Rachel and Megan because they were impressionable — which I guess was something I could finally shit on them for. Honestly, the least you can do is bring enough to the table to actively annoy people.

All that time, I thought I was having honest, engaging conversations with my friends. If your friend does something irritating — like copying things someone else says and then passing them off as their own or vehemently denying getting lip injections ("I wouldn't lie to you. I'd tell you anything. I have three vibrators and I like anal. I did not get lip injections") as if she thinks you don't have eyes and don't know what she looked like before and what she looks like now — wouldn't it be unnatural not to discuss it?

I didn't know if I was a bad person or a bad friend. The only thing I knew for sure was that the only thing that makes you a

worse person or friend than shit-talking your friends is repeating a shit-talk your friend said. It was fine that none of them wanted to be my friend anymore for talking shit; I didn't want to be friends with anyone who was capable of repeating a shit-talk! It's the ultimate form of betrayal and hypocrisy. They were talking shit to me too! And now they're shit-talking the person they thought was wrong for shit-talking. Not to mention they're hurting the feelings of the person they are sharing it with. There's a reason it was said behind that person's back!

After a very lonely summer, my dad told me if I wanted to make or keep any friends in college, I'd have to stop talking shit. Cold turkey. I really didn't want to lose any more friends because losing friends really sucks, maybe even more than not divulging the hate in my heart. So I put my desires aside and decided to get sober from shit-talking. I would enter college a new girl — a "nice" girl! The kind of girl you could say good things about posthumously.

Unsurprisingly, trying to make friends without being able to talk shit about people was quite difficult for me. I had nothing to talk about with anyone. Well, there were some things, but the conversations would end quickly and were noticeably tedious for both parties. Sure, I could be described as nice, but I was *boring!* It was not a good start for my college career.

One month sober from shit-talking and with zero new connections, I luckily found myself invited to a pregame on my dorm floor. There were about six people, only one of whom I kind of knew, all sitting on the floor drinking out of Solo cups and talking about their relationship issues. After a few

minutes, I realized that talking about situationships is something you can always talk to people about, which was a relief because it has a similar rapport to shit-talk. The hookup-talk officially turned to shit-talk though after the pregaming host brought up the new girl her ex was now hooking up with and pulled up the girl's Instagram account for everyone to dissect. Her phone went around the group, and after a few comments like "I don't know why but I don't like her face," "You're so much prettier," and "She's nothing special," it was passed to me. In keeping with my sobriety, I said, "She's cute."

Not that it was hard to keep my mouth shut. That was under no circumstances the kind of shit-talk I enjoy. That's mean shit-talk. Not amusing observational shit-talk. There's a huge difference. I hate when people say mean things. Still, I didn't think anything could be worse than the consequences of talking shit until I experienced the consequences of *not* talking shit. It turns out refusing to say someone is ugly is the rudest thing you can do to a person, and honestly, I can understand. I would have probably been annoyed with me too, and once everyone left, I would have talked shit about me for not getting it.

I thought about my former friends and what they would have done once the phone was passed to them. Megan would have made a horrendous comment about this person being far too underweight. Rachel would have pushed through her fake lisp to mutter something about how hard she was trying to look like a French-cinema fanatic. There was no way any of them were refraining from all forms of shit-talking, and yet I

was left with a new unmanageable fear of doing the one thing that calmed my misanthropic flare-ups.

After this incident, I went back to the shit-talk life. Listen, if people didn't do and say incomprehensible things, I wouldn't need to talk shit about them!! Also, I was lucky enough to realize that the key to maintaining friendships isn't *not* talking shit (although that is a crucial component) but having a mutual understanding of each other's needs. Whether your friend just needs you to go there with her and say, "Your ex's new girl-friend sucks" or "It's fine you bled in my bed," when you truly understand your friend, and they understand you, you can't even think of shit to say about them because you're so grateful to be understood. The thing is, if you want to have friends who understand you, and you're someone who is nearly im-possible to understand, you might only have one friend. But personally, I'd rather have one friend who understands me than six who would repeat a fucking shit-talk.

My Parasite

OF MY MANY IRRATIONAL and rational fears, throwing up has always been my greatest one. Nothing can prepare you for your first puke. No one tells you what it is or that it's going to happen uncontrollably every so often. Even if someone did try to warn you, there's really no way to accurately describe the sensation. The closest I could come up with is that it feels like Satan entering your body to check in if you're still alive. The first time I consciously experienced it, I sobbed hysterically and asked one thousand questions as I spewed vomit all over my parents' bed and then toilet.

"MOM! WHAT IS THIS?! WHAT'S HAPPENING TO ME?!"

"It's just a part of life, sweetie, you get sick sometimes. It's your body rejecting something."

"This is a part of *life!?* Then I don't want to be alive. I'd rather die!"

"Don't say that, sweetie."

Throws up. "Dad! *What do I DO?!*"

"There's nothing you can do, honey, you just have to let it pass."

"Dad! I hate this so much, I don't want to do it anymore!"

"I know, honey."

"I REALLY HATE IT, MOM! When will it be over?!"

"I think soon. Maybe soon."

"Swear on your lives I won't throw up again!"

"We can't do that. I'm sorry."

"Will you give me a thousand dollars if I throw up again?"

"We don't know if you're going to —"

"DAD, YOU DON'T ACTUALLY HAVE TO GIVE ME A THOUSAND DOLLARS! JUST SAY IT SO I THINK I'M NOT GOING TO!"

"Okay! We'll give you a thousand dollars if you throw up again."

Usually with bad things in life, you can at least say, "It was a good experience," once you've recovered from the trauma. No one ever says "It was a good experience" if the time they're describing was pleasant, only when it was treacherous and awful and tested their physical and mental capabilities. My dad says the army was a good experience; people have said climbing a mountain and almost dying was a good experience. Oftentimes, when something is not good-experience-level bad but still really bad, you can laugh at it in retrospect. Like the time I was trapped on a plane for seventeen hours just to be deplaned still in Los Angeles. That was funny! Kind of. But throwing up is so unpleasant, it's not funny at all. The only

thing I learn from it time and time again is that I'm a gigantic baby.

Throwing up is physically the most unpleasant thing that can happen to you (besides all of the other things you're now trying to come up with in your head to top it). Everything about it feels unnatural and demonic. I have avoided it at all costs throughout my entire life, as if it's my personal religion. I've never had more than four alcoholic drinks in one night. Once, I was so anxious about my stomach that I went six days in a row eating only unbuttered toast, but then my mom told me that eating only toast could also make me sick, just in a more long-term way. I've smoked weed every night since I was sixteen for the sole purpose of preventing nausea — I don't like being high, I just like that it makes me not nauseous. I've said many times in my life that I'd rather die than throw up. After the fact, I'm glad I don't actually get to choose.

My nausea from fear of nausea haunts me the most around dinnertime, every dinnertime since I choked, which I don't think is a coincidence. And every time I've vomited has given me a type of PTSD. Once I woke up in the middle of the night and threw up, and now any time I wake up in the middle of the night, even ten years later, my first thought is that it's because my body needs to throw up. I'll be up until dawn reasoning with the version of myself that thinks I'm going to throw up because I woke up.

People can wake up in the middle of the night for no reason at all, it doesn't necessarily mean that.

But it's probably *because you need to throw up.*

No, maybe I woke up because I heard a noise in my sleep and I just don't remember.

Or maybe you have to throw up.

My subconscious could have thought I needed to pee, and it was just wrong.

Stop kidding yourself. You feel nauseous, I know you do. Just admit it. You're nauseous and you need to throw up.

There's no way for me to know if I'm sick or just anxious about being sick. My mind and body are constantly arguing for the truth. My mind is so strong that if I buy into the fact that it's sickness and not anxiety for even a moment, there's no stopping the vomit from coming. It's like your brain taking any other cue: Stand up. Sit down. Throw up.

The mental concentration it takes to move my mind away from the prospect of vomit is like Siddhartha trying to reach enlightenment in a strip club. If I'm in the midst of the mental struggle that is being nauseous, anything can send me over the edge: commercials, a particular person's face, any smell that isn't mint. A few months ago, I was nauseous and my friend put on *How the Grinch Stole Christmas* with Jim Carrey. I didn't know what would make me more nauseous, sitting there watching *The Grinch* as my nausea consumed me or explaining to her that we couldn't watch *The Grinch* because I was nauseous and seeing one more minute of green Jim Carrey would have an irreversible damaging effect on my well-being. All I could get out without accidentally cueing my brain that it needed to throw up was "Can't. Watch. *Grinch.*"

Most people don't understand the danger of speaking when a nearby sensitive person who is afraid of nausea is nauseous. When I was in the seventh grade, my class went on a camping trip to Catalina. The waves on the boat ride were so rough, fifteen kids were heaving over the side, hurling into the sea. Hearing and seeing vomit is much worse than watching *The Grinch*, but still, I stayed focused. Suddenly, a woman who worked on the ship approached me.

"Here, you look pale," she said concernedly, as she handed me a brown bag. I immediately threw up into it.

"I'M NATURALLY PALE!" I screamed back at her as I puked. I'll never forgive her.

There's only one way for me to find out if my brain has manifested the nausea, as opposed to my body, and that's to take a Xanax. Because my Xanax is exclusively reserved for the days I'm feeling nauseous, I end up taking it semiregularly. Yet I've only thrown up once while on Xanax — a good indicator of how often I'm subliminally convincing myself I'm nauseous.

Throwing up that one Xanax was a terrifying experience, as it confirmed the fact that I was actually sick. My then-boyfriend sat on the bathroom floor and held a cold, wet towel to my forehead as I periodically heaved into the toilet. My college boyfriend was very obviously out of my league. He had piercing blue eyes and dark hair like Danny Phantom, who was, weirdly, the first "person" I ever had a crush on. It was clear I was lucky to be with him from the attention he got

from our female classmates, and so I did everything I could to keep him interested. Profusely vomiting in front of him was obviously not the move. But how I behaved during the heaving intermissions was worse.

"WILL YOU GIVE ME A THOUSAND DOLLARS IF I THROW UP AGAIN?!"

"Cazzie, what? I don't even have fifty dollars in my bank account," he said, confused, furthering my discomfort. It's hard to believe he stuck with me after that night, and all the nights thereafter.

The virus, or "little bug," as my mom called it to make me less scared, mentally stuck with me for weeks. I became a hermit, afraid to go outside and catch something. I'd panic and pace the length of my apartment, not allowing anyone to speak freely, living my life in a haze of weed and Xanax. I'd smoke a joint to prevent nausea and then take a Xanax to calm myself down from the panic attack the weed gave me. Every time I went to class, I'd leave convinced that I had contracted a stomach bug. My nausea and anxiety seemed like they would be forever interlocked in a toxic relationship.

My mother pleaded with me to go see a doctor despite my reminding her that nausea was just my personal symptom of being alive. But she insisted, as she's a big believer in second opinions, especially when the first opinion is mine.

After one appointment with a doctor who my mother bragged was "once the Clintons' doctor!" and a few test results later, I got diagnosed . . . with a parasite.

I didn't really know what a parasite was, but I was sure there

was no name that could sound scarier. When he first told me, I was in denial. "Doctor, that's impossible. I live in a bubble."

He then informed me that the most common way to get a parasite was from not washing your hands after you go to the bathroom. I obviously didn't remember a time I hadn't washed my hands after going to the bathroom. That's disgusting. I promise I hadn't done that. But . . . I guess I must have?

In some ways, though, it was a relief. My nausea wasn't the result of neurosis; I was actually ill with . . . a parasite. I wouldn't have to worry about causing my own nausea anymore, only the parasite causing it, which, while just as frightening, was at least much less confusing. On the bright side, I hadn't really had anything substantial to complain about since my parents' divorce. Silver linings.

When I told my friends about my parasite, they had mixed reactions. One was horrified and made no effort to hide her judgment: "Ew, don't you get that from not washing your hands after you go to the bathroom?"

Another friend was thrilled that she now had a reason why I didn't gain weight super-easily.

"*Ohhh*, that's why I'm not skinny, because I don't have a parasite!" (That wasn't why.) "Ugh, you're so lucky. I want one so bad," she said as she eyed the cup I was drinking out of.

I refused to research the parasite further, because I knew if I learned anything about it beyond its name, I would have to kill myself. All I knew was that it was some kind of living organism feeding off my body, which alone is the most disgusting concept imaginable other than throwing up.

My diagnosis came with a long list of things I would need to do to get rid of it: take two weeks of antibiotics, take a massive amount of expensive vitamins, and give monthly stool samples to check the level of parasites. I would also have to go on a strict paleo diet to alleviate my stomach problems. If you don't know what a paleo diet entails, the concept is "eat like a caveman." And as hard as it was for them to find food back then, it's just as hard to eat like them now. Nothing white, sweet or delicious, salty or satisfying.

The last thing my doctor informed me of was that the parasite was contagious, so I couldn't share drinks or anything with anyone. I told him I had a boyfriend and asked if that meant he had the parasite too. It did mean that, he said. Terrific. So that night, I had to tell my hot boyfriend that I had given him a parasite. Note: If you're ever looking to end a relationship, this is a great direction to go in. I can only assume it's worse than having to tell your partner you gave him an STD, given what followed.

He was put on the same antibiotics as I was, and we were instructed not to kiss for at least two months or else we would be "giving the parasite back and forth to each other." How could we go two months without kissing? Kissing is the only difference between being in a relationship and not being in one. I was beside myself. My boyfriend, however, seemed totally fine with it. I was totally not fine with him being fine, but in his defense, it's hard to keep kissing someone who you know is preparing a stool sample in the next room.

Speaking of stool samples, they cost two hundred dollars. The fact that I was *paying* to do a stool sample made the process even more unsettling. If you've never given a stool sample before, and I'm pretty sure you haven't unless you have a Jewish stomach or are seventy, I'll spare you the details. Just know you have to put "the stool" into different tiny plastic bottles by using tiny little plastic tools. It's like a fun science project! With your *shit!* Once you are done with the stool sample, you have to put it in your REFRIGERATOR overnight before you can mail it. Yes, the same refrigerator that stores the food you eat. My roommate was not okay with this. Nor should she have been. There was human feces parked next to her Granny Smith apples. I'm sorry, I seem not to have spared you the details.

After craving bread, cheese, and sugar for a month and having no physical contact with my boyfriend, who was being hit on by others on a daily basis, I got my first stool test results back. My doctor got right to the point: the antibiotics didn't kill the parasite, and I would have to do another round of them as well as continue with the paleo diet, the abstinence, and the stool samples. Because of an article my mother once sent me about the deadly long-lasting effects of antibiotics, I was distressed just by taking the first round. But what could I do? My greatest fear was nausea, and my body was now home to a worm. At least I imagined it was a worm; I still haven't looked it up. So I took the pills for another two weeks. Spent another two hundred dollars on a stool test. Pissed off my

roommate and grossed out my boyfriend. Mailed out my shit in a package and waited for the results, again.

Weeks later, the parasite remained, and my symptoms were getting worse. I was so desperate to never give another stool sample again and keep my boyfriend that I decided to get a third opinion. Doctors usually hate me because I say yes to all of their questions — you know, just in case. "Have you been light-headed recently?" "Um . . . now that you mention it, yeah. Sure." "Have you been having any body aches?" "I guess. Why not." My new doctor was a beautiful Asian woman who immediately made me feel at ease. I had to remind myself she was a doctor and not a therapist when I started to break down about my boyfriend and me not being able to kiss for the past two months. I told her about how I was diagnosed with a parasite because of my nausea and stomach problems, that I was giving monthly stool samples, that I had done two rounds of antibiotics, which made me even more scared for my stomach, and I was on a strict paleo diet.

She reviewed all of my test results and informed me that I did not have a parasite, nor had I ever had one. What I had was anxiety that was so out of control, I had given myself the symptoms of a parasite. Yaaaayyy . . . I *was* just crazy.

It was unclear if I was misdiagnosed accidentally, for money, or simply for the doctor's amusement. I'll never know for sure. I was definitely not happy to be in the same place I was previously, with no understanding of how to control my brain or body. That will surely be a lifelong journey. Anyway, I was determined to tell everyone who knew about my parasite

that I was misdiagnosed so they'd know I was actually very hygienic and had unimpeachable bathroom habits. The only person I didn't tell about my misdiagnosis was my boyfriend, since the only thing that would be more infuriating to him than me having given him a parasite was me never actually having given him one in the first place. No, but it's honestly fine, it's cool. It was a good experience.

Privileged Assistant

Cazzie's oppositionalism and "I don't care" attitude can be seen as an attempt to save face. They permit her to attribute failure to not trying instead of leaving her with the experience of having given it her best and having to see that her best isn't good enough. The fact that she is a child of high achievers makes her situation that much more poignant.

— Excerpt from neuropsychological evaluation of
 Cazzie David, 2007

IF THERE'S ONE THING everyone already knows about me it's that I'm a privileged white girl. And for that, I offer my most sincere and humble apologies. What's worse than a privileged white girl in this day and age? Nothing. Maybe Republicans, definitely pedophiles, racists, terrorists, and, in my opinion, people who plagiarize ideas and creative content. Nevertheless, us privileged white girls are not a popular bunch.

People say being privileged is a blessing and a curse. No, no one's said that. It's obviously only a blessing. But if there *were*

a downside, it would be that people inherently, but justifiably, hate you for it. Even privileged people hate other privileged people for being privileged. No one will ever take a liking to that aspect of your character. No one has ever said, "She's super-cool, she comes from money." Although they *have* said, "She's surprisingly super-cool, considering she comes from money."

In any case, it's technically not my fault. I didn't ask for it. Not to say that if I had the choice, I wouldn't still choose . . . privilege. So, yes, if I had the choice, I would have made that choice, but I didn't choose it.

Reader rolls eyes. *We get it, Cazzie, you're aware of your privilege.*

Good. Then I shall continue.

I experienced all the stereotypical symptoms of growing up with privilege one would expect: not knowing what a Ross clothing store was until last year, being diagnosed with the classic privileged-person neurosis, hypochondria. My guilt makes me certain it's only a matter of time before I developed a fatal disease. I still spend almost every day in crippling fear that tomorrow it will come, as it would only be fair penance to offset the privilege I was given.

The circle of privileged guilt unfolds thus: Remember the world is absurdly sad and unfair to almost everyone but you → get sad/hate the world → feel guilty for feeling sad and hating the world when everything in your world is just fine → try to continue to live your life → remember the world is absurdly sad and unfair, and so on. I was born into a life that didn't

let me develop a social or psychological immune system, so just about everything gets me sick. In high school, to slightly relieve my guilt, I'd drive around my neighborhood every afternoon offering rides to women I saw walking to the bus stop after their work. Some would be frightened when I'd pull up, roll down my window, and ask if they wanted a ride like I was a young, female pervert. Others were shocked. I couldn't tell if it was because they were surprised one of these privileged pieces of shit was making a nice, albeit inconsequential, gesture or because it was such an inappropriate, perhaps even offensive one. Regardless, I continued to do it for years until the day I pulled up next to a woman and asked if she wanted a ride, and she turned around and revealed herself to be a scary, toothless witch lady. Fully aware of the guilt that was bound to follow, I locked all of the doors as soon as she went to grab the handle. She was still grasping onto it as I sped off. It must have seemed like I was playing some kind of sick prank by asking her. It haunts me to this day.

As ashamed as I am about my immense privilege, there isn't much I can do to hide it. That's because I was also lucky enough to be granted the misfortune of being a child of a celebrity. Undoubtedly, the only thing people hate more than a child of privilege is a privileged child of a celebrity. Again, not my fault. Though I do think God wanted people to hate me as much as I would turn out to hate people. He's so funny like that.

I don't *feel* like a child of a celebrity. I can't relate to them. I would rather die a violent death than be a Golden Globe Am-

bassador (the child of a celeb who walks the other celebs off the stage). I couldn't post a photo of myself with winged eyeliner and a blazer and write, *Thank you so much @chanel for making me feel so beautiful* or *Thank you @valentino for getting me out of my sweats for once!* Not that Chanel or Valentino is sending me anything. Besides, do any of these children of celebrities do anything apart from having a face? Maybe the reason I can't relate to them is because what I actually am is just an ugly child of a celebrity?

A psychologist would probably say my hatred for children of celebrities could be boiled down to self-loathing. I guess I am just as predictable as the rest of my vapid breed. We all have to be in the arts! God forbid our mediocre creativity isn't shared with the world! To make matters even more typical, I'm attempting to follow exactly in one of my parents' footsteps. My hope is to be the Garrett Leight of comedy. Garrett Leight is the son of eyeglass designer Oliver Peoples. Garrett also started a glasses line. He's doing well. No one prefers Garrett's sunglasses over his dad's, but they still take his frames seriously. I don't find writing as authentic or quaint a career path as designing sunglasses. The doomed reality that I have to be a writer when I find it such an embarrassing cliché has weighed heavily on me — I assure you, if I could do anything else, I would. If I were smarter, I would have gone to law school and perhaps defended people in court. Not super-important cases, I'm too sensitive for that. But I'd defend . . . oceans? No, I can't see pictures of sad fish.

A terrible truth about society is that it has always been

nearly impossible for anyone to succeed (especially in the arts) without privilege. I'm sure even Aristotle's father had a nice plot of land, because only the privileged have the privilege of being left alone with their thoughts, as the rest of the world's minds are inundated with thoughts of survival.

Ever aware of the problem of privileged children, my parents did everything in their power to prevent my sister and me from undergoing a full transformation into the worst-case scenario of that type. They kept us down-to-earth by giving us minimal attention and never being proud of our accomplishments, by making us think everything was a privilege, even them speaking to us. I'm kidding. Kind of. But one thing they did do was have us get a job every summer after turning fourteen.

Probably due to my privilege, although I prefer to blame it on being a "creative," I'm not what someone would consider the hardworking type. In all aspects of life, I tend to do the minimal amount of effort needed to pass. My first job was at a bookstore on Martha's Vineyard (at least it's not the Hamptons?), and while all the other employees moved around with near-constant smiles on their faces, I made a chair for myself out of a pile of books and half-heartedly asked customers from afar if they needed anything. I was, of course, fired.

As soon as I graduated from college, it was of the utmost importance for me to start earning a steady income. My mother and I started brainstorming job ideas, a difficult task when almost nothing is enjoyable or interesting to me. I tried to think of jobs that would come with an activity to pass the

time, like being a receptionist where I'd be stuck at a computer all day and could learn to play World of Warcraft or working at an art-supplies store so I could draw? My mom kept pushing for restaurant hostess, which I knew wouldn't work out for reasons such as my lack of approachability, my unintentional unfriendliness, and my severe self-consciousness. But she was convinced the best idea was for me to work at the local Starbucks.

"No," I said without hesitation.

"Why!"

"Mom, you know why!"

"I don't. I think it would be perfect for you. It could help you develop better social skills."

"I don't want to take that job away from someone who actually needs it," I explained.

"You do need it," she informed me.

"Right . . ."

It wasn't my best excuse, although it was true. But I also just didn't want to work at Starbucks. Sorry! Is that so bad? Can I feel that way? As soon as she suggested it, I envisioned the imaginary tweet of the one person who would miraculously recognize me: *Why is Larry David's daughter working behind the counter at Starbucks?? Is that really necessary LOL?* Or, worse, a meme: me miserably handing someone a coffee cup and the text below reading *When the recession hits your* Seinfeld *money.*

My mother accepted my refusal to work at Starbucks after I came up with a more calculated excuse: "You want me to just

give people plastic all day long? Do you know how depressing that is?" She agreed. Fuck plastic.

As I was about to choose working in a furniture store — for the sole reason of there being many comfortable places to sit — my dad decided he was going to do another season of *Curb Your Enthusiasm*. Before being excited for my dad, I was excited for me. What a great opportunity derived from sheer nepotism. I told my mother the idea, and she was delighted.

"It would be an experience you would remember for the rest of your life, watching your dad do what he loves. Oh, the memories you'll have. You can write about them in a book one day!"

"Yes, Mother, that's exactly why I want to do it . . ."

When I told my dad I wanted to work for season nine, he was thrilled. "Oh yeah? You wanna work for your pop?" Of course I did, I'm a lazy privileged piece of shit. There is no fear of failure when working for your dad — that's why it's been the go-to job for fuckup privileged children for centuries!

I had previously interned and PA'd (production-assistant-ed) for many summers, so I'd racked up a pretty impressive (nepotistic) résumé. PA'ing is the lowest tier of the film-set caste system. You're the first one on set and the last to leave, and your job is essentially to do whatever it is anyone from any department asks you to. As an entitled millennial, I felt I had surpassed coffee and lunch pickups, especially considering, you know, I'd be working for my dad. I decided to aim higher.

Later that week, my dad's assistant called to congratulate me on my new PA job.

"Thank you. Yes, I'm very excited. Just one question, though: Are there any other positions available?"

"Well, it's a film crew, so unless you can do costumes or lights, that's all there is for you to do."

"Right, yeah, that makes sense. What about, like, social media director, though?"

"What's that? We don't have that."

"Exactly! So what I could do is create and be in charge of the *Curb* social media account. I'd come to set for an hour, take some pics —"

"Oh, no, HBO takes care of all that."

"Right."

"But don't worry — I made sure to tell everyone not to treat you any differently just because it's your dad's show," she said.

"Oh, you did? You didn't have to tell them that."

"No, everyone was really cool about it. They're going to treat you just like all the other PAs."

Fuck.

Soon enough, all of the new PAs met at the *Curb* office for an introductory meeting where we were told that we'd be working twelve-hour days, starting at five thirty or six in the morning. A little early for my taste.

Later that night, I told my dad in a somewhat joking manner that these hours just weren't going to work for me. For a different job, I'd do it (not true; I'd try to find something else), but for my dad? Didn't seem sensible.

He told me that if those were the hours, then those were the hours, and I'd have to go whatever time they told me to.

"Even though you're my dad," I said slowly.

"Even though I'm your dad."

"Even though you're my dad, I have to go in at five thirty a.m."

"Yep. And if you don't, you'll be fired."

"So, no dad perks? I might as well be working for *not* my dad."

He laughed, but I wasn't amused.

The first day filming was November 9, 2016, the day after the election. Like most of the country, I spent the night before wide awake, hysterically crying, and trying not to throw up from the surreal results. I arrived to set shaken and distressed, having gotten barely an hour of sleep. I looked around for other sobbing red faces, assuming that everyone was having the same reaction to our disturbing new reality as I was, but they must have had subtler crying faces. I met my bosses, who were chipper and seemed as if they hadn't heard about the election results. They gave me a walkie-talkie and told me what my responsibilities would be: Guarding the street and informing everyone (by walkie) of my dad's location. I would essentially be his security guard.

I stood blocking the street for two hours, crying as I paced back and forth, thinking about the fear of so much of the population and all of the things that would now happen with Trump as president. When my first shift was up, I ran into Jeff Garlin, who immediately noticed my puffy, red face. He put his hand on my shoulder and looked me directly in the eye.

"Listen, you're going to get used to it. It takes time. I prom-

ise it's going to be okay. Everything gets better. This will too. It's just the first day!"

I nodded, thankful for the reassurance.

"If you ever need anything here at all, let me know."

I thanked him and wiped away a tear as it slid down my cheek. Soon after, Mike, one of the key PAs (the people in charge of the rest of the PAs), came up to me and asked if I was okay. Again, I didn't feel the need to explain since it was so obvious and everyone else was weird for *not* crying. He then started to give me unsolicited tips on how I could "make things easier" for myself. It was confusing, because he was talking to me like the job *wasn't* easy when all I was doing was standing and guarding the street. His first tip was not to call my dad "my dad" when telling people his location. I hadn't yet done this, nor would I ever, and the fact that he assumed that I would be the type of person who would tell the entire film set via walkie-talkie that "my *dad* is walking onto set" completely threw me. I felt like I had been character-assassinated. After he gave me two more tips, I realized that he and everyone else believed I was crying because I was so overwhelmed by my first day at work, that I was such a good-for-nothing shithead, I had been brought to tears from the stress of working. Off to a great start.

Afternoon rolled around, and I hadn't eaten anything since six a.m. I heard my dad's assistant ask him what he wanted for lunch from his favorite restaurant, and as she turned to go place the order, I timidly squeezed my way into her space. "Hey! Can I get something?"

"What do you mean?" she asked disapprovingly.

"With his lunch order. Can I put something in?"

"Oh . . . there are sandwiches available at catering."

Sure, maybe it was wrong for me to ask, but I was hungry, and I have privileged taste buds! "Dad!" I exclaimed. Some people glanced over at me. "Uh" — *cough* — "Larry." He looked up from his phone. "Claire wouldn't get me lunch with yours. She said I have to eat from catering," I whispered.

"And?"

"And I don't want to."

"Why not?"

"For the same reason you don't eat from there."

"Don't you think people would hate you if they saw you ordering in your lunch?"

"They already hate me. And they won't know. I'll hide."

"Don't you think it's unfair for you to get takeout from a restaurant when everyone else is eating catering?"

"Yes, but —"

He laughed and walked into his trailer. Again, not all that funny. I resigned myself to the inevitable and ate with everyone at catering, where we talked about how the food made our stomachs hurt.

Ironically, working on the *Curb* set led to more *Curb*-like grudges, arguments, and misunderstandings than I had ever previously experienced. Besides my personal vendetta against my dad and his assistant for refusing me the opportunity of a good lunch, I spent a lot of my time annoying the other crew

members by refusing to use "set talk." Set talk is a language that is apparently used on every set in Hollywood, one that replaces common English words that everyone knows and feels comfortable using with words no one has ever heard of. When you're carrying something behind someone, you're required to say "Hot points" rather than "Watch out." There's *martini* (last shot), *crafty* (craft services), *grip city* (area for lighting equipment). I wouldn't refer to that area as grip city if you paid me a hundred dollars. But anyone who happened to use regular ol' English was quickly corrected in a condescending manner.

One of my bosses took her job so seriously, she acted like we worked in an emergency room. To her, an actor being late to get miked was equivalent to an EMT taking his sweet time before giving someone CPR. One day, she asked me to inform the other crew members how many clicks it takes transpo (transportation) to get to the parking lot.

"What does that mean?" I asked.

"*Clicks* is set talk for 'time,'" she informed me.

"So how many clicks *does* it take to get to the parking lot?"

"About seven clicks."

"Which is how much time?" I asked.

"Fifteen minutes. But tell them in clicks."

My brain could not comprehend why that would be necessary. "No one is going to know what *seven clicks* means. I'm just going to say fifteen minutes."

"Everyone here knows what *clicks* means."

I raised my eyebrows, and, doing my best *Curb* Larry impression, I squinted my eyes, tilted my head, and said, "Iiiiii . . . don't think they do."

"They do. That's how you're supposed to tell them," she said, which immediately led me to look for someone nearby on set I could ask.

"Ravi!" I yelled. "Do you know what *seven clicks* means?"

He did. My boss rolled her eyes and walked away.

I observed my father get into just as many disputes with people on set as I was. Several of us were in video village (the area where the monitors are kept) where my dad's assistant and a female producer were massaging each others shoulders. Enter my dad. "What is this?" he asked.

"We're giving each other massages," the producer said between rubs. My dad then made some joke along the lines of "If one of you ever saw me getting a massage that would be the end of me." And then walked away, leaving a room of four offended women to talk about it.

"Oh, so women can't massage each other?! Men just *love* to turn it around, don't they? This is how women are with each other!"

The producer then turned to me and asked if my girlfriends and I massage each other, and I reacted like she'd asked something truly repulsive.

"Ew! No way!"

The producer scoffed.

I told my dad about the rest of the encounter, and the next day, in exact *Curb* fashion, I heard him go up to them to clear

the air and uncomfortably say, "So . . . I'm sorry about saying the massage comment yesterday . . . It was a stupid joke. Even though it is technically true. Anyways, you're of course welcome to massage each other in this or any environment." They forgave him.

These minor disputes were somewhat entertaining, until one day, there was an argument between my dad and me. That Friday, the crew set up a raffle. I spotted Mike (the guy who thought I was crying from working) walking around with two buckets draped around his neck by strings, one full of tickets and one full of cash.

"A raffle! What is this for?" I asked excitedly. Set was typically uneventful, so this was a welcome distraction.

"It's just a fun thing we do for the crew. There's already six hundred dollars in it."

"Wow! How much is it for a ticket?"

"Five dollars for one ticket, ten dollars for three tickets."

I ran to my dad. "Dad!" Someone looked over at me. "I mean, Larry — can I have five dollars to buy a raffle ticket?"

He walked with me back to Mike like I was a five-year-old at a fair and handed him five dollars. Mike gave me a ticket and a pen to write my name on it. As I was writing on the ticket, I saw my dad give Mike a hundred-dollar bill before he walked off. I couldn't believe it! It was so unlike him. An extra thirty tickets! That raffle money was mine!

"Can I have the rest of my tickets?" I asked Mike excitedly.

"What do you mean? You want *these* tickets?" he asked with horror.

"Yeah, of course! He just gave you one hundred dollars for them."

"Uh . . . well, the stars of the show often put in extra money without getting tickets for it, just as a nice thing for the crew. Like, for the winner of the raffle."

In the moment, this made no sense to me. Why would someone put in that much money and not take any tickets for it? Why would you put in more money for the winner? They'd already won! It seemed to defeat the point of the exercise. I stood there, visibly annoyed by this minor injustice.

"So you actually want the tickets?" he asked me hesitantly, definitely thinking to himself, *I can't fucking believe this privileged piece of shit is going to win this raffle.* It's not like I would have kept the money for myself. I'd disperse it among the causes that would most effectively relieve my guilt. Duh.

"Fuck yeah, I want the tickets!"

Mike reluctantly started handing the tickets to me, one by one, looking more and more like he wanted to strangle me as he ripped each off.

My dad noticed what was happening and walked back over. "What are you doing?" he asked me.

"I'm getting the rest of our tickets," I said as Mike looked at my dad with eyes that seemed to say *I fucking hate your daughter* or *PLEASE HELP ME* or, most likely, a combination of the two.

My dad was appalled. "These tickets aren't for *you!* It's unbelievably selfish for you to take all of these tickets. You'll win!"

"Yeah, that's the point of a raffle! The more money you put in, the more likely it is you'll win. You obviously just don't know how raffles work," I informed him.

"No. *You're* wrong. The money is extra for whoever wins the raffle. I gave him the money to give to the winner. Hand those back *now!*" he shouted.

Mike looked back and forth between us uncomfortably, not knowing what to do. In one of the more humiliating moments of my life — including the time in college when I briefly blacked out at a club, fell down a flight of stairs, and was so scared I peed myself — I started to hand the tickets back to Mike. By contrast, Mike appeared to find this interaction one of the most enjoyable moments of his life. He just stood there smirking, like all privileged children of celebrities had been brought to justice.

Later, James, a PA who loved to gossip, found me hiding behind set. He told me that two people had come up to him and said, "Did you see Larry yell at Cazzie?"

"Were they smiling when they told you?" I asked.

"I guess, kind of."

I knew it. Everyone there hated me, no longer just because I was their boss's daughter but because they had now witnessed firsthand how bad a person I really was. And not only that, but they also had the satisfaction of knowing that even my dad hated me. But no one hated me more than I did.

Later that day, the raffle winner was announced. It was a crew member, who said he was "so happy" because he wanted to take his girlfriend on vacation. Everyone was saying "Aww"

and "He deserves it!" and "I'm so glad *he's* the one who got the money," while they glanced back at me like, *I CAN'T BELIEVE YOU WANTED TO STEAL THIS FROM HIM.* I obviously just didn't know how raffles worked.

After Rafflegate, I was sentenced to the most annoying jobs out of all the annoying jobs. They gave me lockups (places for me to guard) as far away from set as possible, probably in an attempt to do Larry a favor by keeping away the daughter he clearly hated. They also made my call time thirty minutes earlier than all of the other PAs for the week — because they needed help with "background," they said — which was undeniably a personal attack. I was waking up so early, my body was convinced I had a flight to catch to Europe each morning. Every day I got to set and not the airport, I felt confused.

After a few weeks, I'd had enough and thought it was time I started getting some respect. It was clear the jobs they were assigning me were for their own gratification and not at all necessary. I needed to stand up for myself so they'd know once and for all that I was not, nor had I ever been, someone you could ask to do stupid, made-up tasks.

I found small ways to assert myself. I started to blatantly abandon some of my lockups (the ones that already had a security guard, and yes, they'd have me guard next to a guard who was already guarding). Instead I'd walk around set with a look in my eyes like I had been sent to do something when in actuality, I was just watching them film.

I also started to surreptitiously revise my own work hours. I wasn't needed or wanted enough to continue to put myself

through the torture of opening my eyes before sunrise, and at this point, it would be fine if I got fired. Embarrassing, since it'd be a firing from my dad, but ultimately fine, as the raffle had taken away any dignity I had left. So I told my bosses that my dad had changed my call time to his so we could drive to set together, and I told my dad that my bosses had changed my call time to later, so, conveniently, we could now drive to set together. I manipulated my bosses into thinking my dad loved nepotism and manipulated my dad into thinking my bosses loved nepotism. I am a despicable waste of a human.

Over time, I got my wish. I noticed that I was no longer being asked to do anything. No one even called for me on the walkie-talkie anymore or asked me to announce that "Larry" was getting wired.

The problem (besides, you know, me manipulating the parameters of the job) was that I began to hate myself for it. Who would have thought? In order to mitigate that I began to create my own tasks, as no one was giving me any, a be-my-own-boss kind of situation. My self-assigned jobs included telling all of transpo to stop idling the vans, ensuring that all of the security guards were well fed and hydrated, and standing by the craft services table to prevent crew members from wasting plastic. I also provided entertainment for anyone on line 1 of the walkie-talkies by testing out stand-up material (a safe place to perform because you wouldn't know if they didn't laugh).

Our spring hiatus soon arrived, and before we broke for the day, our bosses handed each of the PAs a gift. For obvious

reasons, I felt uncomfortable accepting mine. As they handed out each gift, they said to each person, "Thank you for all your hard work." It seemed fairly obvious that they were saying this to everyone only to make *me* feel like shit. Pretty low. But smart. It worked. I felt so guilty and embarrassed for not working as hard as the others that I vowed to spend the rest of my life (day) trying to help out as much as I could. If I did that, I figured, then maybe I could leave them with the impression over the break that I was (at least for one day) a hardworking PA, and I'd plan on continuing that overall vibe for when we returned to work.

I went up to Mike and asked if there was anything I could do to help. He looked surprised, but he could see I was genuinely trying. I appreciated that he didn't make a passive-aggressive comment or joke about it.

"Sure. How about on the day, you wait over here and make sure no one passes down the hall."

"On the day? What day?" I asked.

He scoffed. "*On the day* is set talk for 'when we start shooting.'"

"So instead of saying 'when we start shooting,' we say 'on the day'?"

"Yes. It's the lingo we use on set so everyone understands."

Everyone understands English too, but I thought better of getting into this argument again. I knew there was no winning with logic, and I didn't want to ruin the potential image of me not being a piece of shit. So instead I just stared at him blankly until he left. Grudgingly, I made my way to the hall

to block it off, like the privileged child of a celebrity I'd never considered myself to be, as I wondered if the Garrett Leight store had any job openings.

One night after work, I was driving home with my dad and he asked why I happened to be in such a bad mood. In that particular moment it was because:

"People will never really like me and they shouldn't like me. Everything I ever do will be because of nepotism. And so nothing I do can actually ever be respected. Not even by me. So I'll end up doing nothing with my life and will never amount to anything because I'm a useless loser."

He responded with that thing that dads or moms or grandparents who didn't grow up with privilege do, the thing where they say, *Let me take you back to when I was your age.* Or, if you're my dad, who forgets his daughter's age: "How old are you again?"

"I'm twenty-two, Dad."

"Let me take you back to when I was twenty-two. I was working as a taxi driver in Manhattan. I lived in what can only be described as a cockroach-infested-railroad *hovel.* Every night when I got home, I spent an hour killing cockroaches with my boot. I collected pennies to be able to buy a can of Chef Boyardee ravioli for dinner. I had no money, no girlfriend. I was the *definition* of a loser!"

Naturally there was a long pause so I could soak in this perspective.

"At least you paid your own rent!" I said.

I Got a Cat for My Anxiety

I HATE BEING AROUND people. I also hate being alone. The moment I'm alone with my own thoughts, I text every person I know to see if they're available to hang out. Then the moment anyone comes over, I'm bothered by their presence and want them to leave immediately. I am not a people person. I am also not a loner. This is one of the never-ending miseries of being me.

I'm so desperate not to be alone that I actively try to lure people to my place. While my dazzling personality should be plenty of reason for them to come over, sometimes my presence alone isn't enough to persuade friends to drive across town. I've offered to pay for my friends' dinners in return for, well, them having dinner with me. (I regret the offer the second the check comes.) Often at the end of the meal, I get nervous that I'll soon be alone again, so I try to convince them to sleep over to assuage my anxiety for another twelve hours. "C'mon, it'll be fun. We'll have a . . . pajama party? Without the party. We'll have pajamas!" Once in a while, a

friend will agree, and for a second I'll be thrilled, but then I'll think about her body taking up half my bed and how I'll have to wash the sheets after. Or how she'll ask to borrow moisturizer, and I won't have a lot left, and I'll see her stick her finger deep into the container and scoop out a bigger glob of it than I would ever take. Then she'll jabber on about things I don't care about, which is pretty much anything not having to do with me, until I'm once again painfully reminded of how badly I wish to be alone.

After whoever it is falls asleep first, which they *always* do even though my one very reasonable request is that they not fall asleep before me, I'll stay up for hours hating myself for sabotaging my alone time that I would have surely used wisely. I would have watched the movie said friend didn't want to watch, got some writing done, maybe I would have whipped up a soufflé — who knows; the possibilities are endless. But, alas, when I'm finally left alone again, even the aforementioned activities can't stop me from diving down into the depths of hell where my disturbing thoughts reside.

So the cycle repeats. I start texting everyone I know to see if they want to come over and distract me by giving me something else to think about — how much I wish to be alone.

One year, when I was still in Boston, the continuous ruminating got particularly bad and the temporary company was also bad (nonexistent), so something had to be done. After evaluating my options, it seemed there were only two that could really make a difference: go on anxiety medication or find someone to hang out with who would never leave and

also not annoy me. But as long as that person was able to talk, chances were they'd annoy me.

So I got a cat. I'd heard they gave pets to mental patients and that it could make a world of difference. Plus, I figured I could *easily* take care of a cat. They bathe themselves, they basically use a toilet, they don't even need to go on walks, which is perfect because I don't go outside. Yes, I bought the cat. I'M SORRY!!!!!!!!!!!! I tried to get a rescue but it just didn't work out. I didn't end up connecting with the only two they seemed to have in the entire city. They were both pretty old, which is sad, but, like, I wanted a kitten, okay? I needed us to grow *together*. This was for *my* anxiety. It was about saving *me*, not saving a *cat*. (I still feel terrible and am horrified to admit this, in case that wasn't clear.)

It had always been a dream of mine to have a Bengal cat because they look like mini-tigers and having a mini-tiger is sick, even though it screams "I DIDN'T RESCUE THIS ANIMAL." I found a Bengal breeder in Massachusetts and sent her an e-mail. Not long after, I got a message back. She sent me photos of the litter, and to be honest, the pictures weren't very flattering. The kittens looked pretty big and kind of evil, but I figured I should probably see them in person before I made a decision. So my roommate and I rented a car and drove up that weekend.

We were welcomed into the house by a cat-lady stereotype of a person. She had messy, dirty-blond hair that was falling out of her ponytail from all sides, like she had put her hair in that ponytail weeks prior. The house was filled with big

tiger cats running around and empty Chobani yogurt containers, which made everything smell of old dairy. She left us in the kitchen as she went to look for the available kitten that I would potentially be taking away from its mother, brothers, and sisters, but I knew if I were to take it I'd be doing it a favor by getting it away from this evil breeder (that I'm supporting) and her yogurt.

After thirty minutes she came back into the kitchen. "I can't find her anywhere!" As she was about to give up and send us home, she pulled out one of the chairs from under her kitchen table and on it lay a tiny, cheetah-patterned ball the size of my hand. It. Was. So. Small. It — she — was so small that she wasn't even small; she was smoll. 'Cause *smoll* sounds even smaller than *small.*

"She's the runt of the litter. The other cats kind of beat up on her 'cause she's so tiny, so I've been trying to find her a home, but no one wants her because of it." No one wanted her because she was small?! I'd thought I would have to accept that any cat I got would get big! She was a miracle. "I need her."

I named her Link because I love Super Smash Bros. In no time at all, she became the most special thing in my life. I know how madly in love with her I am because I try to put my nose in her mouth, and I'm almost certain true love is when you enjoy smelling your significant other's mouth. I'll hold her so tight and whisper repeatedly, "I love you so much," like I'm a stalker in a thriller as she tries to free herself from my grip. She's too cute to even qualify as a cat; it's almost easier to

believe she's a fake cat rather than a real cat, she's so unnaturally perfect. She must be something else. Something magical that I manifested in a different dimension, where everyone is the most adorable, flawless version of themselves, including pets. Some 3-D anime universe, where cats' fur is velvet and they all weirdly glow in the same way snow sparkles at daybreak. And I swear her coat smells exactly like Le Labo Santal 26; I don't know how, but it does.

Link is the dream best friend. She doesn't do anything annoying. Except for some annoying cat things but cat things are so much less annoying than annoying human things. And we do everything together. When I read in bed, she sits on my shoulder like an owl and looks at the pages. When I watch television, she sits curled up on my lap and stares at the screen. When I write, she sits right beside my computer listening to my typing sounds. When I go to the bathroom she follows me in and walks around my legs in a figure eight until I'm done. We cuddle every night in all the same positions you would in a relationship, spooning, my arms and her paws wrapped around each other, the top of her head nuzzled under my chin like two puzzle pieces. I'm eternally thankful I ended up with a female cat, otherwise it would legitimately feel like she's my boyfriend. I get nervous that if reincarnation exists, I could be cuddling a weird, demented rapist who is constantly thinking to himself, *Boy, I got lucky coming back as a cat, this disguise is perfect!* But even if she was the reincarnation of a normal, sweet girl, I still wouldn't want to be spooning that girl . . . anyway, I really hope cats are just cats.

What I didn't take into account before I bought a cat was its life span, which I've learned can be up to twenty years. This means I'll still have Link by the time I get married and probably for my first divorce. I never considered a twenty-year commitment, which is a long time for a narcissist but too short for someone with thanatophobia. Something I also didn't take into account is that my cat would get sick from time to time. I've warned all my friends that if they ever start throwing up, even if their lives depend on me, I will cower and melt like the Wicked Witch. I'm not helpful in a crisis. Or a semi-crisis. Or a quarter-crisis. Which I proved abundantly the day Link ate an entire bag of almonds that I'd accidentally left on my night table.

For twenty-four hours, Link was projectile-vomiting whole almonds. Yes, whole. Without even a bite mark on them. How did she survive? I don't know. But I was absolutely terrified she wouldn't. The first time she threw up the almonds, I was in the other room, and it sounded like a hailstorm. The almonds were flying out of her like bullets from an AK-47. My cat had transformed into an almond gun. It was dangerous for anyone in the vicinity. The experience left me with an almond phobia.

From then on, every day I woke up terrified that my cat would be sick. I impressed upon anyone who entered my house that if they left any food lying around, Link would eat it and then throw it up, whole. I firmly believed she was capable of eating anything. I removed all flowers, plants, and anything that could be swallowed. I became delusional, imagining her digesting man-made objects. What if she choked? Would I

have to learn small-cat CPR? I looked up the Heimlich maneuver for cats and just reading about it was traumatizing. It described pulling the tongue forward with your thumb and index finger and grabbing whatever was lodged with tweezers! The visual was destabilizing. I started picking up socks, securing toothpaste caps. Maybe she'd claw at my computer until one of the keys came out and I'd come home to find her dead, having choked on an S.

This was when I realized that my cat would actually not take away any of my anxieties but instead usher in new ones, new anxieties that I would never have known existed if I hadn't gotten her, saddling myself with responsibility and dread for half of my adult life. Apparently there are multiple diseases you can get from sharing space with a litter box. I saw an article about a dog who licked a woman's scab and she had to get both of her legs amputated. The day before I saw that, I'd played a game with Link where I pretended to be a dead body and let her chew on my skin; I'd tried my best not to flinch or blink to make it more realistic.

I have anxiety that Link thinks she's in an abusive relationship because I accidentally kicked her two different times because I hadn't seen her there and once sat on top of her when I didn't know she was under the covers. My cat is more scared than most cats, because she is the cat form of me. You should see us both jump when the air conditioner makes a noise. I wish I could just ask her if she's okay; instead, I'm just left staring at eyes that are trying to tell me something and can't. Are any animals okay? There's no way to know.

I'm afraid she's going to find her way into the laundry machine, even though I check every nook and cranny of it before I turn it on. When it's done, I'm still terrified I'll open it to see leopard print added to the usual rainbow of colors. Same goes for the dishwasher. When I was still in school, I was so scared about Link being run through the dishwasher that I told my roommate I'd be on dish duty for the rest of the year if she took out the trash. She didn't understand why we wouldn't just switch off between dishes and trash like normal people. I didn't want her to know that I was "I don't trust that you won't wash the cat with the dishes"–level anxious, so I stupidly told her I preferred dishes, which she pointed out she also preferred. So I just took out the trash *and* did the dishes so my cat wouldn't die.

Technically, there's a world in which I could give Link to one of my ten friends who have asked to keep her and have my other fearful life back, but not without me drowning in a ten-foot pool of guilt. I have enough guilt leaving her alone for an hour during the day, which is good because I needed more reasons never to leave my house. But one night, I had a friend's birthday dinner I couldn't cancel on despite knowing I would spend the entire time thinking about how sad Link must be that I was gone. Everyone I tell this to when I'm trying to make an early exit always says the same thing: "She's fine! She's a cat. They're meant to be alone." To which I say, "We don't know what they're thinking! The nicest thing we can do for our pets is to always assume they're not fine."

Anyways, while I was at my friend's birthday, my sister and

her friend Kyra (who are basically Tweedledee and Tweedledum when they are together) stopped by my dad's to pick up sleepover supplies. By *sleepover supplies*, I mean they pack a BAG, like the same amount of stuff someone would pack for a weeklong getaway. And sometime between the two of them deciding which sheet masks they should do later and packing three extra pairs of underwear they wouldn't need, my perfect little tiger runt escaped out the garage door they had accidentally left open, bolting like she was doing a prison break.

When I arrived home at midnight and she didn't run to the door to welcome me, I knew something was wrong. I hysterically searched the entire house, and as I went through room after empty room, the bad feeling in the pit of my stomach grew.

I woke up my dad (basically a crime), panicking so hard I could barely form words. We searched the house again, and again, leaving no pillow unturned, then moved to the backyard. After we looked under every bush and up every tree, we scoured the street with our iPhone flashlights, jingling her toys like idiots and yelling her name, which she didn't know.

When four a.m. rolled around, it felt hopeless to continue and we decided to call it a night. My dad hated my cat because she ruined all of his furniture, but his face was so full of sorrow, it made me feel worse than I did already.

"I feel so terrible for you, I feel so terrible," he said solemnly. Making me cry harder.

"I feel so terrible for you that I'm making you sad by being so sad, I'm so sorry," I said through sobs.

I slept less than an hour, leaving all of the doors and windows open, praying she'd find her way back and I'd miraculously wake up with her in my arms. I had never been able to feel safe sleeping in the house even with the doors and windows locked and the alarm on, so the prospect of sleeping with wide-open doors and windows was a tad disconcerting, but adjustments are required when one thing gives you more anxiety than another. So at least my priorities were in order.

When I woke up, my nightmare was still reality. I was convinced Link had already been attacked by a pack of coyotes. I hadn't protected her and there was almost no chance of getting her back. I was terrified to keep looking lest I see her perfect, tiny, spotted body run over by a car or being eaten alive by birds and rats. Thinking about her somewhere out there all alone made me sick. Sicker than I was when I saw her projectile-vomit almonds all over my room.

Emotionally speaking, I imagine losing your cat feels like losing a child (except it's not, because it's a cat), but everyone else sees it like you losing an old grandmother who lived in Florida. No one really cares or feels *that* bad for you. I get it. It's hard for people to sympathize with a death unless it's a member of their nuclear family. Even when a friend of yours dies, people can't help but think, *How close were they really, though?* It's a degree of separation people's empathy cannot expand to.

When your pet is lost, there are very few things that you can actually do about it. Unfortunately, one thing you can do is make flyers. Why is making flyers embarrassing to me? Who

knows. But luckily, my friend Rose came over and made them for me on my computer: LINK, 2 YEARS OLD/VERY SMALL/ GREEN EYES/$$$ REWARD!

I sat cross-legged on the floor as I watched her tiny face emerge from the printer over and over again, every fresh page another stab to the heart.

Rose and I walked around the neighborhood and plastered the posters on every pole and car windshield. I was ashamed by how precious and rare Link looked in the flyer picture, because people would wonder how I could have lost such a mystical cat. It looked like one of the student wizards at Hogwarts had lost a pet; Link was a true Harry Potter animal, a tiny Hedwig / Mrs. Norris combo.

After knocking on every door in the neighborhood, I concluded that there is nothing more humiliating than losing your cat; wandering the streets with a puffy face, shouting into space, looking under every shrub, and publicly pleading for help even though you know it's useless, as does everyone who sees and talks to you.

"I'll keep an eye out." "Good luck!" "Hope you find her!" my neighbors said with pitying expressions. I'd once thought that if I ever got the chance to be pitied like this, I'd like it, but now I realized that enjoying pity is only possible when you're not actually in distress. *She's never going to find her*, I imagined the neighbors saying once they shut the door.

When the sun started to go down, Rose and I returned to the house and I sat in my backyard in the rain, wrapped in a blanket, crying, chain-smoking cigarettes (I'd quit four

years earlier), and jingling the toy that she had zero chance of hearing and that I could barely hear myself over my teenage neighbors' party.

Rose eventually had to go home, so I texted every friend in my contacts with shaky hands, asking if any of them could sleep over. I couldn't be alone. Unfortunately, it was hard to lure anyone over to sleep in my living room with all of the windows and doors open as I wept all night. No one said yes, probably because it's "just a cat." However, my friend Emily said she would stop by after dinner to check on me. She wouldn't have been my first choice, if I'm being perfectly honest. Her naive, positive outlook on life had no chance of meshing well with my despair, but I was desperate for anyone, no matter how bubbly their personality.

Emily entered my house to find my dad, my very guilty sister, and me staring at the Apple TV default montage of city landscapes, grim as ever. She took one look at my swollen face, put her hands on her hips, and declared, "We're going to look one more time."

"It's no use!" I said through tears. Then she told some story about her mom's friend's aunt's hairstylist losing her dog and finding her a day later a block away, so I agreed to storm the streets with Emily one last time, but only so I could smoke more cigarettes. My sister came with us for moral support.

It was still raining and now dark. If Link was alive, she would be getting rained on right at that moment. She would be so scared. My poor angel! What had I done to her!

Emily put her iPhone flashlight on and started calling out

her name. I walked behind her, the bottom of my blanket dragging on the ground, crying because I knew it was futile.

We were two houses down from mine when Emily declared, "I just heard a meow."

I wanted to push her. "You didn't hear a meow. Why would you tell me you heard a meow?!"

And then I heard the meow.

"It's probably a stray or someone's outdoor cat that isn't lost," I said, not getting my hopes up.

We slowly moved closer to the noise, which seemed to be coming from the bush next to my neighbors' front gate.

"I don't want to look and be disappointed by some random outdoor cat," I said.

So Emily took the initiative and stuck her head in the bushes for a better look.

"IT'S HER!"

I grabbed her arm. Could it be??!! I dropped my blanket and cigarette onto the wet concrete and peered inside the bush. Link's tiny, innocent face looked up at me. *Meeeeooow.*

Holy fucking shit.

I knew I had to be strategic when grabbing her because if she heard or saw any movement, she'd run away and I could lose her forever, despite having been given a second chance. I also knew waiting to grab her would be a mistake. So I leaped for her, but she freaked and trotted into the neighbors' yard.

I didn't have time to panic. Emily monitored exactly where Link was as I pressed the neighbors' call button over and over again.

"Hello?" the homeowner answered with concern.

"Hi, I'm sorry! My cat is in your front yard, I need to get her!" I said with even more concern. She buzzed me in, the noise so jarring I was afraid that it would make Link run away again. I somehow also had time to note that a lost cat is an incredible excuse to break into someone's house.

Link was now on the right side of their house behind the hedges that lined their property, but there was still a good chance that I'd lose her again. I quietly moved over, inch by inch, monitoring her body language, until I was close enough to reach out and grab her. I got her right before she could run away. I couldn't believe it. She was in my arms, but there was no time to celebrate, I had to get her in the house.

I ran home holding Link so tight she clawed her nails deep into my chest. I didn't care that she might be scratching off my nipple, I was not going to let her go.

My sister, Emily, and I burst into the house with Link, hysterically laughing in disbelief. "Close the door!" I screamed at my sister.

"What?!" my dad said. "What happened?!" He couldn't believe he was hearing laughter. I held the cat up to his face and his jaw dropped. The four of us laughed and literally jumped for joy for twenty minutes. To this day, my dad, sister, and I believe it was one of the happiest moments of our lives. And I am eternally grateful and indebted to Emily and her positivity.

Ironically, I discovered that the only thing more embarrassing than losing your cat is finding your cat. The next day, I walked around my neighborhood ripping down all the flyers

I had put up just the day before. "I found her," I said as people stared at me tearing the flyers into pieces. Passing joggers asked how the search was going. "Yeah, I found her," I'd say, as if it had been as easy as looking in my closet and discovering her under a pile of clothes. I knew that if my cat ever went missing again, I'd be too embarrassed to say anything. I couldn't go back to all of the same houses and say, *Hi! Yes, you are correct, I'm the girl who lost her cat. So, my cat is missing . . . again.* I'd just have to be even more careful than I'd been before.

Since that day, I have weekly nightmares about losing Link. I thought no fear could match that of waking up in the morning knowing I had lost my cat. But it turns out the anxiety of still having my cat and knowing I could lose her again is pretty much just as bad. This cat has brought more anxiety into my life than I knew was possible, and looking back, I can state that my life would definitely be easier if I'd never gotten her. It might even have been easier if I'd never re-found her. Anyways, something to think about if you ever find yourself debating whether to start taking medication or go another route that you think might be more "fun," like getting an animal. I suggest the meds and, more important, birth control.

This Essay Doesn't Pass the Bechdel Test

IT'S ALWAYS FELT OUT of character for me to be someone who could self-describe as "boy-crazy." It's the most stereotypical of all the stereotypical girly characteristics, and I like to think I don't fall into clichés. As a kid, I prided myself on being the opposite of girly, well before it became trendy for hot girls to wear cargo pants and everyone and everything became fluid. Anyways, my point is that pre–destruction of gender stereotypes, I was (and remain) the opposite of girly. I hate the color pink; my voice is debatably deeper than Alan Rickman's; I'm shockingly athletic with catlike reflexes (although that likely can be attributed to my ancestors being persecuted for generations). And I refuse to be in group photos if there are more than four girls in it because it seems like we're all screaming, GIRLS, GIRLS, GIRLS! GIRLFRIENDS! THE FUTURE IS FEMALE! I LOVE MY GIRLIES! PUSSY POWER! WOMEN SUPPORTING WOMEN!

But underneath it all, I'm secretly the girliest girly girl

ever because I am downright obsessed with boys. Being obsessed with boys is basically the equivalent of loving makeup, sparkles, rosé, and your own birthday, but I can't help it. I'm consumed by them, in a "girls at a sleepover eating ice cream and trading stories" type of way. I'll obsess over mediocre boys, boys who are mean to me, boys who are good on paper but shitty in life, boys who are shitty on paper but good in life, sad boys, shy boys, confident boys, boys who are willing to give me attention, and, of course, boys who give me none whatsoever.

In elementary school, when I wasn't panicking over being alive or getting a stomach flu, I spent all my time fantasizing about boys. I'd often force myself to have a crush on someone who I didn't care about just to make class more interesting. Instead of learning long division, I'd opt to stare out the window daydreaming hundreds of different scenarios for me and my crush of the week. They usually involved him saving me from some man attacking me in a dark parking lot. Or saving me from being hit by a car in a dark parking lot. It always took place in a parking lot. So romantic . . .

By the time middle school began, I had already been in love multiple times. One-sided love, but love nonetheless. The first time I realized I was in love came when I was six years old and my crush and I had to escape a thunderstorm on the beach. I will never ever forget him because escaping a storm on a beach as small children in love is the straight-up most romantic thing I can think of. I thought about him almost every night until I had my first kiss in middle school. I obsessed over both my first-kiss person and then my second-kiss person

for months afterward, playing reruns of every word they had ever said to me and every time they ever touched me (once) until the memory was so worn out I didn't know whether it was real anymore. Like, did both kisses actually take place in a parking lot?

No one obsessed over me back until I was fifteen and met my first boyfriend. I hate the sound of *relationship girl* just as much as I hate the sound of any [adjective] *girl*. They're all bad: *girly girl, it girl, horse girl, cool girl, party girl, VSCO girl* . . . if you haven't noticed, it's *tomboy*, not *boy-girl*, because only annoying types of girls get titles with *girl* at the end. But despite fighting these classifications, it took me no time at all to become a die-hard relationship girl.

Being in a relationship felt like walking through a portal into another world. For the first time in my life, I felt like I mattered because there was someone who wasn't a member of my family who cared if I was alive or dead, happy or sad. To be valued every day for just existing is SO TIGHT. You're admired all the time for everything you say, every move and face you make. It doesn't get better than that. The fact that there were even more amazing things about being in a relationship besides self-worth felt too good to be true. Like getting FOREHEAD KISSES when you have a headache. The fact is that you scientifically fall asleep faster. When you're both in pajamas and your legs are intertwined. The wonders of snuggling . . . the first time I felt the cuddly sensation of skin-to-skin contact with my boyfriend, I had a reaction like a kid who had never tried chocolate or seen the ocean un-

til that moment. Before, true coziness was only something I had experienced on those mornings when your bed is miraculously comfier than it's ever felt, where the comforter is cold but your body is warm, and if you just shut your eyes for two seconds, you can drift back to sleep with more ease than on any night you've ever tried. Having a boyfriend is that morning every day. A constant feeling that you are a baby getting wrapped in a towel after a bath. So I pledged never to go back to the other side of that portal, the one where I don't exist and where mornings hurt. My status would permanently be In a Relationship.

My high-school boyfriend wasn't the type of guy a mother would be entirely excited about her daughter dating. He reeked of Marlboro Reds and "toxic" (as my mom called it) cologne ("the chemicals will seep into his skin and yours!"), had amateur tattoos all over, loved an elaborate prank, and was a drug addict. But a really sweet one! And my mom didn't know that, so it's basically like he wasn't.

All in all, he was exactly my type and would influence what my type would be forever. While I might have outgrown other aspects of my teenage rebellion, my predilection for questionable dudes remains. *Questionable* is generous, though. My taste in men is straight-up trash. If I was the Bachelorette and they had to handpick a group of guys that they thought I'd be interested in, it would be a roomful of rightfully convicted felons, trauma patients, narcissists, drug addicts, and cult members. My kink is tragedy and my only requirement is a tortured soul. I love fucked-up guys so much that literally no

one I know would be surprised if I started fucking the demon from *The Exorcist*.

My high-school boyfriend and I were happily together until my senior year when I found out he'd had sex with two of my friends. I also found out he was doing heroin, which I considered a reason to break up despite it being a risk I knew I was taking once I established my type as "red flag." I was inconsolable for months but not enough to keep me from scavenging for a new boyfriend desperately. Contentment just didn't seem possible without regularly having sex with a guy who was in love with me or, at the very least, getting consistent affection from someone who wasn't repulsed by me.

There weren't many boys who were my type at my liberal arts school in Boston. I wasn't into greasy film bros in flannels who called themselves auteurs. To paint a picture, the most popular guys at school called themselves the PTA boys (they were in a Paul Thomas Anderson fan club). My best option was a clean-cut guy from New England, which meant he was whiter than a J.Crew statement necklace and came complete with a catalog of old Facebook photos where he appeared in a variety of highlighter-colored polos with at least ten other friends who were also wearing highlighter-colored polos. All of which clashed with the fact that he always, at all times, smelled like a fresh bong rip. He was very "nice" and "normal" but still had eyes like he might get in a bar fight at any moment, which was ultimately what drew me in. We couldn't have been more incompatible, though. For one, he had no understanding of my anxious nature. When we'd walk down the street together,

instead of protecting me from the outside world like I desperately desired, he'd literally push me into things he knew I was scared of, like flocks of pigeons and people talking to themselves, as some psychotic form of exposure therapy.

He also had no discretion, which I find to be one of the most important qualities a person can have. I've valued it from the first time someone said to me, "Don't turn around but . . ." and to their surprise, I didn't turn around. You'd think no one would ever turn around when asked not to, but most people have no control over it whatsoever. It's as animalistic as a dog chasing after a bunny. To sum up, there are two types of people in this world: those who turn around when you tell them not to and those who don't.

My college boyfriend always turned around. Zero discretion. One time we were at a friend's house for dinner and it was getting late, so I tried to send him vibes that I wanted to leave, poking him in the side as he was talking to his friends and tugging at his arm like I was a child. Once I mentally leave, it takes everything for me to be present in a conversation. In my mind I'm already back home, washing my face and getting in pajamas. So when he didn't pick up on my *Let's go* gestures and glances, I texted him *Can we leave now?* from the other side of the room. Before he even opened the text, he said, "Why'd you text me?" out loud in front of everyone.

I stared at him, expressionless. "Just . . . sayin' hey and miss you!"

"Awww," everyone said, eliciting an immediate eye roll from me.

Then there was the time we were in an Uber and I tried to discreetly express to him via silently mouthing and a hand motion that it smelled bad, stupidly forgetting he's the least discreet person alive.

"What?" he asked.

"Nothing," I replied.

"No, tell me! What is it?!"

The driver was naturally listening much more intently now.

"Never mind, it doesn't matter."

"I hate when you do that! I want to know anyway!" he whined.

I groaned and resorted to texting him: *IT SMELLS BAD.*

"Ohhhh!" he said *out loud.* Then he opened his window and shot me a thumbs-up.

"You're such a burn," I whispered with a defeated laugh.

"What's a burn?" he asked, again at a volume much louder than necessary.

I took a deep breath and texted him what being a burn meant. *SOMEONE WHO IS UNAWARE THAT THEY ARE REVEALING SOMETHING THAT IS NOT MEANT TO BE REVEALED.*

"Ohhhh. Got it," he said, again too loud.

For a while, I thought the worst thing about a lack of discretion was how it led to awkward social encounters, but one day it occurred to me that it could also be a death trap. The epiphany dawned on me when he and I went to the movies one rainy Sunday. There we were, sitting in the theater watching trailers, when I had the same fear many of us have every time

we enter a movie theater: *A man comes into the back entrance with a gun and shoots.* The scenario played over and over again in my head. What would we do? I knew immediately.

The man comes in and pulls out his gun. He starts shooting. A bullet lightly grazes my arm but causes no serious damage, so I use it as an opportunity to fake being dead. I dramatically drop to the floor, eyes closed, because I don't want to see what's happening anyway. And as I'm praying for our survival . . .

"NOOOO! SOMEBODY HELP!" *my boyfriend screams. He gets on the ground, puts two hands on my chest, and starts loudly performing CPR.* "One! Two!"

"Shhhh, I'm playing dead," *I whisper.*

"You're WHAT? YOU'RE ALIVE?! SHE'S ALIVE!" *he screams out in joy.*

"SHHHH. Don't be a bur —" *And the guy shoots us both dead.*

I obviously couldn't be with a burn, but because I knew the idea of being alone felt tantamount to actually being dead, I waited for him to break up with me, which didn't take too long — I was just as unbearable in my own ways.

I was lucky enough to quickly find another boyfriend to fill the void, extending that relationship for as long as I could, because if there isn't a boy who loves you and knows what you did that day, did you even have a day? What's the point of anything happening to you if you have no one to tell your daily funny anecdotes to?

I was able to keep up my serial dating habits until my mid-twenties, when I suddenly found myself alone with no

companion in sight. I was officially — cringe — a single girl. *Ew.* I hated the sound of it. Something about it was so much girlier than a relationship girl. I had never really been a single girl, and I definitely had never been a single adult. Because of this, it took no time at all for me to do the first thing a person who has been out of the dating game for exactly ten years thinks they're supposed to do: sleep around.

The newly single girl's mindset is simple: meet a few guys to rotate hooking up with and have them all wrapped around your finger wanting more even though all you want and will give them is sex. I was like Christian Grey to my new partners, but about hygiene. I'd have a guy over and be like (sexy voice), *Why don't you follow me into the room . . . where I keep all of my toys.* I'd seductively lead him into a bathroom, but instead of showing him an array of vibrators, butt plugs, and cock rings, I'd present to him spare toothbrushes, floss, and tongue scrapers. *Ever used this toy? It's a water picker . . . really, though, please use it before you stick your tongue in my mouth.* Also I'm sure Christian Grey did not send his partners off with the final words "All right, bye! I'm sorry — I mean, thank you. Not thank you; why am I thanking you? Why would I apologize or thank you? But seriously, I'm sorry you had to spend time with me and thank you for suffering through being around me. Let's hang soon. I mean, if you feel like it. So probably never. All right, have a nice life." (Who wouldn't want this?)

Something I observed during my beginning stage of being single, other than how many guys learned absolutely nothing from the Me Too movement, was that all guys, even the nice

ones, *hate* wearing condoms. The condom excuses were truly endless: "I don't have one." "I don't usually have to wear one but I *guess* we can use one." "I can't finish when I wear a condom." "Condoms cut off the circulation in my dick." "I'm allergic to latex." "I just got tested so we don't need to." "I can't stay hard if I'm wearing one." And, my personal favorite, "My dick is too big for condoms."

One time I asked a guy I'd been consistently hooking up with for months to, once again, put on a condom. We weren't exclusive, but *I* definitely wasn't seeing anyone else, and I stupidly thought he might not be either. I had been calculating all of the time we were spending together and I just couldn't imagine how he'd be able to fit in hooking up with someone else, and also why would he want to? Shouldn't his dick, I don't know, feel as tired as my vagina from the frequent sex we were having? I asked him if he had a condom.

"Ugh, do we *have* to?" He moaned.

"Only if you've had sex with someone between us having sex . . ." I said, waiting expectantly for good news.

"Okay, *fine*, I'll put it on," he said grudgingly.

Dope. You can get so much intel from condoms, that's why I, unlike guys, love them.

Another time I asked a guy to put on a condom and he said, "BORING." Loud like that.

Some guys are so disappointed by the mere mention of a condom that if you're in the midst of hooking up and you ask if they have one, they react as if you just asked them to move in. Nine out of ten times, "Oh" will be the first word

out of their mouths, followed by "Um, okay. Let's think about that . . ." The disappointment is so palpable that you can actually see their facial expression contort in slow motion from excited and adrenalized to utterly let down, even if they didn't know sex was in the offing. It's like if you went to a Drake concert and didn't enjoy yourself because Lil Wayne didn't make a surprise appearance, even though Lil Wayne was never supposed to be there in the first place.

I guess after the miracle that is birth control pills and IUDs, men became accustomed to idyllic raw sex, so the idea of wearing a condom became unthinkable, like going back to coach after experiencing first class. It's gotten to a point where I feel like birth control pills aren't even used to prevent birth anymore, just to prevent condoms. You'd think condoms cause actual pain from the reputation they have, but the reality is, they're not that bad; they just, as one guy explained to me, "reduce the sensation." God forbid the sensation is reduced! I honestly feel good about taking a daily pill that screws with my hormones and messing up the natural order of my body so men can have more sensational sex with me.

It turned out that being single was less having guys wrapped around my finger and being fun and independent and more feeling a destructive combination of disgust and shame. When I told my friend that I had come to the conclusion that sleeping with people doesn't actually make you feel better, she let out a condescending laugh.

"Wait, *obviously* everyone knows that . . . you didn't know that?"

You would think your friends would tell you something of such great import to save you from such deep regret, but another thing I learned during this time was that friends thoroughly enjoy when another friend does something stupid, because it's fun to hear about their ill will and also makes them feel better about their own past mistakes.

Anytime I hooked up with someone, I'd feel fine about it for the next eleven hours, like an I'm-cool-I-do-what-I-want feminist badass. The possibility that I didn't feel so cool about it would creep into my mind right as I was trying to fall asleep the following night, but because I'd still be on a high from the rush of it all, the onset of shame was easy to demolish. I'd think, No, *fuck it. It's fun. I don't give a shit*, and fade away into the night with that as my last thought. But as soon as the sun rose the next morning, so too would the irrepressible mindset that everything that had happened was, in fact, disgusting and/ or humiliating. The second I'd open my eyes, I'd get winded by the overpowering force of psychological mortification that came in the form of flashes, both auditory and visual.

Flashes, also known as the prelude to shame spirals, can be triggered by just about anything and can best be described as the distant, sexualized cousin of PTSD. Auditory flashbacks, specifically, usually are derived from a word that made you cringe, like them saying *Sexy* in a way that was very unsexy. Flashes can last for weeks and can appear whenever: when you're in the middle of lunch with friends, exercising, reading in the quietude of your home. They are impossible to control and difficult to make disappear. I had to repeatedly hit myself

in the face with the book I was reading to eliminate one such flash that got more distorted by the second, like it was on a projection in a fun house.

One of the reasons being in a relationship was so easy on my psyche was because nothing about having a boyfriend was embarrassing. There was no overthinking anything I said or did, because once people decide they like you, they're in. They then *stay* in for all of life's unavoidable humiliations, like your mom yelling at you, mispronouncing a word, or your cat pulling your tampon out of the trash and playing with it like it's a mouse. But *before* someone is your boyfriend or girlfriend, everything is fucking embarrassing. The scale can be tipped in any direction at the drop of a hat. Like, you can literally drop your hat and be embarrassed by how it happened, about how you picked up the hat, et cetera. Anyone can suddenly become unfuckable from just about anything.

Dating is by far the most challenging activity for a person who is inherently hyper-ashamed about everything already, but I keep doing it regardless, as I seem to have the sex drive of a teenage boy and am incapable of surviving the day without male approval. I'll get shame spirals from the most benign of circumstances, like realizing a guy and I had the same conversation on both of our two encounters. The simple act of going to dinner can incite flashes because there's "trying" involved. I'll shudder at visions of the two of us sitting at the table trying to outdo each other's witticisms. You can only imagine how long it took me to get over an instance when a guy who I was obsessed with was driving me home from a date and put his

hand out, presumably for me to hold. I went to hold it, despite my disbelief that this boy would want to hold my hand, and a second later when he realized our hands were entwined he said, "Oh no, sorry, I was gesturing for you to pass my Juul." I of course said, "I know, I was kidding." And he pretended to buy it, but I didn't know what was worse, him not believing me or him believing me and thinking that was my sense of humor.

Shame, as one would expect, leads to self-loathing. And because nothing makes me more embarrassed than being single, nothing makes me hate myself more either. This is because when you're single, no one likes you. It's pretty much the definition of being single, because if someone liked you, you wouldn't be single. There's the occasion when you have like seven guys in love with you, but that really only happens once they sense you're on your way to becoming not single again. And I guess you can be single by choice, but I always find that dubious, because why would anyone actively choose not to cuddle, develop a perfect sex flow, and have someone to make fun of movies with? That said, it's hard to come to terms to the reality of my particular circumstance of single-dom — the type where you want a boyfriend but are also emotionally unavailable, so you seek out other emotionally unavailable people who will inevitably disappoint you in their lack of commitment. A lovely and never-ending cycle of emo-tional unfulfillment.

The emotionally unavailable people I hook up with are especially captivating to me because they behave the exact same way in front of me as they would if no one was there.

The way they spit into the sink or pull their jeans down to put on sweatpants, the way they yawn without caring what their faces look like, the things they look at on their phones — they don't mind if you peek at their screens, they have nothing to hide, you're not their girlfriend. Nothing is for your benefit; you might as well not be there. You're like an Amazon Alexa, there only to listen and observe or in case they feel like asking a question.

Meanwhile, I do nothing the same as I would if I were alone. I ration the glass of water a guy gives me before bed to last through the night because I don't want to ask for more and seem high maintenance, nor do I want to trudge through his house and open his fridge without permission. I am excessively alert and aware of every move I make, critiquing every motion like a basketball coach on a Telestrator. Once I leave, I will continue to overthink and review my words and actions until he texts me, whether that be minutes, hours, or days later. It is not until I get that text that I can stop reflecting about my time spent there, as a text is the only confirmation that I did not do anything to make this person like me any less than he did before I came over.

There are two stages of being single: texting and not texting. I remember the different eras of my life not by year but by who I was texting at the time. Not getting texted — meaning a large gap between someone you're obsessing over texting you — is inevitable, but that fact never stops the train of a million reasons you believe might be why he's decided not to text you anymore.

- Was it because my air-conditioning was broken and we both woke up sweating and he had a terrible night's sleep and now he doesn't ever want to sleep over or even see me again because he can't get past how physically uncomfortable the situation was?
- Was it because I was joking about how insecure I am, but he's actually really turned off by insecurity and didn't think it was funny at all and instead thinks I'm crazy?
- Did he mistake my sarcasm for me being full of myself? And he thinks it's completely unwarranted for me to be full of myself because I'm such a loser?
- Was it because the lighting was bad when we Face-Timed and that was the last impression I left on him and now he can't remember what I actually look like except for the image of that horrid little square?
- Did he see through my "I don't care" attitude and can tell I've spent a lifetime being obsessed with boys?
- Does he think I like him? 'Cause I fucking don't. At all. How do I make him know how much I don't like him so he likes me again?

Shockingly, these are still not the most deranged thoughts you can have when someone stops texting you. The truly insane ones come after the overly optimistic, hopeful ones. The ones you still have, despite them being another devastating cliché, because you are obsessive and the thought of someone not being totally obsessed with you is less than ideal. You

know these either from having them yourself or from every romantic comedy:

- Maybe he's actually in love with me and that scares him?
- Maybe he just doesn't want to get hurt?
- Is it possible he doesn't know that two weeks have gone by and he's just busy and he does like me but isn't texting me because he can't hang out right now?
- Is it possible he's scared to get rejected by texting me first, even though I was the one to text first the last two times?

I've made myself so crazy from not being texted I've actually come up with fake reasons for why I'm checking my phone just so I don't judge myself.

Fake me: *Hmmm, I should probably check what time it is again.*

Real me: *LOL, Cazzie, you know exactly what time it is. I can't believe you think we're going to believe that. You are adorable. You really think he'll have texted you in the last five minutes? HAHAHAHA. LOSER! HE'S NEVER TEXTING YOU AGAIN, STOP EMBARRASSING YOURSELF IN FRONT OF YOURSELF.* My inner cadence is an internet troll's.

It doesn't matter how much better than the other person you know you are; power imbalances do not take such trivialities into account. The majority of the guys I interacted with had something freakishly off about them or some bag-

gage from their last relationship. And although I'm certain I have more baggage and trust issues than they ever could, I still manage to behave more normally than any of these weird single dudes. There's one guy who would text me all the time but wouldn't hang out with me. There's a guy who would have sex with me all the time but wouldn't text me. There's that guy who will just kiss you but never fuck you, and I've heard about the guy who will fuck you but not kiss you, although I've been lucky enough not to encounter him yet.

Speaking of guys — by far the biggest myth I was ever told about them is that "guys will do ANYTHING for sex." In my personal experience, this could not be more untrue. Many guys won't do even the bare minimum for sex. Some guys won't even come over for sex. There are guys who won't even send a text for sex. No, this doesn't say more about me than it does about the entire male gender.

A prime example: For my twenty-fifth birthday I went to Mexico with my sister and six friends. A guy I was seeing at the time (the one who would have sex with me but not text me; I was obsessed with him) just so happened to have a trip booked there, staying fifteen minutes away, with his friends for the same weekend. I know I have little credibility at this juncture, but this was in fact a coincidence. I did not follow him there. Not that I am above that and not that I haven't done that before.

On Friday, we made loose plans that we'd try to see each other either that night or Saturday night, both acknowledging that there was a chance that we (he) might not be able to

make it happen because we (just him) were going to be busy with our friends. I decided in my mind Saturday would be the better night for me, based on the tan I'd have by then, but obviously if he were to text me later that night, I wouldn't say no, because although some guys won't do the bare minimum for sex, I, a pathetic, attention-seeking girl, will do the absolute maximum.

He said he would check in with me later, but in order for me to be prepared to meet up just in case (JIC), there were a few things I had to do and plan my day around:

1. Meticulously shave all areas.
2. Massage a lovely-smelling combination of lotion and oil into every inch of my skin so it seemed like my natural scent as opposed to me actively trying to smell good for him.
3. Smooth down my curly-ass hair with blow dryer/ straightener/products.
4. Put on an inorganic deodorant because organic deodorant is the same as no deodorant, and you save those noncancerous odors for friends and family.
5. Put on the new underwear I'd bought specifically so he'd think I had more than the four pairs I had already recycled multiple times with him.

I also needed to figure out the sleeping arrangement for my entire group. Every bed in the house we'd rented already had at least two people in it; mine had three (me, Romy, and my

friend Molly). Before we got to the house (honestly, before the plane even took off), I figured out what the assigned beds would be JIC. So once everyone got settled in, I asked Molly and Romy nicely if they would by any possible chance be willing to squeeze in with the others for one night if he came over. They agreed because there is a place deep down in every person (except for the guys I sleep with) that understands the intermittent desperation to fornicate.

At my birthday dinner that night, I still didn't know if he was going to capriciously decide to come over, so I didn't eat as much as I would have liked to; JIC I would be having sex later I didn't want to be too full to fuck. So even though I would have loved to enjoy my b-day dinner by shoveling down chips and tacos and cake and margaritas, I didn't. And even though I would have loved to spend the entire meal not thinking about whether or not this piece of shit was going to come over later, I couldn't do that either. Because as much as I wanted to enjoy myself in the moment, I wanted to have sex later more. And it's apparently impossible for me to do both.

After dinner, my friends asked every twenty minutes whether I'd heard from him yet.

"No! Don't you think I would tell you all immediately?!"

"Well, should we switch rooms *just in case?*" Molly and Romy kept asking.

"No, we're not switching rooms *just in case*. That'd be humiliating if he didn't end up coming." But doing everything else *JIC* wasn't?

I watched as all my friends enjoyed themselves splashing in

the pool and drinking red wine in the Jacuzzi. I didn't go in, JIC, because if I did, I'd have to start the showering process all over. So instead, I sat there soaking my feet, starving, anticipating a moment that I knew now had at best a 20 percent chance of happening.

When the clock struck eleven and my sister brought out another bottle of red wine and frozen peanut butter cups, I performed the very undignified act of texting him, to which he quickly replied:

Ah, I can't tonight, but let's do tomorrow?

Fine! I wanted tomorrow anyway! It's not like I would have spent my entire birthday differently, physically and mentally, if I'd known.

Unsurprisingly, Saturday went exactly like Friday: mental preparations and somatic deprivation. Still, I was convinced that this time, it would be worth it. Around dinner, I got an update that he wouldn't be able to meet up until much later and asking whether I was fine with that. Fine with that? Obviously, I was fine with that. I have no self-respect, and one of my favorite pastimes is waiting around for a guy to come fuck me! Sure, totally, see you then!

Waiting is another stage of dating. Waiting for a text, waiting for someone to come over, waiting for the power to shift. This particular night, I waited for all three until the wee hours of the morning. Molly and Romy had already gone to sleep squished in different beds with other people, and my remaining insomniac friends had started to retire one by one. *I*, the boy-crazy, shameful loser that I am, waited up until *three*

thirty in the morning for this fucking fuck. I'm so pathetic that I didn't even wait and then fall asleep while waiting. I waited until I got a text that said *Ahhh, hanging with the boys ended up going late* and he was *so tired.*

Tired.

Tired.

Tired.

He was tired.

So he got tired; he's only human!

Disturbingly enough, this wasn't the first time I had waited until the crack of dawn for a guy to come over. I say to myself, *One thirty is the cutoff* (which is already degradingly late), but then two a.m. hits, and then two thirty, and I'll make a new cutoff for three thirty by convincing myself, *That's still kind of earrr-ly. In New York, they stay out until six in the morning!*

I've never had a guy wait up for me. Not that anyone has ever explicitly asked me to wait up for them. If I knew a guy was waiting up for me, I'd feel so bad that I'd probably give him minute-by-minute updates on exactly why I was keeping him waiting:

So sorry, I'm going to be ten minutes later than I said I'd be, my friend is my ride and isn't ready to leave yet!

Sorry, now it's going to be fifteen more because I have to go to the bathroom and there seems to be a long line!

Someone came up and started talking to my friend. Waiting for them to stop talking.

Traffic! Three more minutes! Don't hate me!

I was too embarrassed to tell everyone the next morning

that he never came over, so I said he'd arrived after everyone went to sleep and left right before everyone got up. Which, in retrospect, made it seem like he was even less interested in me than if he hadn't shown up at all. It was also the wrong thing to say, as my sister made me wash all of the pillowcases and sheets so she could sleep in the bed again that night. If you weren't already convinced that I'd do anything for a guy, I would clean perfectly clean sheets for one.

I learned a lot going to sleep that night at four a.m. in a king-size bed to myself while the people who actually loved me were packed like sardines in other beds for no reason. First and foremost, if you don't know for sure if a guy is going to come over or not, do nothing JIC because he is probably not coming over. Second, I learned that I needed to reevaluate my priorities. I'm kidding — imagine if I had only just realized that? But I did finally start to do it. It's not like I'm completely healed to the point where I would never wait up for a guy anymore, but I will under no circumstances wait for one dressed and in makeup. Nope. Not me. I'll wait up until daybreak with my pajamas on and my face washed, because I have dignity now.

I know I've talked a lot about sex in this essay, but I'm not a sex girl, which is something I call a close friend of mine because whenever she talks about it, she makes everyone in the room feel like they've never had sex before. Not because the intercourse she's describing sounds so salacious (it's entirely standard), but because of her unwarranted decision to talk about

it in detail. She's the self-proclaimed sex educator that no one hired coming at us out of nowhere with statements like:

"I'm just a *really* sexual person."

"I *love* sucking dick. Every guy I blow says I give the best head they've ever had."

"He told me my pussy tasted like vanilla frosting."

All I can ever say back is a sarcastic "Nice!" because who the hell says those things even if they're true? No one should ever repeat a compliment they've received, and repeating a sex compliment in particular should be illegal.

Everything she says about herself makes me feel like I'm a prim, frigid being. It's worse when she pressures me to tell her about my hookups. Like when I told her about how I was making out with this guy for the first time and he pulled my underwear down way too soon, how I hated that he did that before my shirt was even off. I felt like it'd be confusing if I stopped him. What was I supposed to say? That I wanted my underwear to be kept on for at least another five minutes? Somehow I feel more naked if my underwear comes off and my shirt is still on than if I was just completely naked. Having just your underwear off is so vulnerable.

"Same! I feel so much more vulnerable when I have clothes on than when I'm naked. When I'm naked, I feel so free and sexy." Not really what I meant.

But sometimes she'll say something that opens up my whole world, like what she said to me after I told her why I didn't end up seeing the guy in Mexico.

"Caz, you are the fuckin' director. You're holding the

auditions! If they miss a fucking audition, they ain't getting that fucking part. Oh, you don't know one hundred percent if you're coming over? Well, there is a *zero percent* chance you're ever getting this pussy again!" Brilliant.

I don't know why it had never occurred to me that my opinion was also important in these situations. I could find more things to hate than anyone, yet all I did was pray that any guy I was with wouldn't hate me. Which brings me to the most clichéd notion that has ever existed in terms of being single, because no discussion about obsessing over boys can ever conclude without realizing "you need to love yourself first." It's always disappointing when you're a contrarian and find out that a cliché is at least a little true. But I guess that's what makes it a cliché.

"Loving yourself" is gross — it's loving pink and taking glass-clinking boomerangs and it's nearly impossible for someone whose entire identity is based on hating herself. It didn't seem right for me. Having a boyfriend was always my preferred version of self-love, which I will henceforth call "not hating yourself" (NHY) so we all cringe less. Being in a relationship is the ultimate NHY because there's a person who is in love with you, and you get to see that love reflected onto you at all times. In order to survive, you need at least one person to love you. When you're single, that person has to become yourself so you don't want to kill yourself. Which is why the corny people who say "Choose to love yourself!" are right; they just fail to recognize that you don't have a choice. The option is literally love yourself or death.

How do you NHY if your default is always hating yourself? I don't know; still figuring that one out. Which is probably why everyone says your thirties are better than your twenties, because you've gotten the hang of it by then and are consequently aware of things like giving people a 0 percent chance of getting this fuckin' pussy (did I pull that off?) if they are doing the bare minimum. That all of the dreadful experiences serve to help you figure out what you want and need in a partner, like a guy who won't sleep with your friends, who values discretion, and who, preferably, understands the importance of using a condom. Sure, I knew I wanted all of those things before living through them, but who doesn't want a better excuse than loneliness and boredom for dating a bunch of people they know aren't right for them?

Being single is coming to terms with the reality that one of life's beautiful surprises is how vexing and life-ruining average dick can be. It's knowing that if you're only happy when a guy is texting you, you're not actually happy. And if you think you're depressed but then get happy when a guy texts you, you're not actually depressed. It's knowing what you are. Which is single. And in the midst of worrying about your appearance, your personality, your sexual chemistry, and the opinions they may have formulated about you, you realize that all anyone is actually looking for is someone who isn't thinking about any of that at all.

Tweets I Would Tweet
If I Weren't Morally
Opposed to Twitter: III

I have urban dictionary open and I'm ready to sext

If u (I) have to take a Xanax every time u (I) see a certain guy u (I) probably shouldn't see that guy

My favorite pastime is reporting all of Emrata's Instagrams

Every note I get on every script is: She has to find joy in something or no one will like her. And I'm just like, yeah, that checks out

Honestly, if your name is Jim I will never hook up with you

I feel like press for movies has become so absurd
— they travel together taking pictures and doing
interviews as if they're the group of people who cured
cancer

I never feel less attractive than when I wear my
glasses to work out

I will get a C-section instead of natural birth solely to
avoid the cliché of my husband holding my hand and
yelling PUSH

This is controversial but I really can't think of anything
more disgusting than a mother's relationship with her
adult son.

Placing my cat around my neck hoping she digs her
claws into my throat

Straight guys are so easily manipulated. Your boy-
friend's psycho girl "friend" could send him nudes
and then write OMG I'M SO SORRY WRONG PER-
SON!!! And he'll be like omg the most insane accident
happened to her I feel so bad.

I don't know one straight guy who can differentiate
between a natural blonde and a dyed blonde

Straight guys don't notice fillers or injections of any kind. Even if you showed a guy a staggering "before" picture, he'd say something like "She prob just grew into her face. Kids are super-goofy-looking."

A straight guy once said to me after we woke up "Ohhh that's why my sister's boobs are always coney in the morning" because they don't have bras on . . .

If you want to look extra slutty, chew gum.

Have u ever put on a sweatshirt you haven't worn in a while and you're out with friends and you reach into your pocket and pull out like ten used tissues from a time you were sobbing?

The new normal is wanting to die

Every person has two numbers of the amount of people they've slept with. One number is how many they've slept with in total; the other is not counting all of the times they really didn't want to but did it anyway.

Sucking on pistachio shells is the only thing I've found that can actually help with anxiety

I have one outfit that I repeat until someone notices.

I feel like big influencers have a sweatshop of people to think of Instagram captions for them

Underrated breakup movie is *Twilight: New Moon.* Really gets the pain

"I never meant to hurt you" is the most meaningless phrase in the English language. WHY WOULD IT MATTER IF U MEANT IT?? I'D RATHER YOU MEANT IT

The easiest way to tell who was dumped in the relationship is by who posts a slutty photo after; whoever posts one was dumped. You do not post a slutty photo after dumping someone — that's diabolical

The only way to get a good photo is to have someone who's emotionally invested and cares about the outcome

Does anyone know what it means to enable cookies on your phone and computer 'cause I've seen it pop up randomly for the last ten years, what the fuck r cookies and how do I enable them??

I hate my friends' group of friends so much, they all think they're alternative 'cause they'll listen to MGMT

and they'll brood thinking no one understands them
but there's like seven of them who all understand
each other

What if I just gave in and made my Instagram bio
"Larry David's daughter"

Why does every model flare their nostrils when flaring
your nostrils is the most unattractive thing u can do
with your face

The forever scariest thing in the world is feeling
around for something you need in the dark

the only thing scarier than feeling around for some-
thing in the dark is getting a phone call from anyone

The easiest way to talk to your dead friends is when
you're underwater

The closest thing to feeling what I think it's like to
move around when you're dead is swimming under-
water

If I was in a sitcom I would be the weird girl in the
family you cut to anytime the conversation has
ended that I wasn't a part of and I would say one of
my various catchphrases: "I'm scared." "Am I

gonna be okay?" "I wanna die." "I hate everything and everyone." "So does everyone hate me now or what?"

Pitch: an apocalyptic movie where everyone's DMs are hacked

Comedians always say something that isn't a joke and then say, "That's it. That's the whole joke."

People always tweet something and then say, "That's it, that's the tweet."

Jess from *Gilmore Girls.* That's it, that's the tweet.

Andrew Garfield as Spider-Man. That's it, that's the tweet. And no, that's not a joke. That's not "the whole joke." He was the best Spider-Man.

What is with the adult friend groups that go to Disney Land? They are wearing the ears. You're an adult! Disney Land is for kids.

One of the things I hate the most is struggling in the water in video games

FaceTime is a skill and I am bad at it.

It's so embarrassing to break up. It's like "Ha-ha,
you were so wrong, you thought you guys were
right but you were wrong and we all know now, that
suuuucks!!!!"

Sweet dreams, fuck reality

Moving Out

She has persistent sleep problems, which may be due to her number of fears. She does not hear voices but "sometimes I'm trying to sleep and if there's a wind, I'll think of something else, like someone whispering."

— *Excerpt from neuropsychological evaluation of Cazzie David, 2007*

In late 2018, after two years of being roommates with my dad and what started to also feel like wingmen following a few instances of receiving a pound-it when I was left with no other choice but to tell him I wouldn't be sleeping at home that night, things started to unravel. We began to fight — a lot. Not about the things most roommates fight over, like cleaning up after oneself or being loud and inconsiderate. Instead, we fought about safety. I bet you're wondering, *What's there to argue about? Who doesn't want to be safe?* Well, my dad doesn't, apparently.

My dad and I seem to have polar-opposite views when it

comes to the protection that's required when you live in a house. My father, a pretty well-known celebrity living in a large city, acts like he's a farmer living up in the secluded mountains of Montana, except I have the impression that most farmers at least own a gun. My dad prefers no security whatsoever. He was on Venmo as himself for years until he asked me why people kept requesting thousands of dollars from him. Unless I take it upon myself, doors and windows are left unlocked and the alarm system that is in perfect working condition remains unused. When I tell him that a lot of famous people have a security person and even most nonfamous people have cameras outside their homes, he scoffs.

"Who do they think they are?! Yeah, *OOOOH*, we're all out to get you! Ridiculous! No one cares!"

I know I'm particularly paranoid, but I think it's entirely rational for me to want to sleep with our alarm system on. Alas, all it took was one night of the alarm going off accidentally for my dad to decide that not only do alarm systems not work, but "they are accidents waiting to happen."

"Their only purpose is terrifying you in the middle of the night for no reason when no one is even there! I've been alive for seventy-two years and no one has ever broken into my house!"

If I weren't so scared of my dad dying, I'd pretend to be a burglar in the middle of the night just to teach him a lesson. Except in that lesson, he'd probably die of a heart attack, and then I would, of course, die of irony.

Living together was initially harmonious. We were never

left to our own devices for dinner; we'd complain over coffee in the mornings and MSNBC at night. He'd leave out the *New York Times* op-eds for me to read on Sundays, and I'd explain to him what memes were — over and over again.

"Dad, the expression on the person's face is a reflection to the above sentence."

"Nope. Don't get it."

It was all going wonderfully until one day, seemingly out of nowhere, my dad started obsessing over how annoying it was to look around for the key every time he wanted to leave or get into the house. It was a monomania similar to when he became infuriated with outlets being located only behind beds and tables. He'd pace around, yelling: "WHAT ARE THEY, SOME KIND OF MONSTROSITY?! WE HAVE TO HIDE THEM BECAUSE THEY'RE SO UGLY!? WE BEND DOWN, BREAKING OUR BACKS, MOVING FURNITURE TO GET INTO THEM?! ENOUGH OF THIS!" Instead of ignoring this, as one should, he redid our entire electrical circuit so we could have eye-level outlets. When I said they looked bad, he took it so personally, it was as if I had said it about his appearance.

I definitely didn't help the key situation, I'll admit. I often forgot mine altogether and would be locked outside for hours, calling him and his assistant twenty times over. When he decided to hide a spare key outside, I never remembered to put it back. I just kept bringing it inside the house with me, locking it in there for the next time I needed it.

One day he decided he had had enough, and I came home

to find the lock on the front door removed and replaced with a door code. A door code. Like it was a goddamn therapist's office. I gasped and rang the doorbell five times in a row. My dad opened the door as wide as his arm was able to stretch, his face beaming with joy, the type of smile I see only when he thinks he's figured out a small but life-changing solution to a problem.

"WELL, WELL, WELL, LOOK WHO IT IS! WELCOME HOME!" he said.

"Father," I said, trying to suppress a smile I had only because his was contagious.

"ARE YOU SEEING THIS BEAUTY?!" he said gesturing to the door code. "HOW ABOUT THIS BEAUTY?!"

"Dad. What. Is. This."

"NO MORE LOOKING FOR YOUR KEY. NO MORE LOOKING AROUND THE HOUSE AND CAR FOR THE KEY. NO MORE LOOKING THROUGH DRAWERS. ONE CODE. *NEVER LOCKED OUT AGAIN.*"

"I've never felt more unsafe in my life."

Going to sleep every night when you're as fearful as I am but also live with a dad who has a shocking alter ego of a free spirit is nerve-racking, to say the least. My dad takes what looks like fifty supplements every single day and hasn't had sugar in fifteen years. The man would sit in a cryo-chamber for six days straight if someone showed him a study that said it *might* prevent illness, but he will take absolutely no precaution to ensure neither of us gets murdered. I'd chosen to live with my dad because he was eventually going to die, but over

time, it had developed into me living with him to protect him from immediate death.

As the security guard of the house, my job is to go hunt for a killer. When I was a child, I was too scared to go downstairs at night alone, as was my sister, so we made a promise that no matter how badly we were fighting or how comfortable we were in bed, if one of us needed to go downstairs, the other one would go with her. We were scared of anything and everything but mainly apparitions and burglars. These fears mostly still remain to this day, but now I'm forced to confront them solo. I've been afraid of coming across something nefarious for so long now that I've begun to feel surprised every time I don't run into an intruder. It's almost starting to get discouraging, like training in the army for seven years and never getting to go to war. Well, it's not like that. Soldiers are happy when they don't have to go to war, and I'm happy that I don't have to fight a murderer. All I'm saying is that there's a lot of time put into mentally training and it'd be a huge waste if it turns out to be for nothing. I imagine being ninety years old and seeing the intruder at the bottom of the stairs. "Finally! It took you long enough!" I'll say.

I'm aware that the chances of me *not* finding an intruder are way higher than the chances of me finding one. But regardless of the odds, I've never missed a night checking all of the rooms and hallways. I don't do it in a brave way, though, like the way the first character who dies in the horror movie checks the basement with a flashlight because they heard a

noise. I do it like the character who has already watched all of their friends die — running through the house and screaming, knowing the murderer is about to grab me by the shoulders.

In this process, I lock all the doors and windows. Then I double-check them by shaking the knobs to ensure I did in fact lock them and it isn't my brain tricking me into a false sense of security. I close the curtains in every room so no one can see into the house, just in case someone is hiding in the backyard. Then I pat down the bottom of all the curtains with my foot to make sure no one is hiding behind them (even though I'm the one who closed them). And last but definitely not least, I put on the alarm code on and pray to God it doesn't go off and wake my dad up because the wrath of my dad waking up in the middle of the night for anything ESPECIALLY AN ALARM is unlike any wrath you've ever witnessed — like a Mob boss who just found out you're a rat.

Once I'm done with my search and lockdown, I can get into bed, but because anxious people can't just go to sleep, I stay up panicking. If I could have any superpower it would be the ability to fall asleep when it is nighttime and when I am tired. Falling asleep is a miracle, a magic trick. Anyone who is able to do it should consider themselves magicians. The act of falling into sleep terrifies me; it's like there's no difference between that and going under anesthesia, so there are many things I must do to distract myself from the fact that that is what I'm doing. First, I sit facing the door so I can see and react immediately if someone enters. Then I put on a television

show at medium volume, quiet enough for me to hear anyone walking around but loud enough to drown out the air-conditioning noises so I don't mistake them for paranormal beings. The show must be lighthearted and fun, not so fun that the sounds will keep me up but fun enough that there's nothing remotely sad or scary in it that could result in a bad thought or dream. My night dreams are even more terrorizing than my daydreams, but I won't go into them because listening to people's real-life stories is boring enough; who wants to be subjected to someone's imaginary night? Everyone thinks they have the scariest dreams, just like everyone thinks that they have the best dog or best therapist. But I do wonder if, when I dream that I'm going through the horror of being kidnapped and initiated into a cult and having to cut off a baby's head so they wouldn't kill my family, is my brain essentially going through the trauma of that happening on a minor scale? If I drowned in my dream, then technically, I felt the fear of death as my lungs filled up with ocean water, and I sincerely believed I was drowning . . . Anyways, just something I'm curious about. Like, sure, I've had zero hardships, but dream Cazzie has been through the wringer!

After I've forced myself to listen to non-scary TV dialogue for a few minutes, and as my dad is peacefully slumbering in the other room without a care in the world, the usual debate starts in my mind: Do I lock my bedroom door in case the intruder manages to get into the house? But what if my dad has a medical emergency and I can't hear him because my door

is closed? Or what if I can't hear the intruder enter his room? Do I leave my door ajar? But if my door is open, maybe the intruder will come into my room when he otherwise would not. What's safer — locked, unlocked, or ajar? Of course, I could just take a sleeping pill, pass out, and avoid these negative ruminations altogether. But my mother sent me an article on the dangers of sleeping pills a while back, one that was too dense to read all the way through, so I can only assume that the dangers are very real and horrifying.

When I tried to talk to my dad about how unsafe I felt, he made me feel like a true piece of shit. "You think you're so special that out of everyone on the planet, someone is going to choose to come kill or kidnap *you*?" Then he gestured to the door code. "And how could this possibly make you feel unsafe?"

"Someone could easily watch one of us entering the code. It could probably also be hackable —"

"Oh, SHUT UP, you're nuts!" he said in the same offended manner he'd had when I said his outlets were displeasing to the eye.

After many days of getting even fewer hours of sleep than usual because of the door code, I decided I should confront my dad, lovingly and patiently. We *were* roommates. House decisions should be made together!

I walked down the stairs, expecting to find him at the kitchen table popping supplements, and heard the door code being entered. *Must be my dad coming in from getting the*

newspaper, I thought. But it wasn't — it was his yoga teacher! So much for being loving and patient. I went and found my dad.

"DAD, WHAT THE FUCK?! You gave our front-door code to your *YOGA TEACHER?!*" I whisper-screamed so she wouldn't hear me.

"Yeah, isn't it amazing? I don't have to walk over to open the door anymore! I'm telling you, this door code is the smartest thing I've ever done."

"Do you know what else would be smart? An open-door policy! Let's just leave the door open!"

"It's impossible I could have raised such an idiot."

"DAD, who even is she!? She can't have our front-door code! No one should have it but us!"

"Of course she can! Stop worrying! Trust me, she's a very nice person. What do you think, my yoga teacher is going to murder us?!" he said.

"No . . . but what if she gives it to someone else?! What if someone knows she's the only one who has the code and then ties her up and tortures her until she gives it to them?!"

"If someone cares that much about getting into the house, they would just break the fuckin' window!"

He had me there. But I still felt it was wrong for someone I didn't know to have what was the equivalent of a key to our house.

It didn't take long before everyone had the door code: his new girlfriend, his friends, his masseuse, the gardener. I

wouldn't be surprised if the mailman had it. Every time I tried to bring up the issue with him, I was met with defiance. The door code was the best thing that had ever happened to him. He literally thought getting into the house via code was magic.

A few months later, his girlfriend made plans to move in, so I made plans to move out. I was too tired and stressed to keep living there anyway, and it's not like I was leaving him all alone now. I know I said I would never move out because I needed to spend as much time as possible with my dad before he died, but he wanted *me* to die! Plus, his girlfriend had a cat, so I couldn't stay there with my own cat. My cat's going to die eventually too, so I should also be thinking about spending as much time as I can with her. My cat's life span and my dad's are pretty neck and neck at this point, so I guess that meant I love my cat more than my dad? Which is fine, because I know for a fact that if my cat could talk, she'd believe in alarm systems.

I told my mother I wanted to move out of my dad's house, and she was thrilled. She was eager for me to leave the nest, perhaps because she was jealous that I was more troubled about my dad's upcoming death than I was about hers. She just feels more immortal to me, which I was forced to explain to her after she admitted her feelings were hurt about my anxiety over my dad's death. Telling her she had superhero attributes wasn't enough, so I mentioned the undeniable fact that she's ten years my father's junior, but logic had no part in this conversation.

"I could drop dead out of nowhere! You don't know!" she yelled.

The moving-out project came at a good time; I was happy to have a bonding activity with her, in part to relieve some of my guilt. My mom and I excitedly started sifting through options together. I told her I pictured myself in an extremely safe apartment somewhere central, not too far east or west of LA. She then went on about how renting would be a waste of money, and the financially wise option would probably be to buy a small house as an investment. I wondered if I was hearing her right.

ME?! A *HOUSE?!* MY OWN HOUSE?! How could this be?! My mother is notorious among my friends and family for paying for scarcely anything of mine. She stopped paying for my eyebrow waxes when I was sixteen, saying waxes were a privilege, not a necessity, although she generously decided to offer one wax a year as a birthday present. My father spent the next seven years reluctantly paying for them. Maybe that's why I was more worried about his death — because if he died, I'd get a unibrow.

My mother regards my sister and me as kids or adults depending on what's convenient for her. It's always "Because I'm the adult and you're the kid!" until I need something and then it's "You're an adult! Figure it out!" I would never even have mentioned the word *house* to my mother for fear she would immediately start screaming about my sense of entitlement and how disgusting it was for me to even mention the

idea of her buying a twenty-four-year-old *kid* a home. I tried my best to hold in my utter surprise over her suggestion. If I seemed even slightly happy or shocked by the generosity of it, she would instantly take it back.

"I think buying a house would probably be the smart thing to do, yes," I said, teeth clenched.

After I found out one of my mother's trusted friends had recently bought her daughter an "appropriate" home because it was a good time to invest, it made slightly more sense. But I think, above all, my mother liked the idea of giving me such a large responsibility. Watching me contend with the challenges of having a house was right up her alley.

Mom! My house was flooded, and I don't have flood insurance!

Well, now you know what goes into owning a home. This is how many people become homeless, and now you'll know what that is like as well. You're an adult. This is life. I wish you the best of luck.

But those tribulations were still far down the line, and my excitement overrode them. My mom set me up with the same real estate agent who'd helped her friend's daughter and sent me on my way.

The real estate agent, Melinda, was a character straight out of a Pixar movie. There's no Pixar movie about a real estate agent, but if there were, she'd be the inspiration. Think a tall, lanky Edna Mode. She only wore striped shirts. Seriously. Every day, a different-colored stripe. The color of the stripes

always matched the rest of her outfit — her pants, her shoes, her bag, and her lipstick. She had a jet-black bob with straight bangs that landed right above her eyebrows. Her voice was crackly, and she spoke so slowly I could anticipate the ends of her sentences long before they were over. I couldn't help but finish all of them for her out loud; I hate wasting time.

We looked at houses for weeks; I was desperate to find the perfect one and would settle for nothing less. I was spending so much time with Melinda, it was as if I cared about *her* death. Eventually she got to know me so well that by the time we walked into the hillside Laurel Canyon abode, she knew it was the one before I said a word. We looked at each other with wide eyes, hers sparkling from the upcoming paycheck, mine with visions of me curled up on the couch with my cat in the heavenly cloud of a living room.

Everything about the house was original, with not a thing I'd want to change. It had all of the aspects I'd dreamed about and more: trees through every window, white brick, exposed wood, fireplaces, high ceilings, and soft light pouring into every room. And the best part of all? A high-tech security system.

To me, the house now represented the key to happiness, something I'd felt was unachievable as long as the future exists. I knew in this house I wouldn't be (as) afraid and that my depression couldn't thrive, as I'd be surrounded by things that were cozy and bright. The house would force me to be productive so maybe I could eventually feel like I deserved to live there. I'd have grown-up dinner parties with friends and

sleepovers with boys who would immediately want to date me because I'd have the most special little house they ever saw. The potential of the new-house version of me seemed limitless.

We left the house with pamphlets and plans and met up at the local coffee shop to go over them. Melinda and I ordered almond lattes, and she (slowly and cracklingly) told me about everything that goes into making an offer. I took it all in but impatiently rushed her along so I could tell my mother about the house and because I have the attention span of a goldfish.

I eagerly called her on the way back home from coffee and prefaced my proclamation with "You're not going to believe me, but I actually found the house of my dreams."

She said no. Sometime during the many weeks I spent looking, she decided it's absolutely insane to buy a twenty-four-year old a house. Who can blame her?

Although I did secretly agree, it was embarrassing to have gotten my hopes up. I couldn't let that part go, that she would have me go through the process of looking for a house for no reason. So once I visited her in the Vineyard, I tried to further understand why she did this. She admitted that in addition to coming to the conclusion that it was completely insane (again, who can blame her?), I was also not responsible enough to own a house.

I was mostly upset for all the hours I'd wasted with Melinda. My mom told me it was a good thing that I'd spent all that time with her, because I needed to learn what the market

was like and how the process worked for when I *would* be responsible enough to own a house.

"I DON'T NEED TO LEARN ABOUT THE MARKET! I'M NOT TRYING TO BE A REAL ESTATE AGENT! I spent all day, every day, with that woman for no reason!"

I didn't want to be on the Vineyard with my mom who thought I was an irresponsible child, so I planned to go back home. Oddly enough, a few days before my flight, my dad's house was flooded. And I mean absolutely everything was flooded.

Luckily, he had flood insurance, but it would take months to restore the house, so he'd have to move into a rental for the time being. Apparently, there was not enough room for me and my cat in the rental with him and his girlfriend, so I sucked up my pride and asked my mother nicely if I could stay in her house in LA until she returned from Martha's Vineyard in five months. I'd be able to have my own space and at least feel somewhat at home, I reasoned.

"Nope," she said abrasively.

"What do you mean, no? It's my home too."

She denied that and said her home was *not* also my home, it was hers, and I was much too irresponsible to stay there. So not only was I too irresponsible to own a house, I was now too irresponsible to even live at my own house. I thought it was a mother's job to make her children feel loved and welcome in their home, but my mother seemed to think she should do the opposite. Actually, she just did the opposite with me; as she proceeded to inform me, Romy was allowed to stay there

whenever she wanted, because she was much more respon-
sible.

At this point, you're probably thinking my mother must
have had proof of me acting nefariously. It's true that I've
done many things that people would consider thoughtless.
When I was a sophomore in high school I threw the senior
class's two-hundred-person after-prom at my house while my
parents were out of town; I lied twice as frequently as I told the
truth to my mother about where I was and what I was doing,
starting from when I was eight years old and was told I wasn't
allowed to watch *Miss Congeniality* at a friend's house and
did anyway; when I was sixteen, I toilet-papered this douche-
bag's house and he blackmailed me, threatening to show my
parents and the police the security tapes if I didn't get him a
thousand dollars by the end of the weekend, so, sure, I sold
some of my mother's belongings to get the money. But she
never found out about any of that, so I didn't really know what
her deal was. I should have been a perfect child in her eyes.
Nevertheless, the only evidence of irresponsibility my mother
needed not to allow me to stay in her house was "Because you
leave clothes all over your room, you borrow things without
asking and don't return them, and because you're a SLOB.
You're a TOTAL SLOB."

"Why does it matter if I leave clothes in my room? You
won't even be there to see it!"

"Because I worked hard for my house and I didn't do all of
that work for you to go live there and mess it up for no rent
or gratitude."

"If you were looking for rent, you should have gotten a roommate instead of having kids! It's my house too."

"You have a serious entitlement issue that you think everything I own is yours. Someday you're going to own things, and just because you own them doesn't mean your children can use them whenever they feel like it."

"Mom. I don't just feel like it — I have nowhere else to live! It really hurts my feelings." I felt like she was punishing me for something she knew I'd done in a past life but wouldn't tell me about.

"Well, that's your perspective." She *always* said this.

"No, it isn't my perspective, they're my feelings."

"Your feelings are *your* perspective. Take some personal responsibility. You are in charge of how you feel, how you respond, how you react."

"How do you live with yourself?!" I screamed, and then she gave me the middle finger.

"DID YOU JUST GIVE ME THE FINGER?!"

"NO! I DID NOT, CAZZIE."

"YOU CAN'T JUST SAY YOU DIDN'T IF YOU DID! I SAW IT!"

I went back to Los Angeles on terrible terms with my mother and planned to stay at a friend's house for a few weeks, while my cat stayed with my old roommate. I was suddenly a drifter with only enough belongings to fill a backpack: contacts, one pair of jeans, a hoodie, two pairs of mismatched socks, some clean underwear, a pair of sweatpants, and my one pair of leggings, which had a hole in the crotch. The

backpack contained all the stuff I owned because my house had flooded, and I tend to deprive myself of most things I don't *need*. Even if I do need it, I wait until the last possible second to get it. I don't buy tampons when I'm on my period; I collect them like it's a game of Pokémon, always asking the next person I'm meeting if they can bring one and grabbing five whenever I find them in a gym bathroom. If something is broken, I won't say anything about it or get it fixed until it becomes absolutely unmanageable. I went a year wearing my glasses with the left lens completely cracked. Once the light bulb in my room went out, and I lived in the dark for six months. Because I *could* live in the dark; I was surviving living in the dark. Meanwhile, one of my sister's cabinet knobs fell off and she had a maintenance person over the next day gluing it back on. A cabinet knob.

I got to my friend's house, and we sat on her couch, shared a joint, and caught up on everything that had happened over the summer. In the midst of me complaining about something, my friend jumped up and exclaimed, "Oh, shit, what's that stain on the couch? Is that chocolate?"

"I don't know."

"Do you have chocolate with you?" she asked.

"No, I don't have chocolate. Why would I have chocolate?"

She rushed to the kitchen to get sparkling water and a rag.

I put my hand in my pocket and when I pulled it back out, it was covered in melted chocolate from Hershey Kisses I had stashed there who knows when. And it suddenly occurred to me . . .

"Ohhhh. This is why my mom wouldn't let me stay at her house."

My parents finally agreed to help me rent an apartment because I had nowhere to live and couldn't keep causing mayhem in everyone else's home. I teamed up with Melinda once again to find one that would suffice. To my surprise, we quickly found an apartment and of course considering my karma, it happened to be in Melinda's building. It didn't have an alarm system, but it didn't need one; there was only one door with one lock, which is easily the greatest thing about living in an apartment. The difference that having only one door makes for my nighttime security ritual! And there was no way Link could escape here. I realized apartment living might lead me to be the least anxious version of myself I could ever be.

"See?" my mom said. "Aren't you happy you didn't get the house? Everything happens for a reason!"

"No. Please stop."

A few nights after I moved my backpack in, some of my friends came over to hang out and drink wine. I hadn't bought furniture yet, but I *had* bought wineglasses, because only one of those two things was a necessity. We put on music and *Cheers*'d to my future in this apartment, a future that wasn't as bright as the one in the house but brighter than the one where I could have woken up with a knife-wielding stranger breathing over me. It was also nice to be able to have a conver-

sation without shushing my friends every five seconds so my dad wouldn't wake up screaming.

After an hour so, someone knocked on the door. I slid over in my socks to answer it, assuming it was a neighbor welcoming me to the building.

I was right about the neighbor part, but judging from the look on her face, she was not welcoming me.

"Do you live here now?!" she said as soon as I opened the door.

She was old, roughly mid-eighties or an unhealthy seventy, with the haircut you accidentally give yourself as a child when you first discover scissors.

"Yes, I do! I'm Cazzie."

"Pat. Are you renting this apartment or did you buy it?" she asked in a severe tone that I hadn't heard since I was sent to the principal's office in seventh grade for illegally selling gum for a dollar a piece so I could buy myself a Sidekick.

"I don't see how that's important, but I'm renting it."

"I already called management to tell them about you. You are way too loud! We have rules here! You cannot play music past ten!" She said this like it was the twentieth time she had told me to keep it down rather than the first.

"I'm sorry, I just moved in. I didn't know the situation with the walls —"

"Well, *the situation with the walls* is that they're really thin!" she said mockingly.

I looked over at my friends, who were all huddled together

in the living room listening to the old woman berate me, likely thinking of all the fun times we would never have in this apartment.

"I'm sorry; we'll keep it down. I didn't know." I thought she had to be done.

"My husband is DYING. So it would be great if you could be quiet!"

"Okay. I'm so sorry."

"And we can hear your heels stomping around every night, so maybe you can wear sneakers!"

"I don't own a pair of heels, so that's impossible, but even if I did, I think that would be an inappropriate request."

She turned and left, leaving me in the wake of her bad mood. If she weren't so rude, I would have felt terrible about her husband dying, but she was a bitch so I felt only a normal level of bad.

"I guess we have to be quiet," I said to my friends.

"We weren't even being loud," one of them said.

I shrugged because that made less noise than speaking.

Pat and her dying husband quickly destroyed my dreams of free will and happiness. Every time I put a plate down on the counter, I'd do it delicately so as not to disturb them. I watched movies with no more than a level-twelve volume and never once put on music again. I even took my sneakers off as soon as I walked in. Pat, of course, would never know any of this. All she'd ever see me as was the loud spoiled brat who'd moved into her apartment building. It's not like the building was even all that quiet — you'd hear sirens at least once

a day from ambulances that would come to the front of the building to transport residents. It turned out that most of the residents were around Pat's age, and I was essentially living in a retirement home. Almost everyone had a walker or a wheelchair. There were nurses entering and exiting left and right. I quickly realized that instead of the apartment allowing me to envision my best self, it was forcing me to envision my oldest, nearest-to-death self. All the time.

I remained terrified of Pat for months. I'd sprint to the elevator anytime I left my apartment, then press the button repeatedly for it to come faster out of fear she'd leave at the same time and we'd be stuck awkwardly riding the elevator together. But while the circumstances weren't ideal (Melinda, Pat, the elderly, and the ambulances), it was worth it for the calm I felt when I closed my eyes at night. For the first time in my life, I was able to fall asleep without being scared.

When the holidays came around, I decided I should probably get Pat a gift as a (very) late apology. We had yet to run into each other since our standoff, and I figured a gesture could clear the air for the inevitable day we'd exit our apartments at the same time. When I'd moved in, two people had sent me an orchid, which felt like something a respectable adult would give. I bought a white one in a gray ceramic pot, wrote a note to go along with it, and left it for her in the lobby.

Later that night I had three friends over. I was so paranoid we would wake up Pat and her dying husband I ended up having to reluctantly shush them a few times, telling them apologetically, *I know, this is so annoying, and it's weird be-*

cause I live in my own apartment, but my neighbor hates me, so if we could just shhh . . .

Regardless of my whispering rule, they ended up staying until two in the morning. I was relieved when they finally decided to go and made sure to continue shushing them through the hallway and until the elevator doors shut.

The next morning, I went to get coffee for myself and my doorman Julio. When I came back, Julio told me he had given the orchid to Pat and said it was very nice of me to have gotten it for her so quickly.

Quickly?

"Oh, I thought you knew . . . Pat's husband died last night."

I gasped.

"She called me last night to complain about the noise coming from your apartment . . . I went up to check if you were being as loud as she said, but I didn't hear anything, so I didn't knock, and I came back downstairs."

"Oh my God."

Pat and her husband's last shared moment together was talking about how loud I was. Pat called downstairs to complain about me during her husband's final hours. I was probably the last thing he heard before he died. They were saying goodbye to each other forever over my friends' laughter. And to top it all off, she had just received my orchid with a note that said, *Pat! Happy holidays to you and your husband. Hope I've been keeping it down. :) Cazzie.*

My recently developed ability to perform the magic trick of

falling asleep in the apartment was gone. For weeks, I was up all night, frantic Pat's husband was justifiably haunting me. I decided I had to move out. There was no other choice. If I was going to be haunted by anyone, it would be by my dad and his door code.

Erase Me

Her failures are likely to induce stress and feelings of inadequacy and she is likely to incorporate blame rather than being able to appraise her circumstances and the demands they make realistically.

— *Excerpt from neuropsychological evaluation of*
 Cazzie David, 2007

EVERY CHRISTMAS, MY FAMILY spends the morning together. It always goes the same way. We gather at nine thirty in our pajamas after fighting the night before over how early I have to wake up. I'm always tired. My sister is always mad at me for being tired and not showing enough Christmas spirit when greeting her. We always have toasted sesame bagels with lox. My dad always goes on a rant about how pathetic it is that we're Jews celebrating Christmas: "I can't believe there is a tree. How do you all not feel stupid sitting around this stupid tree?!" And without fail, my mom always gives me and my sister a terrible present.

Before you slam the book shut for how insufferable of a complaint that is, I'm telling you my mother does this on purpose. Any gift is, of course, a privilege. I'm just unsure as to why she does this. Does she get pleasure out of seeing our disappointed faces? Does she think there's some justice to giving two Jewish American LA private school stereotypes ChapStick on Christmas? I confronted her with this absurdity only once, during the Christmas of 2014. My sister and I ripped open our gift, naively expecting something better than a pair of socks or whatever new hair ties supposedly damage your hair less. But, alas, we each got an extra-large bag of pistachios. I was certain that this *had* to be a joke. It's not even like pistachios were my favorite nut. For the first time, I didn't feel like I had to thank her through gritted teeth. Instead, I burst out laughing and said something along the lines of "Very funny! You've outdone yourself!"

As you can imagine, this was poorly received. A fight ensued about how ungrateful I am and how there were millions of kids who would be thrilled to receive a bag of pistachios on Christmas morning. Which left me feeling like shit because that's probably true.

The Christmas of 2017, my mother was more excited than usual to hand out the gifts she had gotten us. My sister opened hers first while I took my time, anticipating the usual bar of soap or all-natural deodorant stick that doesn't work at all. Everyone insists they've found the one natural deodorant that works, but none of them do. *You just smell like palo santo body odor and I smell like rosewater seagrass body odor.*

Suddenly, my sister gasped. "Oh my God!"

"What?" I said.

I ripped the recycled brown wrapping paper off the gift, a particular thrill because it was the first time in history my mom hadn't yelled at me for not carefully unwrapping the paper to use again.

Inside were two booklets on South Africa.

"We are going. On an African safari. In May," my mom said.

My sister screamed again, the kind of scream that's reserved exclusively for the girl in the movie when she finds out she's not actually the orphan child of two chimney sweepers but the princess of Monaco and Stanley Tucci is about to give her a makeover. It may not surprise you to learn that I've never screamed out of joy, only the regular reasons people scream.

She ran up to my mother and tackled her with a hug as I sat there staring at the photo of a roaring lion on the pamphlet.

My mom had gotten us an incredible present. Anyone in the world would be overjoyed. Even all of the millions of ungrateful shitbags who wouldn't have appreciated pistachios would have loved it. Everyone in the world but me, apparently.

Let me explain. I'm what any person who has been on a trip with me, but mostly my mother, describes as "a bad traveler." For I possess the two qualities that make it impossible to take pleasure in it: laziness and neuroticism. I hate jet lag; I'm scared of leaving my house; I hate being on planes; I'm scared of getting sick; I'm scared of food. If I could, I would

stay in one place for the rest of my life. I know that's really pathetic but I just don't feel the need to see the world to be a more well-rounded person; I feel like my insecurities have done enough rounding for me. All I truly care about is my health, and shooting through the sky in an enclosed metal tube filled with one hundred strangers breathing directly into my mouth can be hard on the body and mind. Did I mention I'm a germaphobe?

"So we're going to . . . South Africa," I clarified.

"I know you're a bad traveler, but this trip is required and *life-changing*. These animals are going to be extinct in fifty years. We have to go see them and experience them before they die and are gone for eternity."

Another well-intentioned sentiment with an underlying apocalyptic twist.

I let out a monotone "Wow" to show her that I was grateful, but my anxiety was already kicking into overdrive. How long was the flight? How many days would I be stuck with my family? Did I have to get shots? Were the shots bad for you? Did I have to take malaria pills? Did malaria pills have side effects? Will I shit my pants?

My mother had predicted my nerves and was prepared for my questions. You don't *have* to take malaria pills, she told me, but it was recommended, and, yes, they did often have side effects, usually stomach problems. Stomach problems or malaria was a hard choice to make, especially since I was too afraid to look up what malaria involved.

"Why don't we all just look up pictures of South Africa on

our phones together instead?" I suggested. They laughed. But I was serious. "There's an African wildlife photography book in the living room! I'll just go get that and we can have an experience safely in our home."

"This is going to be the best trip of your life!" my mom enthused.

I longed for the Christmases of nuts and organic tampons. In fact, I was in such denial about the reality of the trip that when my friends asked me what I got for Christmas, I told them trail mix. I remained hopeful that something would arise in the next four months that would stop the trip. Anything could technically happen. I could die. Someone else could die. You never know — better to be positive about it.

When April came around, and it didn't seem like anyone was going to die, I did what I had to do — tried desperately to sabotage the trip.

I programmed South Africa news alerts on my phone so I could immediately know if something happened that could be of use. I was elated when a notification popped up about a severe drought. I'm sorry, elated is not right. It's truly so awful. But also how perfect? I couldn't believe my luck to have something of this magnitude to use to my advantage. There was no way our trip could still happen. I texted the article to my mother: *South Africa is in a drought! There's no water!*

I got a text back that said *Hmm*. She ended up doing some research and decided it was fine because they were apparently set to run out of water in July, not May.

Comforting.

But won't we feel bad using any of their water? I don't want to take any of their water . . . it's wrong, I texted.

I'll talk to some people about it.

A few hours later, it was another *No worries.* Apparently, our presence would not affect the drought, my mother said, even though she was the one who'd told me "Every drop counts!" since I was old enough to turn on the sink myself.

When it became clear that no divine intervention was going to show up for me, I had no choice but to start mentally preparing. I asked for more details and found out we were flying to Holland first, which made me more anxious because it meant the trip was even longer than I'd thought.

"What's in Holland? Why do we have to go to Holland?"

"We're stopping to split up the trip, and we're going to go see the Anne Frank House."

It was too much. An entire second trip? To experience history? "Mom, don't get mad, but I *really* don't want to see the Anne Frank House. It's way too sad for me."

"Cazzie! It was sad for *her!* She had to hide in an attic for two years! Be grateful. Do you know how hard it is to get tickets to the Anne Frank House? They're coveted! We had to apply months in advance."

Admittedly, that was pretty surprising. Not to diminish what would be a transformative and meaningful experience, I just didn't know that trying to get into the Anne Frank House was like trying to get tickets for the Beyoncé Hollywood Bowl concert.

I resigned myself to my fate. It was no use fighting this; we

were going. When my mom handed me a pair of khaki safari pants that I wouldn't have been caught dead in, I decided to say an early goodbye to life as I knew it. I was fully ready to be killed in a plane crash, to be eaten by lions, or to die of sadness at the Anne Frank House.

Before we headed to South Africa, my entire family and I would go to DC for Romy's college graduation. I'd packed two weeks early so I could brainwash myself into loving traveling by looking the suitcases straight in the eye whenever I was in my room and telling myself, *You love this! You love packing a bag and going off to see the world!*

There was one other thing I would do that week before my trip, which was initiate a break with my boyfriend at the time — an exceptionally hard task when it makes you sick to your stomach to think about hurting someone, let alone someone you love, let alone someone who is codependent.

He had been all I'd known for two and a half years. The first time we met, it was immediate grotesque middle school crush infatuation. And that feeling never subsided. People hated being around us because — and I know, ew, I'm sorry — it was like we were the only two people in the room, never letting go of the other's hand no matter where we were or what we were doing, sharing conversations that must've seemed alien to those who weren't us. We were like kindred spirits, always laughing and making fun of everything, and when we weren't, there was still something weirdly romantic about us

moping around together wearing matching black hoodies in ninety-degree weather in our own cloud of pot smoke.

Everything about our relationship felt special and in turn made me feel special. I tried to make him feel the way I did but I wasn't as good at it as he was, which shortly became a problem that never went away. Still, I felt so lucky to be in a relationship where, for the first time, I had no fear at all that the person I was with didn't want me as much as I wanted him. And despite feeling genuine love for him, more than I'd ever felt before, he had a hard time believing me, getting it in his head that I didn't do the things one who really loved him would be doing. Being loving or nurturing didn't cut it. It was easy for me to empathize with; I had seen myself in him.

Long after it had become untenable I contemplated ending it, but there would never be a good time. I couldn't do it if it seemed like one of his emotional blackouts was coming on, because the results would be unpredictable and potentially dangerous. Previously, self-harm and suicide threats had come about from trivial circumstances, incidents that would go from 0 to 100, which were so momentarily urgent, like the last minute of an escape room before the time goes off, except I'm the only one in the room and all the clues are tricks. Once he was back in a good headspace, I wouldn't be able to bring myself to do it either; I was too mentally exhausted to do anything besides emotionally recover from the chaos of the week before. I'd go through that time in a state of cognitive dissonance, attempting to return to a consistent view of myself and

of him. When a few days had passed and normalcy returned, I would no longer want to call it off. It'd feel so good for my environment to be calm that I didn't want to do anything that would disrupt it again. Plus everything would be great; we were as close as two people could possibly be, and I loved and missed that person so much, so why ruin the time I'd get to spend with him?

I ended up pulling the trigger on the conversation after four consecutive days of being kept up in circles on the phone until three in the morning for whatever new reason I was causing him unhappiness. If I weren't so worn out, I wouldn't have gone through with it. But my sanity and health were the only two things I cared about besides him, and they had both been deteriorating for some time. So my conscience screamed at me, *DO IT, CAZZIE! FUCKING DO IT NOW, I SWEAR TO GOD!* until I did.

I was afraid of all the possible scenarios that might happen and knew that I would always feel responsible for his safety whether we were together or apart. But in that moment, I preferred to be scared than to spend yet another day on the receiving end of a diatribe as to why I had failed him. Something that didn't start occurring until we were five months into dating, but once it did, continued every few weeks thereafter, lasting for hours or days no matter what I did to try to resolve the issue. It didn't matter how logically or lovingly I approached the situation or how many times I apologized for something that at first I knew was ridiculous but by the end no longer felt so sure of. It took me a while to realize it wasn't

my fault. But it wasn't his fault either. After figuring out what was wrong, he did his best to get help and I learned everything on the diagnosis I could. You cannot believe what a hell this disorder is to live with, and I have endless sympathy for the people who have to spend their lives struggling with it as well as for their loved ones. It was extremely painful to admit that I was no longer strong enough to stay.

But I was also not strong enough to stay away. It seems I am also codependent. Only a few days into our break, I called him to get back together. I regretted doing it and missed him like a drug. Deep down, I knew I was never going to stick with it; whenever I was upset, he was the only one who could make me feel better, even when he was the reason behind it. He was my person, and I was always going to be there for him; I just couldn't take it anymore and thought it'd be the only way I could make it stop, at least until I could clear my head.

I was crying and ready to express my remorse before he even picked up the phone. But it was too late. He told me he was now the happiest he had ever been, and he wanted to continue our time apart. This 180 wasn't what I'd expected, but it wasn't unfamiliar. I said okay and that I loved him, tears streaming down my face, and he hung up quickly. I thought he must be punishing me for wanting to end it, and I knew it wasn't actually him on the phone but the other him, and I prayed it would switch over again soon. Two days later, I received a text from him officially breaking up with me. The flippancy of the message might have been what fucked me up the most. It sounded like it was meant to end things with

a person he'd been dating for a couple of weeks. There was so little thought put into it, I could tell he'd composed it while walking down a flight of stairs. I even knew which stairs he had written it on.

The next day I was still crying as I boarded the flight to DC for my sister's graduation. I felt like it was all my fault for ending it in the first place, and I'd been stupid for not thinking that permanence might be one outcome. After I settled into my seat, I scrolled through Twitter and saw that my ex of one day had a new girlfriend. I think I probably left my human body. My dad held me as I shook uncontrollably in his arms for the entire flight. I was paralyzed with fear. This wasn't in the realm of possibility of things I thought he would ever do to me. He was fiercely loyal, never so much as looking at another girl or doing anything that would cause even a speck of doubt or jealousy in my mind. From the moment we met, he did everything he could to make me feel like I was the only girl who had ever existed or would ever exist for him. I believed him because in addition to being exceedingly loyal, he was the most honest person I had ever known. Not because all the things he said ended up being true, but because you could tell he deeply felt them, at least in that moment.

When we landed in DC, I opened Instagram as fast as I could, shaking so much the phone almost fell out of my hands. The first thing I saw was a picture he'd uploaded of himself with his hand covering his face to show off his new finger tattoos. My name, which had been written in cursive across his ring finger, was now covered over with black ink.

Another tattoo he had of my favorite emoji (yes, I know how fucking absurd that sounds) was now replaced with a matching tattoo he got with her of what I guess was her favorite emoji. And that is the exact moment when all emojis were ruined forever and I began living in a *Black Mirror* episode.

The only other detail I could pick up from the photo was that someone else's hair tie was around his wrist. He used to always take my hair ties off my arm and put them on so he could "wear a piece of" me. I felt like I was being terrorized. Did he want me to take note of the hair tie? Or was he just repeating everything I'd thought had made our relationship special with someone else *one day later?* Then I noticed that all of his friends started following her at the same time, friends I thought I'd become close with over the last few years. Was this a calculated effort? Was he asking them to do this to hurt me? Why would he want to hurt me so badly? Did it have nothing to do with me at all? Why were none of them standing up for me? Was it all to punish me for wanting to take a break? How could he stop caring about me in a day? Were they following her because *she was actually his girlfriend now?!* How can you even get into a new relationship in a day? The haste hurt like an amputation.

Even though I had supposedly escaped my emotional prison, I didn't feel like I had. Instead, I felt like I'd been transferred to a new prison, a much worse prison, an almost pitch-black room lit only by footage of them meeting and immediately falling in love accompanied by audio of her baby voice whispering sweet nothings in his ear dubbed over his

past declarations of love and trust to me. It was a place where he could still control all of my emotions, but now from afar. He could now finally be happy because he had transferred his mindset that always told him *No one cares about you* over to me, even though he always had someone right in front of his face who did, and I was the only one with someone right in front of my face who didn't.

I guess that's why the end of my relationship still blind-sided me, regardless of the fact that it was technically my doing. It was just unbearable to sit with the feeling and humiliation of being so discarded. There's a particular impossibility to processing the shift of being the most important person in someone's life to being absolutely nothing to them in a matter of a single day. It can be quite the mind-fuck. Especially when that person made you feel like he couldn't live without you, and if you had known that he could have, you might not have spent every day enduring his abandonment fears only to be publicly abandoned yourself on a larger scale than you could have ever imagined.

I knew that what I saw on that single visit to Instagram would be just the tip of the iceberg and that it was going to get much worse, fast. At a minimum, I wouldn't be able to go on my phone again for a very long time. If I saw any of this play out in real time, I would die trying to understand the rationale. I deleted all of the news and social media apps on my phone and texted all of my best friends *Heeelpp meeee* because I was too profoundly shaken up to think of anything else to say. I was terrified of everything that was happening,

everything that was going to happen, and everything that had already happened. Obviously there are far greater afflictions in the world than breakups, but they really can make you feel like you might die.

I spent the next day and a half in a fetal position in the empty bathtub of our hotel room in DC, smoking all my weed pens that were supposed to be saved for out-of-the-country nausea emergencies. My dad came and checked on me every hour or so.

"How're you doin', sweetie?" I think he was hoping that at one point I'd respond, *You know what, I'm actually fine now! I don't care anymore.* To which he'd say, *Thatta girl!*

But I couldn't formulate any response beyond trying to catch my breath from crying so hard.

I cried into my hands throughout Romy's graduation ceremony, too ashamed to see anything other than the darkness of the cave my palms created for me. I was poked to look up and watch her take her diploma, as I did, my dad's girlfriend peeled a crunchy old contact off my tear-soaked glasses frame. If I weren't so distressed, I would have laughed.

Romy had made plans with her friends months before to celebrate their graduation later that night with all their siblings. She relayed that it was *imperative* I attend the festivities despite what was happening and what I looked like. How embarrassing would it be if she was the only one whose sister didn't show up? I tried telling her that it wouldn't be as embarrassing as her sister showing up like *this*, but she didn't care.

"You're so selfish! I never ask anything of you! You've ru-

ined my entire graduation weekend and made it all about you!" She stormed out of the hotel. This time, she wasn't being dramatic; I definitely *was* ruining her graduation weekend.

As you might have picked up, I'm pretty easily guilted. So I splashed some water on my face (it was the most "getting ready" I could bear) and let my dad and his girlfriend walk me to Romy's apartment. They brought me right to her door, since no one had the heart to leave me alone for even a second. I walked like I was an ninety-year-old woman, like every step was a struggle and standing up straight was impossible for my body.

"Betrayal is worse than death," I kept repeating as we walked over.

"Life is a long, rough slog. Even if you have means!" my dad said. "Think about how many people have to live without means."

Perspective wasn't really working for me this early on. It almost made me feel worse that I could be this lucky and still feel this intense level of anguish.

My dad sadly patted the top of my head as Romy opened the door.

Inside, a bunch of twenty-one-year-olds stood around with red Solo cups. The girls were all wearing the same sexy, tight black tops, while the guys wore colored collared shirts, their faces flushed from beer. I wore my sweatshirt that had old and new mascara stains on both sleeves from me wiping my eyes on it the last few days. A classic look.

Romy introduced me to all of her friends, and the next thing I knew I was sobbing to three of them in the bathroom as if I'd known them forever. They should have been celebrating the end of the best years of their lives, but that's what happens when you force a broken girl out. The new graduates alternated between classic don't-feel-bad comments like "OMG, they're so dumb!" and their own breakup horror stories that all started with "My high-school boyfriend . . ." or "When I was abroad, my boyfriend . . ." But mine was too isolating for anyone to be able to understand. I know, I know there is no hierarchy of breakup suffering. But my boyfriend that I spent every last drop of energy I had on, had a new girlfriend after one day — who also happened to be a hugely inescapable public person. *So you were saying, your boyfriend drunkenly made out with a girl once in Barcelona?*

When my sister and her friends announced they were ready to head to a club, I tried to beg off and go back to the hotel, but three of her friends had just done lines of cocaine and started doing that thing that all people who've just done coke do where they make it seem like tonight is going to be the greatest night of your life. They insisted I stay out with them and because I didn't have the bandwidth to agree or disagree, I followed along, holding on to whoever was closest to me regardless of whether I knew them or not. The physical contact helped remind me I still existed despite how valueless I felt.

After about four minutes at the club, a song of hers started playing and I ran out hyperventilating and caught a cab.

On the way back to the hotel, my manager texted me to remind me not to say anything to anyone about what was happening or it could end up on the internet.

Just curious, would you say that crying in a bathroom to twelve sorority girls was not advisable?

I wondered how this story would end. I imagined for me it would be lying in a hospital bed in the middle of South Africa after having a heart attack, and for him, it would be his best, most fun scenario, which was already his reality.

The next day my mom sent a text to all of my friends telling them not to tell me anything that was going on with my ex. She sent this right after another breakdown I had when one of them updated me on the latest actions from the world's greatest love story. Cue the loop: *Why would he do this? He knew I would see, so was it to hurt me? If it's not to hurt me then how could he not care what this would do to me? Is he actually not thinking about me at all?* I'd planned on not following another male human on Instagram for at least six months if we broke up so as not to trigger any anxiety or pain. I wondered what he would do if I had done anything like this to him. But only for a second, because I knew.

"Cazzie, we cannot analyze sick behavior," my mother said as I sobbed into her lap, again.

I analyzed it anyway. Every second. Until I began to think that maybe it wasn't the behavior that needed to be analyzed. Maybe it was as simple as me being useless.

The next morning, my family was gathering for brunch at the hotel we were staying at in Georgetown, although I didn't

feel like I was actually anywhere on this planet at that moment. I had been up the entire night making myself sick with intricate thoughts and visuals of them, the idealization of her, and the devaluation of me. I was still up ruminating when the royal wedding started at five a.m. I remember thinking that Meghan Markle looked so beautiful. I watched it in its entirety, which under normal circumstances I could have never done because, wow, was it boring.

I was glad I hadn't slept that night; it was the only way to avoid the pain of waking up and having all the information come at me like a speeding train. NONE OF IT WAS REAL, YOU MEAN ABSOLUTELY NOTHING TO HIM, and NOW HE'S IN REAL LOVE dropped into my head like bombs. The three previous mornings I had woken up screaming in agony. My dad and his girlfriend literally had to pull me out of bed by my arms to stop it.

"I can't! I can't! I can't! I can't do it."

"CAZZIE, COME ON! YOUR ANCESTORS SUR-VIVED THE HOLOCAUST!"

Staying up all night made me feel like I was making progress in comprehending what was happening. A part of me felt like I had to use all twenty-four hours of the day for my brain to try and catch up, they were moving so fast. Even though the reality was I had just stayed up all night.

I splashed my face with water because that was still the only hygiene I could muster and met my family downstairs. I knew my demeanor would make everyone miserable, but there was no scenario where I could fake it.

"You look good, Caz. Natural. Like Meghan Markle," my mom said when I arrived downstairs.

I looked up at her with a naive expression that implied *Really? I do?*

I didn't, and I think after she said it, she realized I didn't too, judging from her expression.

After brunch, we all flew to Martha's Vineyard, where we'd stay for a week before heading off to South Africa. There, I was expected by my mother to rehabilitate myself in order to be a "person people would want to be around on this trip." I don't think my mother considered me a person people would want to be around even before this happened, so I think she must have meant a person who could get out of bed and maybe have a conversation, a person who remembered she should drink water and then, once she remembered, actually went and did it.

Generally speaking, I tend to move through life with little observation about how things look and feel. My surroundings have never really mattered. I'm too busy obsessing to notice a large oak tree through the window or the color of the wallpaper. Yet, in Martha's Vineyard, the colors and details are too strong and beautiful to overlook. All you see is green and leaves, and everything you eat is green and leaves, which can confuse you momentarily, like, *Am I a leaf living in a leaf?* The sun shines pink and orange. Little red and yellow birds hop around looking for seeds, and baby bunnies run across the road. The air smells fresh and clean, but not in a tailored "newly cut grass" way. Here it smells good because the grass

is left to grow. It's the most serene place, where some of the best times of my life have been spent. But now everywhere I looked felt like a twisted contradiction, like I was tainting this beautiful place with darkness just by being there.

Being super-hurt is a lot like being on Xanax. When you take Xanax, you care infinitely less about the things you normally care about, like falling asleep without washing your face or putting your retainer in. Same thing when you're hurt. You do things you would never do if you were feeling okay. For instance, drinking the remains of a water bottle you found at the bottom of your bag from the hotel a few days ago or touching your hair with your hands that you haven't washed since petting a dusty horse. Or what I was doing when I first thought of the similarities between being hurt and taking Xanax, which was lying on my back in the woods. In ordinary circumstances, I wouldn't even enter the woods. But in that moment, I didn't care that it would get dark and I could get lost, or that ticks were crawling up the sweatpants I'd been wearing for the past four days. I no longer cared about my health or preventing sickness and death. Everything I'd once cared about, I didn't anymore, the most ironic being that I no longer cared that I was traveling with my family to another continent. In fact, it was maybe the only place in the world I could bear being.

The best way I can describe myself during this time is that I was back to how my four-year-old self acted post-choking: so frightened and helpless, I'd have to be told by my mother to eat another bite of dinner.

"One more bite, Caz."

"How could he do this to me? He was my best friend. What did I do? How is this happening? Am I going to be okay?"

"Yes, Cazzie. Have a sip of water."

After dinner, I laid on the couch with my head on my mom's lap as she read me whatever book was in arm's reach. My mother and I didn't have much physical contact when I was growing up (although she would argue until her dying breath that this isn't true); my psychotherapist said there were early attachment issues and I was a rebellious teen far before and past my teenage years. However, there were few moments that week that weren't spent with my entire body weight draped around her shoulders.

About five pages in, I realized how pathetic it was that my mother was reading a book aloud to me, and it brought on a new spiral. Anytime I did anything to try to feel better, it somehow made me feel worse, because I'd be reminded of what I was doing at that moment versus what they were doing. Like, I was crying reading *The Five Things We Cannot Change: And the Happiness We Find by Embracing Them* and clutching a healing crystal my friend gave me while they were running around saying things like "the happiest [they've] ever been," "the most in love [they've] ever been," "luckiest ever," "hottest girl in the world," "dreamt you," "ten inches," "come to bed," "I have everything I have ever wanted," "ever been," "in the world," "the most," "ever," "ever," "ever," "ever."

"Imagine how Jennifer Aniston felt!" my friends would say. But at least Jennifer Aniston got to be . . . you know . . .

Jennifer fucking Aniston. And Brad and Angie weren't commenting on each other's Instagrams saying they were the loves of each other's lives after a week. They weren't defending their own actions by throwing their former partners under the bus or spreading gratuitous PDA all over the internet. Maybe if I had behaved like that he would have believed I loved him. If I got a tattoo he would have believed me. If I was famous and shouted my love from the rooftops he could have believed me.

I had no choice but to come to terms with the fact that they were now in a relationship. Even though it wasn't a regular relationship or even a regular celebrity relationship. It was abnormally unavoidable; everywhere and obsessed over by everyone. Even people's out-of-touch parents knew about it. The two of them offered their relationship to the media eagerly and with pleasure, like a suicidal brunette walking into Ted Bundy's apartment. Okay, like *me* walking into Ted Bundy's apartment.

My anxiety physically caused me a lot of pain. All of my insides were in a knot. My chest was in a knot, my stomach was in a knot, my legs were knots, my throat. I masochistically decided to check my Instagram notifications through Safari just to, you know, tighten all those knots even more. It seemed her fans had found me and they really wanted to make sure I knew I was inferior to her in every way, which is absurd because, like, how stupid do you have to be to think I would not be aware of that at this moment in time? *No wonder he left u. Wow, biggest upgrade of the century! ur Walmart she's chanel!!*

u look like an orphan. I had been searching my entire life for what I looked like and they'd found it for me. Of course! I looked exactly like an orphan! More now than ever before because you could see the abandonment in my eyes.

The comparisons wouldn't get out of my head. I know you're not supposed to compare yourself to other women, blah-blah-blah, but how the fuck could I not when other people were?

"Everyone thinks it's the biggest upgrade ever," I lamented to my friend on the phone, hoping she would say literally anything that could dispel my belief that I was the ugliest girl in the world.

"Not necessarily — you're just so different . . . you're real!"

"*Real* means being attainable and normal. You can't trick me into thinking being real is a compliment; it's being flawed."

"No, it's like, who would you rather be with, this normal girl or this video-game character?"

"The hot video-game character."

"She's, like, Instagram-hot! You're, like, Renaissance painting–pretty. Wouldn't you rather be that?"

"No, of course not. I'd obviously rather be Instagram hot! It's 2018!"

"She's like, a fucking little bunny."

"Bunnies are hot. Bunny ears are literally shaped like two vaginas."

Determined to overcome the emotional hurdle, I created some of my own healing techniques:

I tried to train myself to stop caring every time I entered my

computer password. I had changed it from my nickname for him to IFUCKINGHATEYOU, which felt like it could have some sort of psychological impact.

I tried to meditate to get the songs out of my head. Music has always been like caffeine for me; if I have it too late I won't be able to sleep. I literally cannot listen to a song past five p.m. without it getting stuck in my head until four in the morning. But I didn't need to hear music to be tormented by it now. I cannot adequately put into words the type of aggravation that occurs after eight days in a row of waking up with one of her songs about being really good at sex stuck in your head. It felt like an authentic form of torture meant to personally make me go insane forever.

I tried to watch relatable breakup movies but they were not even kind of relatable. So I moved onto divorce movies. Breakups were easy; this situation was way more on the level of a messy divorce. And divorcées are chic! Chic people would get me through this.

I tried to read to pass the time too. But it's hard to concentrate when every five minutes you remember who you are and what your life is. It got to the point where I needed to escape language altogether, so I downloaded Duolingo to learn Spanish. *Todo yo tengo en mi vida son libros y español.*

I didn't know it was possible to have so many different thoughts about one thing. I felt like I was morphing into a database consisting only of theories and judgments about two people. I started to keep a diary, because I'm a sad walking cliché. I was desperate to get rid of at least some of what was

in my head to make room for the new confused notions that were coming in by the second.

> Dear Diary,
> Another day being me.
> Must be nice. To be anyone in the world but me.

I logged my daily emotional progress, as I was unable to participate in other activities.

May 24 — Martha's Vineyard

I haven't changed my tampon since whatever time I woke up and it's now 2:56 p.m. JUST CHANGE YOUR TAMPON, CAZZIE! It's the least you can do for yourself. Wow, that's the nicest thing that has been said to you by you in a week.

As a reward for thinking a sweet thought, I changed it. I never thought I could feel productive or even proud of myself for just managing my blood.

May 25 — Martha's Vineyard

I felt okay for the first time in two weeks. It was for exactly three minutes at four p.m.

I looked through photos of me from when I was a kid. *You had no idea this was going to happen to you*, I thought,

looking at my nine-year-old self as if I had died in a tragic fire. Then I hit myself in the face for being so dramatic. But I couldn't look at the photos without a little self-pity, even though my dad said self-pity is the most disgusting quality one can possess. It was just weird to see photos of such a normal kid from such a "normal family" knowing one day all she'd be was collateral damage to a spectacle.

May 26 — Martha's Vineyard

My mom made me meet with a therapist because she wanted me to acquire some coping skills before we left for the trip. I arrived red and sobbing, which has become my permanent aesthetic. I can say with absolute certainty that there are few things more uncomfortable than meeting a new therapist and starting your first session off crying before it starts. In any case, I introduced myself and told her the story from the beginning. She had, of course, read about it on the internet.

"And that's what happened," I said.

Her expression was almost as shell-shocked as mine. "I am so sorry," she said gravely. "He is *such* a dick."

I let out a pathetic "Ha."

"I don't know what to say. Honestly, I think time is literally the only thing that can help this. That, and trying to let it go."

That, and trying to let it go?!?!?!

LET IT GOOO, LMAOOOO!!

It was my last session.

May 27 — Martha's Vineyard

My stepfather, Bart, loaded all of the matching army-green duffel bags that the safari program had sent us into the car. I was embarrassed that we all had the same suitcases; it made me feel like we were a freaky traveling circus.

Bart's fifteen-year-old daughter, Bella, was also joining us. She had moved in with us when she was eight and can only be described as the Cinderella to my Drizella and Romy's Anastasia. Not because we were mean to her but because she was new and blond, and we were Ashkenazi Jews who fought about things that didn't matter in front of her.

My mom and sister were all buckled in and ready to go as I stood fifteen feet away with my laptop strapped around my chest, looking up at the sky.

"Cazzie, let's go!" my mother shouted.

"Hold on! I'm taking in my last moment without you people!" I took a deep breath and got in the car. "Well, we're all here and we're going to Africa, I guess," I said as we drove down the dirt road.

They were quiet.

"Imagine if we don't even make it to Africa, and this story ends in a plane crash on the way to Africa."

"STOP IT, CAZZIE!" my sister shrieked. "It's not okay. I'm really superstitious!"

"Romy, people say stupid things all the time," my mom said. I was surprised. We weren't even in Amsterdam yet and she was already a chiller version of her former self.

When we got to the airport, my mom handed me another self-help book called *How to Be Happy and Live in the World*.

"Mom, please stop handing me self-help books in public."

I was worried someone would see the happiness book coming out of my bag. Or that someone would notice my untamed leg hair peeking out from my sweatpants and tweet: *Just saw ——'s ex at the airport and, yep, she hasn't shaved her legs since the breakup.* Thankfully, I was invisible.

May 28 — Amsterdam

We arrived at the hotel around nine in the morning Amsterdam time, showered, and reconvened downstairs for breakfast. I drank one of the best lattes I'd ever had — joy is found in the little things — and amused myself by reminding everyone what time it actually was for us.

"Isn't it weird that we're having breakfast at two in the morning?"

"CAZZIE, STOP!" It was apparently a family rule to never think about what time it was back home; we had to immediately be in the new time zone or else time itself would cease to exist or something.

After breakfast, my mother had arranged for us to walk the city with a tour guide, because things weren't bad enough for me. Every time she decides to use a tour guide, she regrets it. It's like she forgets the part about being stuck with a peculiar stranger for hours on end. Obviously, I find walking around

with a guide humiliating, and this one was even more so because his shirt had huge block letters that said AMSTERDAM TOURS across it. His name was Philip and he looked like if Paddington Bear were an old Dutch man. He wore a khaki bucket hat with the string pulled so far up to his chin, his neck fat spilled over on both sides. We met him outside of the hotel on the front patio and I put an expression on my face that proclaimed *I know how embarrassing this is* so people around us might judge our needless tourism less harshly.

It started drizzling, but apparently it was crucial to his tour for us to endure a short lecture before we took on the city. He was much too sweet and sincere to annoy me, but I began to run out of patience when he pulled out sixty laminated maps of Amsterdam waterways. I looked at my mom, anticipating her *Oh, I forgot that I regret it every time I get a tour guide* face. It was plastered on her. For what felt like an hour, Philip gave us a seminar on the history of Amsterdam from the twelfth century to the present. None of which, I predicted, would ever come in handy later in life, much less that day. My mother couldn't help herself and began to gesture for him to speed it along. He looked at her with a puzzled expression.

"We're just antsy to get going and see the city," she said in a level tone.

"We'll get there . . . this is important. It's important!" he said as he pulled out the next laminated map. I'd rather be seen with a self-help book.

Finally, we headed out, damp from the drizzle and already

sick of learning minutiae about Amsterdam. I walked five feet behind everyone to scout out a place I could buy weed from because I was, for some reason, under the impression that all restaurants in Amsterdam carried it, that this was a magical place where people ordered joints along with their lunch. So as my family and Philip peered into a historic cheese shop, I walked into a restaurant next door.

"Hi. Can I get weed here?"

"Excuse me?" the hostess said, clearly freaked out and trying to contain a nervous smile.

"Do you guys sell marijuana here?"

"No . . . only cafés sell marijuana."

"Oh. Is this not a café?"

"No. This is a hotel restaurant."

"So restaurants *don't* sell weed here?"

"No."

I was a dumber tourist than my family hanging out with the guy who had canal maps spilling out of his pockets.

I caught back up with them. Thankfully, Philip was *super*-easy to find.

The rain passed and was replaced by glaring sunshine just as we were dropped off (sans Philip) at our last stop on the tour, the Anne Frank House. I didn't have sunglasses, which my mother endlessly berated me for.

"How could you not bring sunglasses?! How can you see!? It's bad for your retinas! Imagine the full force the sun has on your eyes. So bad for you, Caz!"

I don't own sunglasses for many reasons apart from them

embarrassing me; I also lose them as soon as I get them, and why would I cover up the one part of me that helps distract from the rest of my face? Plus I don't understand the appeal of seeing the world tinted darker than it already is. The last thing I need is something that induces a gloomier reality.

After forty-five minutes in line for the Anne Frank House with the sun beating down on us, I officially wished I owned sunglasses. We were all dying to complain about how hot it was and how long this was taking, but no one could bring themselves to do it considering the building we were standing in front of. I imagined my mother's response if I let out a groan of impatience.

You think this is long? Try quietly tiptoeing around a room for two years waiting for the war to end only to be taken to a concentration camp to DIE.

It's enough to make you feel like it should be illegal to complain. That only a life sentence would be fair for me after my lifetime of complaining.

The visit to the house was, as predicted, intensely heartbreaking. The audio of a young girl's voice reading the diary aloud echoed off the walls and was so distressing, it felt like lightning was going to visibly strike the house every time she revealed another harrowing detail. The reminder of our history was horrific. I had the consistent urge to close my eyes and scream, *Make it stop!*

I was particularly struck when I looked at a photo of her

and her father, Otto. He looked kind of like my dad, and I looked a lot like her when I was younger. It made me think the idea behind those Instagram comments I got wasn't that I looked like an orphan but that I looked Jewish. Either way, I was proud to be in her company.

My mom got overwhelmed and tapped out when we reached the tiny staircase to the annex. I made it to the first room, the one that Anne's father and mother and the van Daans hid in, but I felt the onset of a panic attack in line for her room and I had to turn around as well.

Bart, Bella, and Romy met my mother and me outside of the museum and told us about the room.

"So, what'd you guys think?" Bart asked.

"It was so sad," I said.

"So sad," Romy repeated.

"Powerful," my mother said.

"Very moving," Romy added.

"Can't believe it," I said.

"I was a little disappointed by it," Bart blurted out.

"Yeah, me too," Bella agreed.

"What?!" my mom, Romy, and I said in unison.

"Listen, let's just say it didn't move me as much as I thought it would and I wasn't impressed."

"The Anne Frank House didn't *impress you?*" we said, once again in unison.

"I thought she was living in a closet! It was two rooms! I'm thinking, *I can live here!*" he went on.

"But the rooms were still so tiny!"

"There was nothing there, it was empty. It was underwhelming," he said.

"It was where they lived," Romy said with disgust.

"They should have re-created the beds or something. Anything!"

"Hmm, that's interesting," my mother said. She always says "That's interesting" when she doesn't find what you're saying interesting.

"Maybe because you're not Jewish, you couldn't connect to it," Romy added.

"No, I was incredibly moved by the national lynching memorial. I just think they could have done a better job here. They *should* have done a better job."

"Let's all agree to disagree, shall we?" I said.

"I wish I saw the room. I think I needed an after-hours private tour. It was too claustrophobic," my mom reflected. And that was the moment the Franks decided to eternally haunt us.

The Anne Frank House sadness wore off after a few hours and was once again replaced with my twisted breakup terror. When we got back to the hotel, I locked myself in the bathroom to cry and call one of my friends.

"Cazzie, they're both obscene! What they're doing is obscene," she said.

"In math, two negatives make a positive. Is that the same for them?"

"CAZZIE, SHUT UP!" Romy screamed from the other room. She couldn't take me asking one more question about it.

"You dodged a bullet," my friend said as I tried to be quieter so Romy wouldn't hear me.

"I didn't dodge the bullet. I was hit with one hundred bullets and am now in critical condition in the hospital," I whispered.

"Your ego is just a little bruised, that's all."

"No. Not a 'little bruised.' Someone pulled out my ego, beat the living shit out of it, and threw it back to me like a crumpled newspaper."

"You jumped off a burning ship!"

"No, I was pushed off the ship! I'm alone drowning in the water and no one cares."

And so on and so forth.

My friend then let it slip that they had just posted their first Instagram together. I'd known it was coming soon at the rate they were going; it was just a matter of (no) time before it happened. Though even if they'd posted their first one together two months after our breakup instead of the two weeks it had been, it still would have felt like whiplash.

I visualized the millions of comments and hundreds of sycophantic articles. I asked her to describe the photo to me, because I was too fragile to see it. She told me they were in matching Harry Potter sweatshirts, which was particularly comical apart from being so stereotypically millennial, because for our first date, we also, embarrassingly enough, went

to Harry Potter World. There, we bought the same matching sweatshirts they wore in the photo, except mine was Ravenclaw and hers was Slytherin, which is too ironic to make a joke about. His sweatshirt and mine were still both folded up in my closet back home, gathering dust, sitting next to each other like gravestones.

Other Things That Happened in Amsterdam

I smoked a lot of weed in front of my mom, which was permitted by her only because of the combination of Amsterdam and my breakup.

I had to leave both museum tours we went on because I couldn't stop crying.

The food was amazing, but I also cried at both dinners.

I decided I'd move to Amsterdam if I never got over this.

May 30 — Johannesburg

I wrote for five hours straight on the plane. My hands were numb and got stuck in the shape of crab claws. Writing all of my disoriented thoughts and getting even farther away from American pop culture gave me a sudden burst of energy, like I was literally running as far away from them and everyone who obsessed over them as I possibly could.

I looked through the movie options to give my hands a rest. I tapped my sister on the shoulder to ask what she was watching.

"Fifty Shades Freed."

"Oh, that's stupid and fun — maybe I'll watch that too."

"Don't. I think she has a song in it."

I dropped my head heavily onto my arm that lay on the plane table. My forehead fell directly onto the bracelet he had bought me. It hurt like hell and left a screwdriver imprint on my forehead for the next two days. An almost-perfect metaphor for my place in the world.

We were spending only one night in Johannesburg, to get some sleep before traveling to the border of Mozambique in the morning. Before we'd even gotten into the car to go to the hotel, my sister called the first shower. But even if I had called it, she would have taken it, because she'd argue she needs it more for her OCD.

As I waited for Romy to get out of the shower, I walked around the hotel room in circles. I was too plane-dirty and antsy to sit down. I FaceTimed my friend Owen, who happened to be with two of my other friends. He didn't answer, but they called me back a minute later. I imagined them seeing the call and saying, *Fuck, do we have to FaceTime her back?*

I think we have to.

Okay, ugh . . .

When the FaceTime opened, they all had huge fake smiles plastered on their faces. "HEY!" they said collectively with fake enthusiasm.

"Hey . . ."

"How are you doing," he asked as they all tilted their heads ninety degrees as if on cue.

"Um . . ." I started to cry again because it made me think about how I actually was doing. So after a few awkward seconds, I told them I had to go shower and we said our goodbyes.

Whew, that was pretty painless, I imagined them saying after I hung up.

How was I doing? I wanted to self-induce a coma and not wake up for years, but even years didn't seem like it would be enough time to feel normal. Never waking up would be my first option. I don't know, I think intensely wanting to die is the only thing you can truly feel as a result of watching the entire world fawn over people who are simultaneously bringing you so much pain.

I felt everything he had always felt all at once: rage, self-hatred, loneliness, wanting love from someone you feel "doesn't care at all." I had the urge to do all of the things he would as a result of these feelings, things I believed were wrong of him to put me through. It made me feel like a hypocrite. And because I had seen how many times he felt this way — even though his reasoning was often warped and mine seemed inevitable — it made me feel regret and guilt. That maybe all of his unhappiness really had been my fault because I hadn't understood the depth of his pain, and now I finally could.

Overwhelmed, I fell to the ground without caring if my head landed softly. I lay on my back on the dirty hotel floor as tears ran down the sides of my face and into my ears, creating little puddles. I heard my sister turn the water off. I stood up,

wiped my face, and hopped on one leg to shake the water out of my ears.

May 31 — Travel Day

Like a zombie, I silently followed my family down to the lobby, then to the car, and then to the plane, looking like a depressed high-school boy, with my headphones plugged in underneath my hood, listening to nothing.

We landed near the border of Mozambique in the middle of a dirt tarmac and piled into a white van with the lodge's name written in cursive across the side. Everyone was excited and talking, but I couldn't hear what they were saying. The only thing I could hear was my mind telling me over and over again that I didn't matter. I felt so dumb for spending every minute consumed by something so insignificant. But I couldn't stop it, no matter what mental gymnastics I attempted.

A few moments after we pulled away from the tarmac, we saw a pack of twenty zebras through the window. Then baboons. And giraffes. Then some kind of rare bird I don't remember the name of, but it was still so cool. It was as if all the animals had come out to greet us. And I swear, every time I saw one, a bit of light entered my body.

After we settled into our rooms, we gathered for our first safari. We were given our schedule — two safaris every day, one at five thirty in the morning, and one at four in the afternoon.

It was clear we were all thinking the same thing: *Why are we going on this many safaris? Won't we get the idea after one?* It felt like we'd already seen everything there was to see on the drive over here.

We were instantly proven wrong. Every sight was new and exciting, and with every trek out, I felt less numb, although that could also be attributed to my being revolted at my own ability to be upset while on an African safari. It was dead quiet except for the sounds of birds, monkeys, and elephants (whose trumpeting, I learned, could be heard up to six miles away). I felt myself starting to look at my situation differently. Seeing exactly how this planet has always looked, and being surrounded by majestic creatures who have been around for millions of years, made everything happening back home seem small, stupid, and shallow. There's just nothing more extraordinary in the entire world than being next to an elephant in the wild. This is super fucking corny, but I guess it took actually seeing the world to remind me what mattered in it. And how unbelievably lucky I was to be able to experience something like this, especially in that moment. So I guess thank you, Mom, for the best Christmas present ever.

June 2

The only thing more amusing than the animals on the safari was my mother. Going on a game drive with a neurotic Jewish mother (NJM) in the back seat makes for an entirely unique

experience. If you're lucky enough to ever go on a safari, I recommend bringing an NJM along with you for the entertainment. Every time we'd hit a bump she'd yell, "WHOA!" When we'd off-road she'd emphatically ask, "Is this safe?! Are you sure this is safe? Whoa! Hold on, you guys!"

"We're fine, Mom," I said.

"Mom, you're so embarrassing," Romy said.

She even warned the driver (who'd been doing this for twenty-five years) to "watch out for that ditch up ahead" and "be careful around the buffalo!" But she really killed me when she told the tracker (who sits on an exposed seat at the helm of the vehicle) to come into the car so he wouldn't get ticks from the tall grass.

June 3

My mother read me chapters aloud from *The* FUCKING *Untethered Soul.* I was too broken inside to protest the things that I would normally be repelled by for unoriginality. It was easier to submit. At the lodge, the two of us lay on the deck that looked out onto a watering hole where elephants might come to drink at any moment, my head on her lap, and she read sections to me softly, like I was a delicate baby bird who'd have a stroke if she went above a certain volume. As she read on about how to stop thinking incessant negative thoughts, I had incessant negative thoughts. I tried to pull away from them and come back to her voice, but it was ridiculously challenging, like walking against sixty-mile-an-hour winds. She read

about how important it was to be present, and I went back to the tools I'd been taught at nineteen on how to be mindful and think only about the things in front of you. I looked down at our matching khaki pants and button-up white shirts. She smelled of coconut oil. Her hands held the book and her black framed glasses sat on the bridge of her nose.

"Mom."

"Yes, honey?"

"Will my life ever be normal again?"

She put the book down and pushed her glasses up. "Remember in *The Wizard of Oz* when Glinda tells Dorothy that she always had the power to get home?"

"No."

"Well, she said that."

"So what does that mean?"

"It means as soon as you choose to stop letting it affect you, you will get home."

"I don't think I've ever really had a home."

"Oh, shut up, Cazzie."

Warranted.

June 4

Every night at dinner, my mother asked one of us to give a toast. We had been together for enough time now that everyone was running out of things to toast. There's only so many times you can do health, family, and being blessed enough to get to go on a safari. I had previously given only one toast in

my life and it was two weeks prior, at my sister's graduation dinner. My mother had asked my dad to give it, but he declined, as he's incapable of saying anything trite. "I can't, I don't toast." When he said this, I saw my sister's expression go from anticipation of her father singing her praises, which she desperately wanted to hear, to being thoroughly let down. So I swooped in before she could really get herself worked up over it. I was, after all, the next best thing, since I am also an unforthcoming toast and praise giver. I recited some stuff about how amazing she was and how proud of her I was. It didn't have to be that thoughtful because the mere act of me making a toast was so out of character that anything would suffice. I felt embarrassed and unnatural doing it, but I proved to be less socially inept than my father, which was a comforting fact just for life in general.

Because in that moment I happened not to be crying, my mother asked me to give the toast.

"I don't give toasts," I said.

"You're just saying that 'cause Dad says that," my sister said.

"No, I'm saying it because, like Dad, I also don't give toasts."

"You gave one on my graduation night."

"Yeah, I did."

"Well, you *had* to," she said.

"I didn't *have* to."

"I mean, you ruined my graduation weekend and made it all about you. So the least you could do was make a toast."

I think you can imagine how this dinner turned out. If

you're assuming it ended with me storming out because my sister had no understanding of my situation and then her breaking down because I seemed to have no understanding of how badly I'd ruined her graduation weekend, then you'd be correct. It seems we're both completely self-involved. But probably mostly me.

June 5

I cautiously re-downloaded Instagram to post a few select photos from my trip so maybe I wouldn't look as pathetic as I felt. Even though everything I uploaded got twisted in the most absurd ways. And even the posts I deemed untwist-able quickly proved me wrong via the direct messages I received.

A drink: *Yes, girl, live your life! Drink the fuck up! I would!*

My feet in the dirt: *OMG you're calling them dirt!!!*

A Jacuzzi: *Soak your sorrows away! We're here for you girl!*

An elephant: *Yes! Animals won't fuck you over! Men ain't shit.*

My sister: *Is your daddy gonna buy you a new boyfriend?*

Anytime I do anything, I experience panic and shame. Anytime I do anything that can be considered public, I experience amplified panic and shame. My panic and shame were so far past overdrive, I couldn't articulate what it was I was even feeling.

The fact that people were talking about me at all, let alone talking about me being dumped on such a large scale, was a nightmare my psyche was not equipped to handle.

I tried my absolute best to look at nothing else on my phone, as the few times I did, I'd come across their new photos or tattoos or statements and the relentless articles. I avoided the Explore page at all costs. It was a legitimate war zone; any scrolling would have killed off the few living cells I had remaining. I had started to become deranged, feeling betrayed by anyone who even "liked" something that implied support for either of them, as if it said something about that person's character that they didn't see what I saw. I couldn't see past my own experience, and so it was as if the entire internet was pouring alcohol all over my open wound.

Going onto social media after a breakup is like going to work at the same office as your ex. In the case of my ex and his extremely famous new girlfriend and the behavior they were indulging in specifically, the metaphor was amplified tenfold. Going onto social media for me was like having to go back to work in the same *cubicle* as my ex *and* his new girlfriend while they had pornographic sex in front of me all day that was broadcast over the loudspeakers. And then everyone in the workplace stands up, starts clapping, and declares, "THIS IS THEIR SUMMER!!!!!!!!"

You'd have no choice but to quit, right? Like, quit your phone and quit life.

June 7

We saw more hippos, leopards, rhinos, and lions, seven different types of deer, crocodiles and baby cheetahs, and moun-

tains that dinosaurs used to roam. It was incredible. But after seven long days, I wanted to throw my family to a pack of lions and never see them or another sunset again.

I didn't feel entirely ready to go back to the States, but I was eager to see anyone who wasn't on this trip. Every minute started to feel like an hour. I'd politely ask, "So, how many days do we have left here?" which quickly turned into "So, how many meals does that mean we have left?" Once you have fourteen dinners in a row with the same people, it doesn't matter if they're your heroes — there is nothing left to give. I wanted to leave just so I could stop having dinner with them.

June 8 and 9 — Cape Town

You can tell Cape Town is running out of water because they have it written everywhere you look. On the coasters, on the walls; even the Wi-Fi password was SAVEWATER. There's an alternative hand soap that doesn't require water so you don't have to use any to wash your hands. When Los Angeles was in a drought, the city did almost nothing; people still watered their lawns. It was eye-opening to see the contrast.

June 10 — Wine Country

We had lots of wine and downtime where we all kind of just waited for the trip to be over. Romy and I were getting along really well. Making it to the end of the trip allowed

me to pretend that maybe I was also coming to the end of my heartbreak/mental break. My brain was allowing room for other observations and thoughts and the fucking songs finally stopped being stuck in my head. It gave me hope that the more time that went by, the more things I'd be able to think about again, until one day those other things could fully take over the noise. So, you know, time and "trying to let it go."

Yep, I thought to myself. "She'll be fine."

June 11 — Flying Home

As I stood in line to board a sixteen-hour flight with my new-found sense of acceptance and relief, I got a call from my manager. She asked me if I was sitting down; I said no. She asked me if I was with my family; I said yes.

She told me they were engaged.

And I laughed.

Thanksgiving

I HAD RECENTLY GOTTEN back home from inpatient mental-health treatment. You're probably thinking, *Uh, Cazzie, you already wrote about this in another essay.* No, that was when I went for anxiety; this is when I went for everything else. It was a last-resort type of thing. Therapy felt like it was for the norms, for solvable issues about boys ghosting you, mild childhood trauma, or depression from the routine of life. Anytime my therapist tried to give me advice now, I would just shout back, "HA, TELL THAT TO MY SELF-WORTH!!!!" I was like a spirit who had unfinished business and therefore couldn't pass over to the other side. I just stayed around haunting myself. My mom didn't understand why I felt I needed to go. When she asked me why it was necessary, I told her:

I have obsessive negative thoughts every moment of the day.

I have uncontrollable rage that's making me feel invincible.

I need constant reassurance that everything is going to be fine, like I'm a child.

I need constant male approval.

In the past few months I've spent more time crying than not crying.

I have relentless self-loathing and crippling self-esteem issues.

I'm addicted to my phone.

I'm terrified of death but I also have daily suicidal thoughts.

I'm embarrassed by my own existence.

I can't stop hitting myself in the face for all of these reasons.

It's truly shocking I'm not on medication, but I don't want to be, so I feel this is my only option because I'm not coping.

She told me to go and wished me luck, even though I could tell the fact that I was going was even more embarrassing to her than it was to me. I knew it wouldn't help all that much, as I'm incapable of being convinced of anything I know not to be true. But at the very least, I'd be forced to exist without my phone and maybe catch up with my brain, which I'd left somewhere in my bedroom last spring. Plenty of visionaries (tech bros) have gone away to find themselves and then come

back and changed the world, so I tried to think of it like that. But instead of changing the world (or helping build a self-sustainable drug village), I'd just be able to survive in my own.

It's still hard for me to believe that with all of my embarrassment issues, I managed to drop myself into what felt like the most embarrassing place I could possibly have found. But I thought maybe that would be a good thing. Like, embarrassment exposure therapy. I'm not going to say much of the actual work we did, partly because, like Fight Club, you're not supposed to, but mostly because if you knew what I did there, I'd have to kill you because it was so humiliating. The only reason I would never recommend this place to anyone else is that I wouldn't want them to know the mortifying activities I was forced to take part in on my path to "achieving inner peace." If my dad had any idea, he'd disown me, convinced I couldn't be his blood if I was capable of participating.

The therapist I had there tried to pin all of my embarrassment issues on my dad, which was funny.

"So. You're very codependent, yeah?" she said in her thick Castilian accent. She was referring to my paperwork, which consisted of nearly one hundred questions regarding every detail of my life and reason for coming.

"Why do you say that?"

"You say you don't like to be alone, that you hang out with people all the time so you don't have to be with yourself. You let this boy walk all over you."

"Yeah, I guess I am codependent."

"Why'd you let this boy walk all over you?"

"I don't know," I said.

"I know. It's because you idealize the men in your life. You think they're so great, you let them do whatever they want," she said confidently.

"No, that's definitely not true."

"Well, you idealize your father."

"No, I don't think so."

She turned a page in my file. "You wrote right here, 'My dad is the greatest person on the planet and he is too good for this awful world.'"

"Right . . . well, he is."

"You see? You idealize him. No one can be the greatest."

"I see why you would say that, and for most people you'd be correct, but my dad *actually* is. I don't think that just because he's my dad. People who don't have him as a dad think it."

She looked at me skeptically, but purposefully, so I'd know she was looking at me like that. "He has flaws. Everyone has flaws," she retorted.

"Yes, but they are innocent and don't hurt anyone."

"They hurt you . . ."

I couldn't help but laugh at the prospect of any of the issues I had being my dad's fault. He was the only person who didn't give me issues! How simple and misguided.

"You say you have a lot of shame. Can you pinpoint when this started?"

"Yeah, actually . . ." Please hold for a tragic acting-class monologue.

"When I was, I think, four, my mom made me take this

dance class. There was a big recital at the end, all of our families came, and it was on this huge stage. The dance number started and everyone ran out onto the stage, but I couldn't move. I stood on the side holding on to the curtain for dear life until my teacher physically pushed me out there. I saw everyone in the audience, froze and immediately began to cry. I know it doesn't sound like a big deal, but it was exactly one of those scenes they put in the beginning of a movie to show a moment in time when the main character was humiliated as a child. Anyways, after it was over, I was still kind of crying and I remember my dad pulled me aside and whispered into my ear, 'You couldn't go up there and dance because you're COOL. It means you're cool that you couldn't do that!' He said it was the moment he knew we were exactly the same. That always stuck with me, like — you're cool if you don't do anything that's embarrassing."

"Mmm-hmm . . ." she said with a *Told you your dad fucked you up* look on her face. Pfshhh. Ridiculous.

The stupidest thing out of the hundreds of stupid things about having to go to one of these places is that no matter how you frame it, the real reason you're going is that you have momentarily forgotten how many people have been on this earth. To go away and focus solely on your own peace of mind, you must be so consumed by your own experience that you ignore the fact that billions and billions of people have come before you and will come after you (if not for the Earth warming), and it barely matters that any single one of us are one of those billions. If you were truly aware of this, you wouldn't be

able to pay attention to how bad you're doing and how much you hate every part of yourself because you would know how fucking meaningless it is. But I guess the only way to work on not hating yourself is through doing something that in turn makes you hate yourself that much more.

And it did seem to work. In the weeks since my return, my friends noticed I was lighter, more tolerant, less angry, not crying. I had basically reached enlightenment — you know, for me. Thanksgiving was right around the corner, and I hadn't seen any of my family since I had gotten back, but I was looking forward to implementing my newfound acceptance of flawed people around my favorite flawed people in the world.

My cousins and I were set to fly to Martha's Vineyard to spend the holiday with my mom and my sister, who was flying up from New York. I was going because I had to but I'm pretty sure everyone else ended up making the decision based on wanting "fall vibes" for the holiday. Holidays in Los Angeles tend to feel like everyone is just pretending it's a special day. The only thing that allows you to tell it apart from any other is the lack of traffic and the abundance of people outside taking their dogs for a walk.

Barely anyone is on the island in the fall because it's cold, every store and restaurant is closed, and it's almost impossible to get to. It is a hell of a journey. A six-hour flight to Boston, followed by a connecting flight on a small rickety plane that's so ancient, every time you enter it you have the full awareness that it could go down from a mild gust of wind. Without fail, every time we land safely, I'm surprised.

My mom was waiting for us outside the gate, which you can see from the runway. My mom always starts wildly waving way too early. Even before we get off the plane, I'll see her through the plane window moving her hands to and fro like she's holding up a lighter at a Led Zeppelin concert. Once I step off the plane, I always give her a small gesture so she knows I've spotted her, but she doesn't stop even then. She continues to wave until I'm right in front of her face and she has no room to wave anymore. It's so embarrassing, but I was trying not to get so embarrassed anymore.

Whenever you arrive somewhere you haven't been in a while, it doesn't matter how much progress you've made as a person; the insecurities you last invaded the space with are there to greet you with open arms, like nothing has changed. Everything smells, looks, and feels the way it did the last time you were there, that it makes you feel the same too. The energy is so palpable, it makes your past problems your current ones and your current ones your past ones, to the point where you feel like the person you were talking to morning and night the last time you were there, the only person getting you through the day, is the person you are still talking to, even though that person is gone.

The holidays are hard if you don't have a family. But they're also hard if you do have a family . . . who is crazy. My mom's house on the island fits all of us: two cousins, my sister, an aunt, the husbands and young kids of said cousins and aunt. It's sufficiently big, but no house could ever be big enough for my family's personalities to inhabit. If I'm 100 percent Jewish,

I'm certain every one of my other family members is at least 150 percent. Three Jews had to have made each one.

Every day, my entire family gathers in the kitchen from nine a.m. to noon. Not me; I'll wait for them to leave. But my room is the closest to the kitchen so I can hear everything they say from the moment I wake up until the moment they finally leave. I'll lie in bed angrily listening to the mumblings of their conversations, most of which are about how I'm sleeping.

"Is Caz awake?"

"Of course not."

"Should we wake her up?"

"Probably, or she'll sleep the day away!"

"She could sleep until four if we don't!"

I've never slept until four. It's a frustrating rumor they perpetuate for reasons I don't understand. The latest I've ever slept in on record is maybe twelve. I can't figure out why my family cares so much if I'm up or not. There are plenty of them to entertain one another. Even though I *am* awake and just refuse to get out of bed, using any excuse to remain under the covers. In the past, that meant I'd look through all of my apps over and over again until I felt mentally ready to see a surrounding that wasn't my bedroom. It was too soon to fully fall back into my addictive habits, so I was still checking them but allowing absolutely no refreshing. I vowed I'd let myself get only half as addicted, which, according to my screen time, was still very addicted.

When I was at that stupid, embarrassing mental health place, I was so desperate for internet access I tried to bribe the

cook there for the staff Wi-Fi password. All technology was banned, but I had snuck my laptop inside the secret pocket of my suitcase. By the fourth day, I was feeling so anxious to know what was going on that I wrote "wifi pw?" on a Post-it note and stuck it to a twenty-dollar bill and passed it to the cook during dinner. He was always so depressed, probably because he wanted to be a renowned chef and instead was cooking tasteless health-conscious food for a bunch of rich, broken people. I thought that at the very least, it would have brought a smile to his face, but he looked at my Post-it and put it back on the counter, expressionless. It was for the best he didn't give me the password. I knew the circle of events that would follow: I'd find out more things that would enrage me, text all my friends for reassurance, go on Instagram to try to obliterate what I had seen that angered me, filling all of the space in my mind I had specifically come there to make with empty moments from other people's lives, a combination of people I don't like and my friends' friends whom I'm obligated to continue following forever because they followed me and are my friends' friends, and my friends' friends can't think *their* friend's friend is a huge bitch. Which I am.

I eventually adjusted to having no internet, but the only way for me to do it was to pretend I was living in a time when phones didn't exist and had never existed and that I was essentially living in the days of yore. If I remembered I lived in a world with other people who had phones, then I would have anxiety about the things that were happening back home I didn't know about, which was pretty much just as bad as

having anxiety about the things I did know about. So for the remainder of my time there, I decided I lived in a horse-and-buggy town with no horses or buggies and just twenty deeply depressed people.

My mother burst through my door. I hid my phone under my pillow and pretended to be asleep.

"Caz."

"What."

"When are you getting up?"

"Soon. You literally just woke me up."

"Do you want me to make you breakfast?"

"Not at this very moment. Thank you, though."

"So let's say ten minutes?"

"I'd rather not be tied down to a scheduled breakfast right now." *What am I talking about?*

Every time my mom enters my room or I hear someone mention how I'm sleeping, I add fifteen minutes to the time I'll spend in bed before coming out. I don't know why. There is obviously something wrong with me. But it's just too highly anticipated, them all sitting in the kitchen awaiting the last face to be up in the morning. I can't bring myself to do it for the sole reason that every member of my family makes such a big deal of it when I come in, saying things like:

"Wooo, she's up!"

"Well, good AFTERNOON!" (*It's eleven!*)

"What a surprise! Look who decided to finally get up!"

"I don't think I've ever seen you awake this early!" (*Suuuure you haven't!*)

I wasn't going to give them the satisfaction. Whenever the family reunites, everyone somehow forgets it's been ten years since I was a teenager. And when everyone treats you like a teenager, you follow suit and become a teenager. *Cazzie the teenager . . . classic grumpy morning Cazzie.* They love to tell stories from my teenage years of trying to get me up in the morning for school or flights. *Everyone* has a story. *CON-GRATULATIONS, YOU WERE ALL SO ANNOYING WHEN I WAS A KID THAT I REFUSED TO OPEN MY EYES AND JOIN YOU IN BEING AWAKE!* The attention given to my sleeping habits only made me an angrier version of my teen self, but I vowed I wasn't going to get angry anymore.

What ended up helping my anger the most wasn't the program, meditation, or therapy. For a while, I was stuck in a bad habit of punching my steering wheel every time I got in the car. One day when I was at a red light, I started banging my head against it (as one does . . .). When I stopped and looked up, I made the most uncomfortable eye contact I've ever had in my life with a pedestrian. The incident made me feel like such an idiot, it kept me from doing it again, making me think of the Joan Didion quote: "It was once suggested to me that, as an antidote to crying, I put my head in a paper bag. As it happens, there is a sound physiological reason, something to do with oxygen, for doing exactly that, but the psychological effect alone is incalculable: it is difficult in the extreme to continue fancying oneself Cathy in *Wuthering Heights* with one's head in a Food Fair bag."

"CAZ!!!!!!!!! THE COFFEE IS GETTING COLD!" my mom yelled from the kitchen. I could hear them when they whispered in there; yelling was so far past unnecessary.

"MOM! STOP SCREAMING!!!!!!!!!" I screamed back, louder than she did so she would know how far a scream went in this house.

No answer. But a minute later . . .

"CAZ!"

I got up before my mom sent in someone even more crank-iness-inducing, like my uncle Mike. If he came into my room, there would be absolutely no hope for my mood to uplift for the rest of the day. The only person I've never minded waking me up is my dad. I think it's because he does it without really caring if I get up or not, like there are more important things to care about in the world than me seeing the morning light.

Fortunately, by this time some of my family had dispersed, so entering the kitchen was less emphatically received. I still tried to be inconspicuous, hiding my face in my hoodie as if it were an invisibility cloak. My mother was sitting at the kitchen table organizing vegetable seeds into pill contain-ers.

"Hey," I said.

"Your behavior is unacceptable. You are in *such* a crappy mood," she said.

"I'm in a crappy mood because I was woken up in an abrupt and harsh manner."

"What about some *gratitude?!*" she exclaimed.

"This has nothing to do with gratitude; I'm just asking to be

treated like an adult and for you to not scream my name when I'm five feet away."

She left the kitchen. I always surprise myself with my desires, and I guess this was what I wanted — for everyone to leave me alone. Why did I want this so much more than being excitedly greeted by my family, with breakfast lovingly made for me? I'm such a contrarian freak.

I went outside to calm myself with a walk. The fall in Martha's Vineyard can only be described as cozy and haunted. It's wildly eerie; it's the kind of place where it feels like one of us is going to mysteriously go missing, and years later when you walk through the forest you'll think to yourself, *Only the trees know what happened to her that day.*

When I came back, my sister was making a gluten-free, sugar-free, dairy-free, grain-free apple almond cake for Thanksgiving since she can't eat regular anything because of her stomach. I asked if I could help, for selfish reasons, as I was afraid that if she didn't let me, I'd go on my phone. She said I could cut the apples, so I grabbed a knife that was already out on the cutting board and started slicing.

"Caz, that knife is dirty."

"Oh. Sorry." I rinsed the knife in the sink and dried it with a rag.

"That rag is dirty."

I rinsed the knife again and dried it on a clean towel.

"Actually, I'm just going to do it," she said anxiously.

I handed her the knife; she put it in the dishwasher and got

a new one. I chose not to find that annoying, and in exchange she let me leave the room without calling me mean.

The next morning, three different family members came into my room to try to wake me up. I mean, seriously, what kind of home is this?! I might as well be in boot camp. I barged into the kitchen, livid. Everyone was there.

"Well, look who it is!" one of my cousins said.

"All right, listen! I'm going to say this once: I do not want to see a single face in the morning unless I have decided, myself, that by leaving my bedroom, I am allowing faces in my peripheral vision. Do you understand?!"

Everyone was silent.

"No faces. Got it . . . what about a note under the door?" my aunt said. They all laughed. I rolled my eyes and went to pour myself a cup of coffee.

"Caz, have you gotten your flu shot yet? Rom and I were going to go down to the pharmacy and get them today," my mom said.

"*Fun.* Thanksgiving flu shots. Yeah, I did." I don't have a death wish; I would never travel in November without a flu shot.

"Did you make sure there was no mercury in it at the place you got it from?"

"Uh . . . no, you took me there last year, so I assumed it was fine."

"The vaccine is always changing — you always have to make sure. The mercury is linked to Parkinson's, ALS, and

Alzheimer's," my mom said nonchalantly. I dropped my head into my hands.

"Caz, come on. It's a fact of life. Everyone gets sick."

"No. I can't ever get sick. Ever," I said through my fingers, which were now stretching parts of my face in different directions.

"You can't prevent it! Everyone dies of illness eventually," my mom replied.

"Unless you're murdered, which really wouldn't be that surprising since you're so mean," Romy said.

"No, many people die from natural causes. Probably more than people who die from illness," I argued.

"What do you think dying from natural causes is?" Romy burst out laughing.

"Uh . . . dying in a natural way?"

"Cazzie. It's a nice way of saying a person got sick."

"Mom, is it true you can't die without getting sick?" I asked, feeling a bit uneasy that I might actually have been thinking positively for once.

"It's true that you can get sick from worrying so much and having such negative thoughts!"

Thanks, Mom.

Natural causes, I guess, was my Santa Claus. My last hope in this excruciating world. But it was cool to have remembered that nothing was good and that I was stupid in the same moment.

A few weeks prior, I wasn't scared of dying at all. The room I had been assigned to was deep in the middle of the

woods, a cabin that looked even more murder-y than the ste-
reotypical murder-y cabin. It'd be impossible for anyone not
to feel like they were going to get murdered every night. I
wasn't scared about being murdered, though — not because I
thought I wouldn't be, but because I didn't care if I was. The
only thing I was scared of was one of the massive trees falling
onto my room and crushing me as I slept, only because it's a
much more embarrassing way to die than I'd prefer. Dying
via a tree falling on you seems like the universe was trying to
kill you, rather than it being an accident. No one could say,
"NOOOOO, it wasn't supposed to happen!!!!!!!!" Because,
IDK, it kind of seems like that was supposed to happen . . .

Being scared of sickness and death again was a clear sign
I was getting back to normal, although I don't know if it was
preferable.

On Thanksgiving morning, I was woken up by a ten-foot
stick poking my foot.

"WHAT THE FUCK!?!"

"It's not a face!" my stepdad yelled from the window where
the massive stick was coming from, hysterically laughing at
his own infuriating joke.

I didn't get upset because he seemed so excited about it
that it was sad. Too much effort put in. An hour later, I re-
signed myself to seeing my family. I didn't want to get *dressed*
for Thanksgiving but I wanted to change to feel a little better
about myself. I'd been wearing flannel pajama bottoms and a
fleece sweater I'd taken from my mom's closet every day, and
I had very knotted hair from sleeping in a different version

of a bun every night. I didn't want the attention I'd get from coming out in jeans and a sweater. The reactions to me not wearing an XXL hoodie would elicit more attention than waking up. I put on leggings as a compromise.

That evening, my sister and I sat by the fire as we waited for dinner to be ready. It was freezing in the house because my mom refused to turn the heat on. My sister was underneath a large blanket, which she wouldn't share and kept exaggeratedly shivering underneath. "Brrrrr, this blanket is so cold," she said.

"Is it colder than no blanket?" I said, also shivering.

After everyone was called to the table, my mother informed us of everything in the meal that had come from the garden, as she did every time we sit down to eat. Ninety percent of what we eat when we're there comes straight from the ground, because my mother's dream of having a garden that is even more extra than Oprah's was fully realized.

"Let us be so thankful that we have food on the table and even more so that it's food from the garden. Thank you to everyone who helped make this meal, but more important, to everyone who helped grow and pick this meal." She'd grown and picked it. "Here we have a salad, everything in it picked from the garden. Carrots from the garden. Mushrooms and sweet potatoes that I picked *from the garden.*" One person at every dinner jokes, "Is it from the garden?" and I don't know what's worse, hearing my mom repeat that everything is from the garden or hearing a family member repeat that joke.

After about five minutes, my mom suggested we all go

around the table and name what we were most grateful for. A tried-and-true Thanksgiving tradition and, for my family, a tradition for most regular dinners as well. My mom's response to just about anything is "Think about what you're grateful for." But it'd be insane if I had to remind myself to be grateful when everything in front of my eyes twenty-four hours a day is a constant reminder. The only thing I could ever think of not to be grateful for is that I'm trapped in this incredibly privileged life saddled with a brain that simply refuses to allow me to appreciate it, lest I detest myself even more than I already do.

"Who wants to go first?" my mom asked.

"I wonder what everyone is going to say," I said sarcastically. Everyone would say family or their health and being able to spend Thanksgiving here, an attempt to suck up to my mom. I would've said, *I'm thankful for everything but being me*, if not for the concerned reactions it would incite. So I'd probably resort to a bad joke like *I'm thankful for bread*, and everyone would just say, *Oh, Cazzie . . .*

Everyone talked about how good everything looked, especially the sweet potatoes, and we all complimented Romy on her table setting. Bottles of wine, one red, one white, were passed around until everyone had filled their glass to their liking. In a side discussion, I looked to my older cousins for wisdom as a part of my constant search for assurance until we heard "One conversation!" come from the head of the table and stopped talking. I turned my attention to my youngest cousins playing and, predictable in my own ways, wondered

how much longer we could keep them from finding out how fucked up the world was. I started to feel bad about the fact that I couldn't get through one otherwise perfect holiday without having imperfect thoughts, and then I started to feel stupid for feeling bad, as if I hadn't lived with myself for enough time to know it would be like this forever.

Whenever you're going through something, people tend to tell you, "Everything will be okay." And you'll say, "How do you know?" And they'll say, "Because they always turn out to be, no matter what," or "You're capable of getting through anything." Well, neither of those are true. Things won't always turn out okay. And there is plenty of stuff I am totally incapable of getting through and even some mild traumas that I would rather euthanize myself than endure. I will never be able to accept that the world is a fucked-up place, that good things happen to bad people, that injustice and stupidity are rampant, and that horrific, awful things happen every day that no one asked for. Everything will not always be okay, but as I look around the table with the unavoidable gratitude that comes just from having sight, the fact that my dad is still alive, my cat is in my home, my sister is healthy, my family is annoying but I have one and they love me, I haven't gotten radiation poisoning from my phone yet, and right at this very moment, at least during this dinner, everything is okay . . .

Possibly for one of the last times ever.

And then, inevitably, it was my turn.

"Cazzie, what are you grateful for?"

Acknowledgments

Thank you to my editor Kate. I don't know what this book would be like without you. Something like this but a lot worse. If it's still bad then thank you for making it so much less bad than it could have been. Thank you for always pushing me only in the right directions, for your consistent support, sensitivity, and insight. How someone can simultaneously be so wise and in tune with the trivialities of pop culture is beyond me.

Dorian, thank you for believing in me even though you still have yet to know whether or not you were right to do so. Thank you for championing this book, for understanding me and therefore being able to speak on my behalf, as I time and time again proved to be unable to do so.

Naomi Bernstein, my dear friend, without whom my smartest points in this book would be the dumbest. Thank you for letting me pretend it's possible I could have come up with lines that only someone as intelligent and self-aware as you could think up. If I could steal a person's brain, it would

be yours, and I am eternally grateful to you for letting me rent it out with your edits.

Elisa, I know the reason God will never give me a husband is because he gave me you. Thank you for your endless generosity with notes and reassurance, for always telling me the truth in such comforting ways that they feel like lies, for always being there for me, and helping me even when you know I don't need it.

Thank you to my mother for the endless material and for having such a good sense of humor about said material. Also for making me feel confident enough to write this book from the beginning. I'm sorry for possibly ruining your experience of having a child. If I could do it all over again I would be a perfect little angel. Any strength I possess is because of you.

Romy. Thank you for being the first person I consult on everything. You're the best version of what Mom and Dad's DNA could possibly make. You're everything that is good. The human embodiment of a cupcake.

Dad, you're my best friend in the world. Thank you for always making the time to read my work, from my middle-school homework to my college essay to the essays in this book. Thank you for never giving up on making me a better person and writer even though it's useless. Having you as a dad, mentor, and hero is the best thing that could have ever happened to me.

Liana, thank you for your brilliant ideas, for going above and beyond to help make everything I do as thoughtful as it

can be, for keeping me in check, and for your honesty and unwavering support.

Pete. I love you. Thank you for being encouraging when you did not have to be. Your bravery inspires me and your friendship means the world to me.

To special friends who took time out of their lives to read early segments of this book: Nicole, Rebecca, Rose, Owen, Taylor, Molly, Jessie, Ella, Karine, Nick, Crissy, and Maddie.

Others who either eased my anxiety about this book or helped with it in some way: Sharon, Alyssa, Nick S., John, Miller, Jackson, Lily, Chen, Kyra, Lisa, Emily B., Jared, and Sophie <3.

Thank you to everyone at Houghton Mifflin Harcourt.